T·H·E B·R·A·N·D·Y·W·I·N·E V·A·L·L·E·Y

AN INTRODUCTION TO ITS

C·U·L·T·U·R·A·L T·R·E·A·S·U·R·E·S

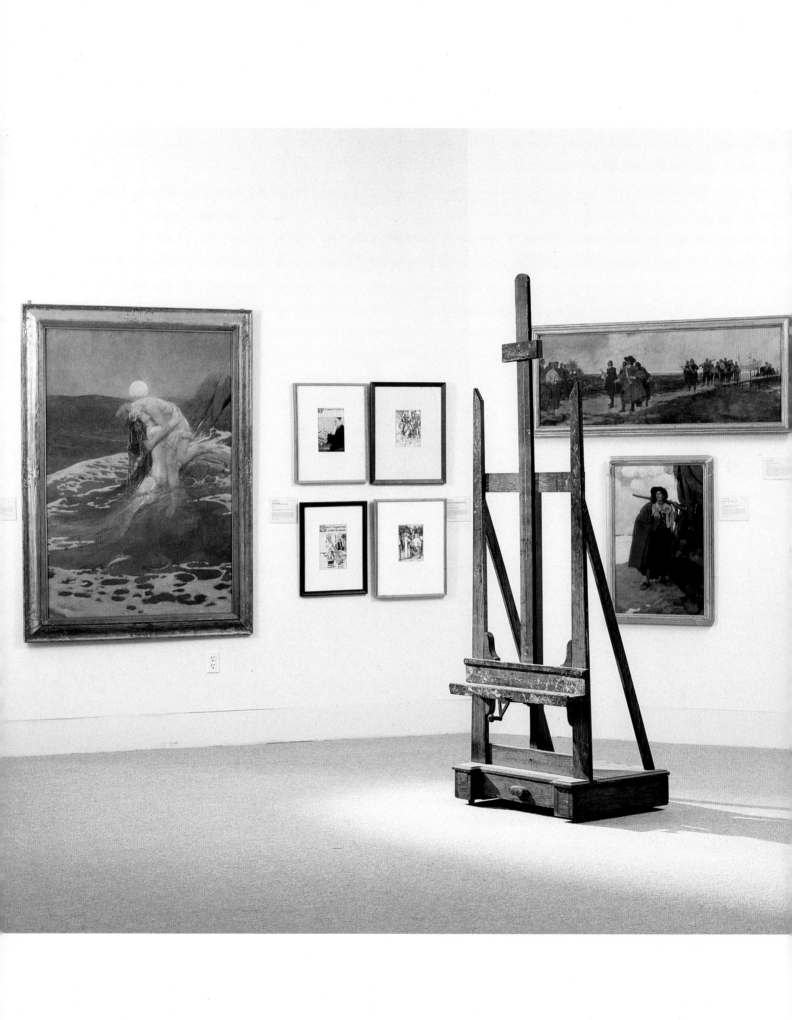

THE BRANDYWINE VALLEY

AN INTRODUCTION TO ITS

CULTURAL TREASURES

JAMES S. WAMSLEY

. . .

ORIGINAL PHOTOGRAPHY BY
STEVEN MAYS

HARRY N. ABRAMS, INC., PUBLISHERS, NEW YORK

Editor
MARK GREENBERG

Designer
MARIA MILLER

• • •

Library of Congress Catalog Card Number: 92–82042
ISBN 0–8109–3628–3

Published in 1992 by Harry N. Abrams, Incorporated, New York
A Times Mirror Company

Printed and bound in Japan

• • •

On the title page
Paintings by Howard Pyle are reunited with his easel in the Pyle Gallery.

CONTENTS

A·C·K·N·O·W·L·E·D·G·M·E·N·T·S

I n producing the text of *Museums of the Brandywine* I was helped along the way by a number of kind and solicitous people whose knowledge of the Brandywine region and its specific institutions was, and will always be, much greater than my own. Melissa Mulrooney coordinated the entire nine-part project, and then introduced me to the riches of the Delaware Art Museum, where she is director of marketing communications. I am especially grateful to that museum's director, Stephen T. Bruni, for generously guiding me on a perspective-inducing tour of the lower Brandywine Valley.

Other museum representatives who will always have my sincere thanks are Jill MacKenzie, head of external affairs for Hagley; Lynn Davis and Janice Roosevelt, Winterthur public relations; Barbara Butler, former director of the Delaware Museum of Natural History, and Mary Jane Arden, public relations; B. J. Whiting, tour supervisor of Nemours, and guide Paddy Dietz; John H. Braunlein, director of Rockwood, and Becky Hammell, curator; Barbara Benson, executive director of the Historical Society of Delaware, and Timothy Mullin, site director of the George Read II House; James Duff, executive director of the Brandywine Conservancy, Lucinda Laird, public relations, and former staffer Erin Harrington; and Colvin Randall, public-relations manager at Longwood Gardens.

Outside the museum orbit, my thanks go to Abrams senior editor Mark Greenberg, whose grasp on the reins guided this potentially unwieldy vehicle to the finish line, and to my wife, Gwen, whose support and literary suggestions came, as always, at the times when they were most needed.

James S. Wamsley

I·N·T·R·O·D·U·C·T·I·O·N

· · · · ·
 "**E**verything lies in its subtleties, everything is so gentle and simple, so unaffected," said Newell Convers Wyeth of the Brandywine Valley, his adopted home and source of inspiration across four decades. That an artist of N. C. Wyeth's magnitude felt like this would, of itself, focus a degree of aesthetic notoriety on any river valley, but the Brandywine's call was a great deal more than a private siren song for one painter. For a century and a half, notable American artists have felt the Brandywine's elusive appeal. Neither majestic nor conspicuous, as an artistic milieu it can be challenging and abstruse, this landscape of river, village, and farm ("succulent meadows" and "big sad trees," as N. C. Wyeth said) in which only good craftsmen—professionals willing to work hard for the Brandywine's gold—may find satisfaction. Artistic niceties aside, the Brandywine Valley is a Mid-Atlantic environmental exemplar, friendly and helpful to those who respect it, a place where geography and climate seem especially fortuitous. The Brandywine Valley was scaled to fit humankind.

It takes its name from the Brandywine River, or Brandywine Creek, a matter of semantics on which even local people cannot agree. Some say the Brandywine, rarely more than 100 feet wide, never gets large enough to be called a river. In any case, the stream is formed by two small southeastern Pennsylvania branches, which connect in the rolling hills of Chester County, just north of Chadds Ford. In final form, the interstate Brandywine ambles across the Delaware line, flowing no more than 20 miles before losing itself in downtown Wilmington's Christina River. Then the Christina—itself no Mississippi—abruptly ends its brief span at the majestic Delaware.

At that intersection with a great navigable river it was inevitable that a port town, Wilmington, be established to serve the region between Baltimore and Philadelphia. For a century or so, colonial millers found the Brandywine an especially tractable,

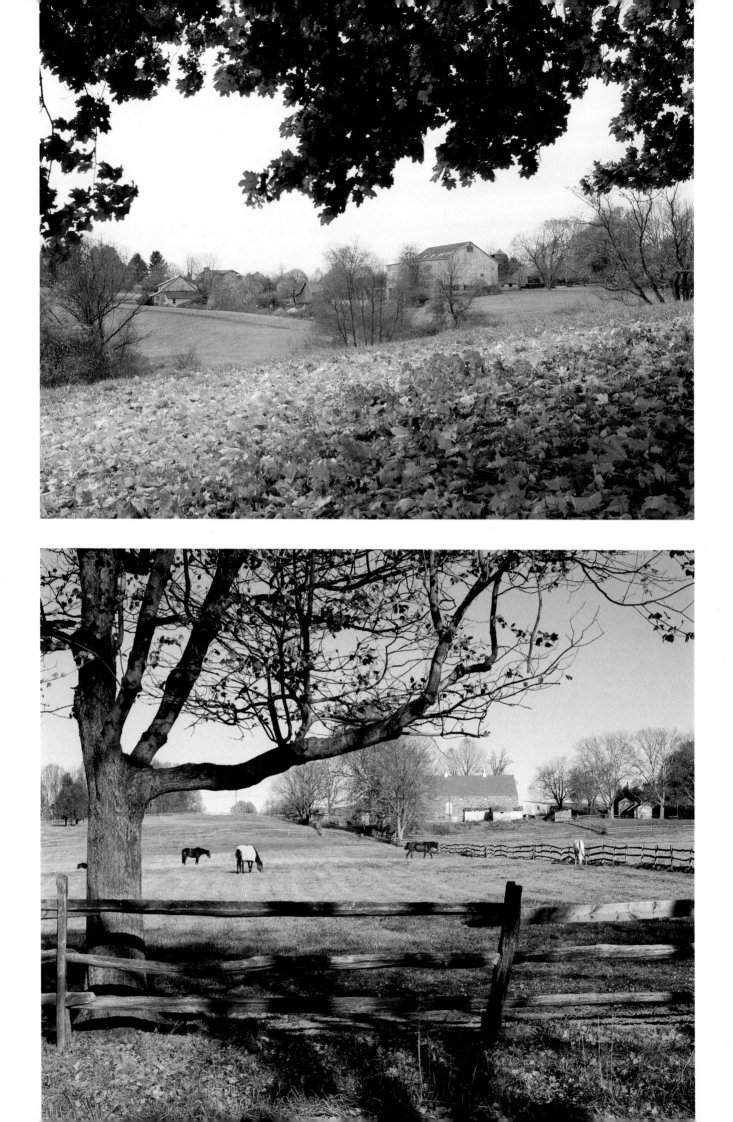

The Brandywine valley still retains its centuries-old pastoral roots.

dependable stream. The Brandywine created pioneer industrial nabobs of relative wealth, rooted in the traditional milling trades of flour, cotton, paper, and leather. But with the dawn of the nineteenth century a new industry appeared on the lower Brandywine, run by a French immigrant, Eleuthère Irénée du Pont, whose father was a friend of both Louis XVI and Thomas Jefferson. The demand for Du Pont gunpowder created fortunes in every succeeding du Pont generation, and those fortunes often were turned toward cultural pursuits. Du Ponts and other Brandywine millionaires became patrons of the arts, created palatial residences, gardened on a heroic scale, and became scientists, antiquarians, and preservationists. Typically, the estates, galleries, and gardens thus established soon became public treasures of a high order.

The best of these are grouped together in a loose confederacy called, informally, the Brandywine Nine. Here is an assembly of art, antiques, architecture, natural science, and gardening that is unique on earth. Some are individual superstars, like Winterthur. That vast mansion holds, in almost two hundred period rooms, the world's finest collection of American antiques and decorative arts. The Hagley Museum and Eleutherian Mills, original heart and soul of the du Pont enterprise, mingles fascinating historic structures with some of the Brandywine's most ethereal river views. Rockwood, a rare and original 1850s Gothic Revival estate, is a monument to vanished styles and mores. The Delaware Art Museum combines an amazingly good collection of nineteenth and twentieth-century American art with the country's most important Pre-Raphaelite gathering, to which it adds the supreme collection of Wilmington's own Howard Pyle. The Historical Society of Delaware stages challenging exhibitions in its Old Town Hall of 1798, and welcomes the public to one of the great Federal era mansions of America, the George Read II House in New Castle.

Nemours, the ultimate du Pont mansion, is a glittering 102-room French château that links American capitalism and the ancien régime. The Delaware Museum of Natural History has assembled the fauna of the world, with especially notable collections of shells, birds, and eggs. The Brandywine River Museum explores the region's artistic legacy in a blend of local subjects and major American artists, including the inimitable Wyeths, while displaying a wealth of American illustrative art. Longwood Gardens, once the private estate of the maximum du Pont chieftain, is a thousand-acre wonderland of gardens, conservatories, fountains, and amphitheaters.

These institutions complement one another, and taken together, they touch the heart of the Brandywine Valley in all its natural and cultural subtleties and subplots. The visitor finds an intertwining of history, enterprise, fantastic wealth, cosmic-scale collecting, striking architecture, and a tradition of first-class art as old as the country itself. The treasures of the Brandywine have proud local connections, but that is a bonus, for those treasures are anything but parochial.

· · · ·

·
·
· *Along the Brandywine River*
·

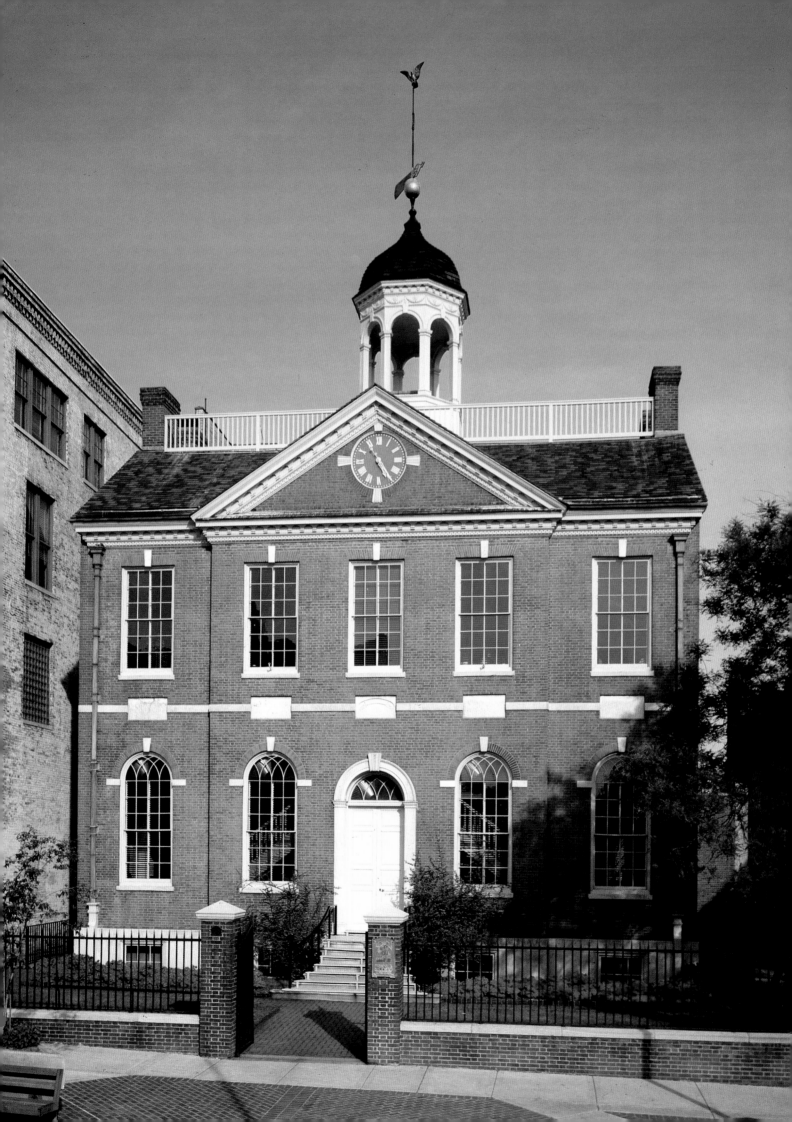

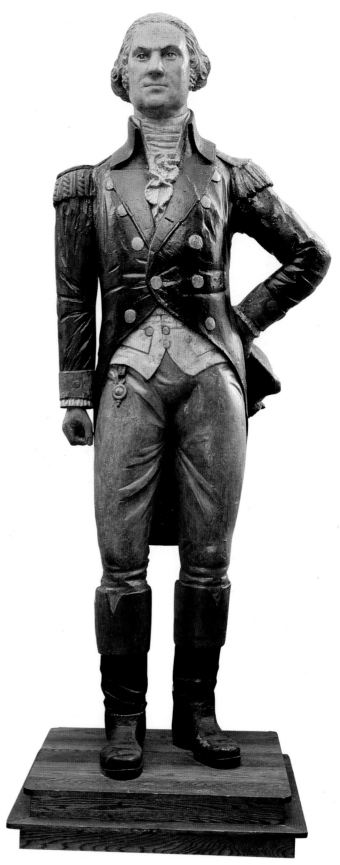

T·H·E
H·I·S·T·O·R·I·C·A·L
S·O·C·I·E·T·Y
O·F
D·E·L·A·W·A·R·E

An astounding artifact greets visitors to the Historical Society of Delaware's Old Town Hall, that neoclassical prize gracing Market Street in Wilmington since 1798. A wooden statue of George Washington, 9 feet tall, waits just inside at the foot of an airy, slender staircase. When back-lighted by a nearby Federal fanlight, General Washington fairly coruscates with energy: left arm akimbo and right leg poised as if to stride forward.

This gigantic image of the Father of Our Country, carved in the nineteenth century by an unknown but manifestly skilled and exuberant hand, first graced a commemorative arch in New York City's Washington Square. Toppled from his arch, he was reincarnated as a cigar-store effigy. A visiting Dela-warean took pity on the statue, brought it to Wilmington, and donated it to the Historical Society, where the Father of Our Country has welcomed children and adults for over fifty years.

A visitor thus greeted knows instantly that stuffiness is one quality not to be found at the Old Town Hall Museum, whose schedule of changing exhibitions guarantees something fresh, and sometimes provocative, to see on the main floor, a beautifully proportioned space under a towering ceiling sup-

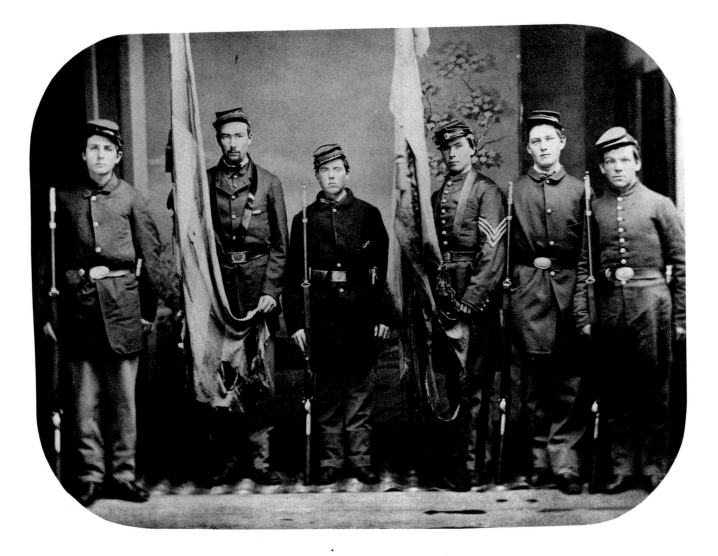

They answered the call to the colors: men of the First Delaware Regiment.

Page 14. *Wilmington's Old Town Hall, built in 1798,*

became the headquarters of the Historical Society

of Delaware in 1928; today it preserves within its walls

a treasury of Delaware artifacts and art.

Page 15. *A striking folk-art statue of George Washington*

once stood atop an arch near Washington Square in New York City.

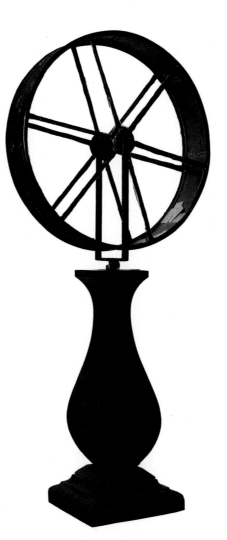

During the Civil War this lottery wheel held the names of men chosen for the draft at Old Town Hall.

ported by four massive columns. One attention-getting exhibit in 1990 was a case in point: the museum mounted a searching look at Delaware's early record in civil rights.

The organization of the Historical Society of Delaware was, indeed, contemporary with the Civil War, occurring in those late spring days of 1864 when the armies of Lee and Grant were locked in stupendous battles down in Virginia. The hour might seem a curious one to be organizing a historical society, but patriotic Delawareans wanted to preserve the relics of the war into which they had been plunged. Delaware had certainly been in no rush to get around to it, compared to other original states like neighboring Pennsylvania, which unveiled its society in 1824. The modern explanation is that Delaware was still a rural society in the main, and its only city, Wilmington, lagged behind nearby Philadelphia, which was the economic and intellectual powerhouse of the region.

In any case, the new organization soon received its first gift, a piece of the boat in which Washington crossed the Delaware, presented by William Bringhurst. The museum's artifact accessions in its early years ran toward historical curios from heroes of the Revolutionary and Civil wars. Most of the emphasis was on building a

library collection of manuscripts and books, staging lectures, and launching a publications program. Such collecting reflects a period of time when history was primarily a literary endeavor.

The young Historical Society struggled for generations to find adequate quarters. Its first home was a rented room in the Wilmington Institute. Then it rented quarters in the Masonic Temple from 1872 to 1878, whereupon it leased Wilmington's old First Presbyterian Church. The church, outgrown by its congregation, was a delightful gambrel-roofed structure dating from 1740. The move seemed to presage better days for the society, and a local newspaper editorialist hoped "that a new and wider interest will be awakened in favor of the Society which for years has been nourished and gradually built up by the labors of a few. Our State is rich in history, but the memorials had been neglected too long and many gradually were lost or found their way to other places."

Gradual growth did occur in membership and in the collections, but when the society offered to buy the building, the Presbyterians were unwilling to sell. Certainly the lease, at $150 per year, was a bargain, but by the early twentieth century it was clear that the society needed a permanent home, where fragile documents could be properly cared for. The opportunity finally came in 1916 when the city of Wilmington put its historic Old Town Hall on the auction block. In what must have been a staggeringly steep price for the time, the society bought it for $90,517.

This triumph of virtue and good intentions brought a new challenge to the society. Despite World War I and the ensuing depression, wealthy Wilmingtonians—including Pierre S. du Pont, the squire of Longwood Gardens—raised the money to preserve and restore Old Town Hall. In 1928, the society moved into its new permanent home.

At last, acquisitions for a first-class museum collection could continue. The first was a Delaware battle flag captured by the British at the Battle of Brandywine. Also arriving in 1928 was the first significant object of Delaware-made furniture, a clock made by Wilmington's Samuel McClary. Its accession card bore one of the most distinguished donor names in antiques collecting: Henry Francis du Pont, the guiding light of Winterthur. With the 1958 gift of the H. Gregg Danby collection of furniture, the museum's decorative-arts collection reached a new plateau.

Displayed on the main upper gallery where once Wilmington's burgesses gathered, the permanent collection now includes pieces that would be coveted by any museum of decorative arts. Consider one mid-eighteenth-century tall clock, exceptional not only for George Crow's supernal skill in making the works, but also because Crow, a resident of Wilmington, served as both burgess and high constable in the 1740s and 50s. The combination of craftsmanship and local color finds appealing continuity in another clock, whose works were made by George Crow's son, Thomas. The mahogany, rococo-cased production, by an unknown hand, is a tour de force, reflecting the highest Philadelphia style of the Revolutionary era.

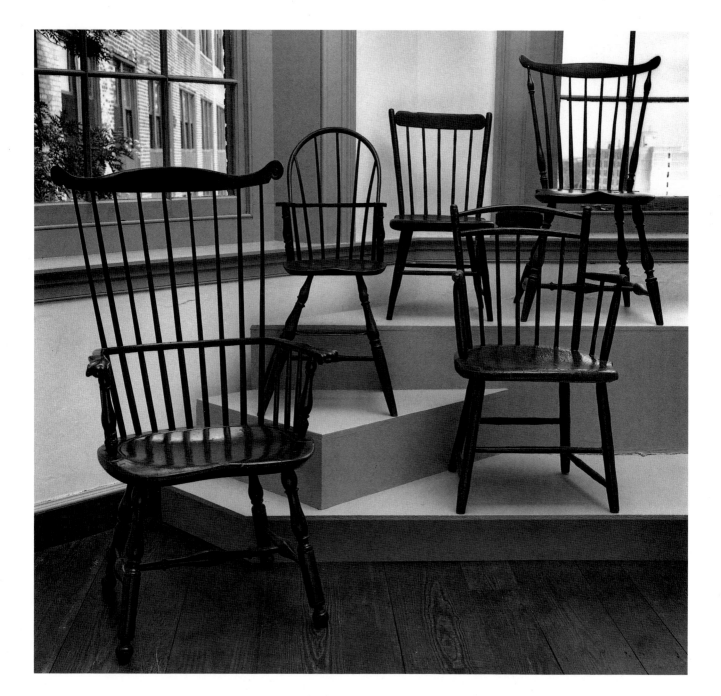

Windsor chairs, all made in Delaware, are in

the Historical Society's furniture collection.

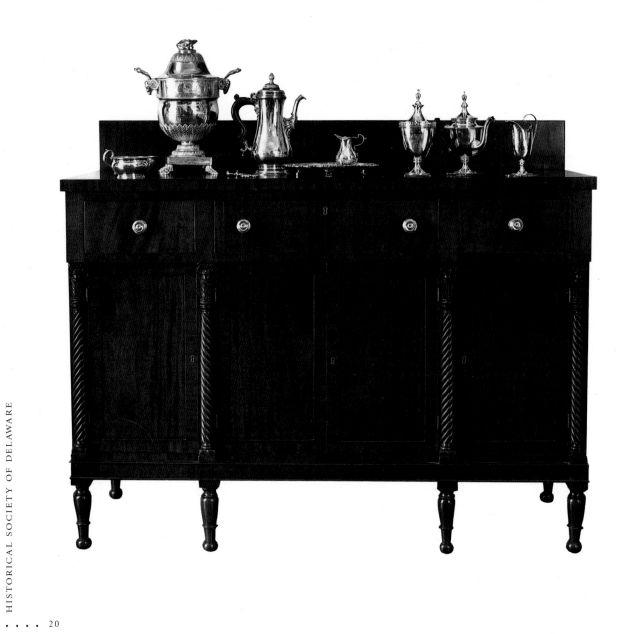

A bow desk used in Old Town Hall

in the Historical Society's furniture collection

This Delaware-made Empire sideboard dates

from 1822 and was made by James McDowell,

a Delaware cabinetmaker. It displays a selection

of silver from the collection.

Joseph Newlin, another Wilmington craftsman of perhaps equal talents, remains an enigma. But his place in Delaware furniture history is secure via one walnut desk and bookcase made late in the eighteenth century, one of only two pieces of his work known to survive. Skillful handling of its undulating drawers and reeded pilasters indicates that Newlin was an assured master craftsman, but about his life and other works, little is known.

Not so George Whitelock, whose grandfather was a pioneer Wilmington brewer, Isaac Whitelock. Around 1801, early in his career, George made the museum's splendid Hepplewhite sideboard after the design of another George, Hepplewhite's own *The Cabinetmaker & Upholsterer's Guide.* Such top Delaware craftsmen exhibited great skill, being members of a sophisticated fraternity alert to current European vogues. At least one London-trained master, Charles Trute, immigrated to Wilmington (via Jamaica and Philadelphia) and built pianofortes of high quality, of which the museum owns two. They were made between 1803 and 1807, a period when the versatile Trute was also keeping a tavern in Brandywine Hundred. We can hope he was half as good a publican as he was instrument maker.

Such are a few representative examples of the furniture collection. Of the other major decorative arts, silver is served strikingly well in the work of several first-class craftsmen who called Delaware home, and whose working careers coincided with the classical revival era of the late eighteenth and early nineteenth centuries, arguably the high-water mark of such bench-crafted American silver as the museum's tea service of three urn-shaped containers by Bancroft Woodcock and

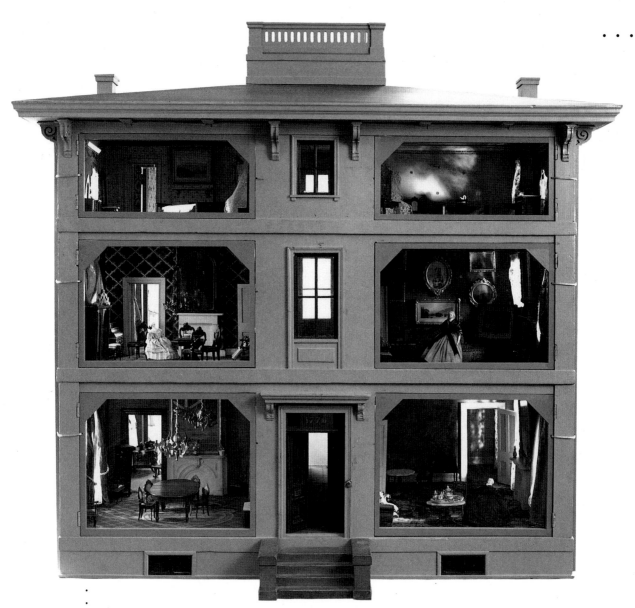

This Victorian mansion in miniature, 6 feet tall, retains the original curtains, upholstery, furnishings, and paintings that Philadelphia craftsmen installed in 1864.

Thomas Byrnes. Not only were these locally made, but they were handed down in the prominent McComb family of Wilmington. The artistry of Bancroft Woodcock shines in several choice objects in the permanent collection, and his history as a craftsman is linked intriguingly with other artisans in the Mid-Atlantic region. He was a friend of the silversmithing Richardson family of Philadelphia and teacher of various other future craftsmen, including his own son, Isaac. Isaac Woodcock's museum representation includes an excellent 1792 cream pot.

In the category of "relics and curiosities," established so long ago with that fragment of Washington's Delaware-crossing boat, the cigar-store Washington is rivaled today by a 6-foot-tall dollhouse. Created during the Civil War as the prize for a charitable fund-raising, the model house is a completely furnished time capsule of mid-Victoriana.

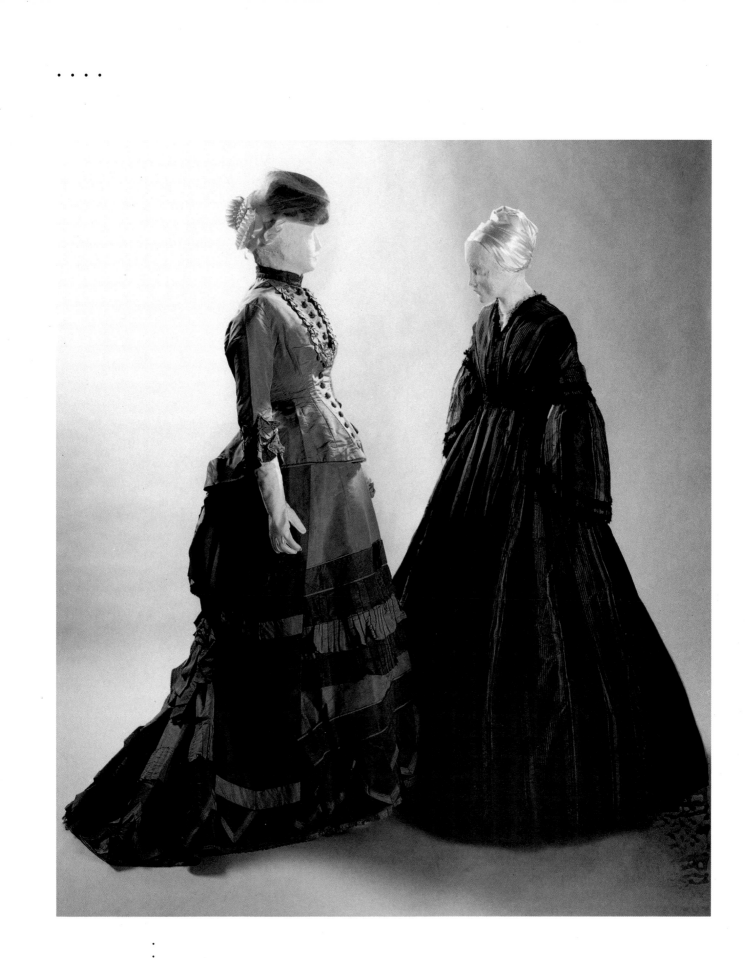

These gowns were worn by Delaware ladies in the 1860s and 1870s.

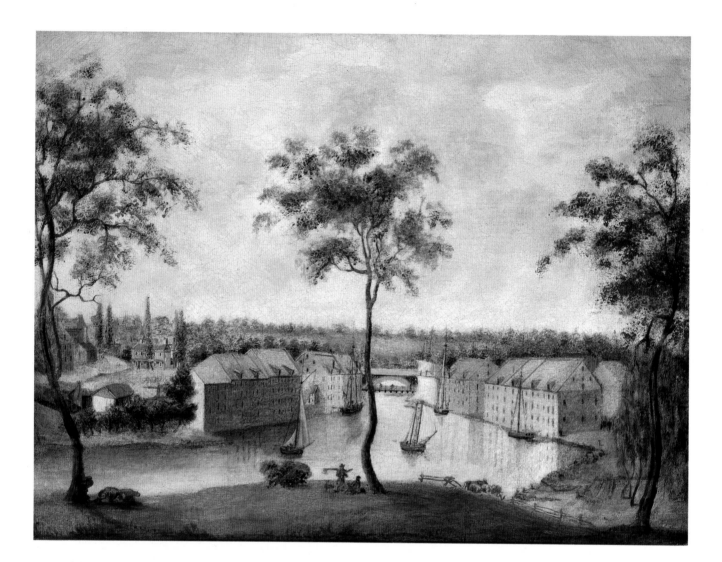

Bass Otis

Brandywine Mills, Wilmington, *c. 1840*

Oil on canvas

Courtesy Historical Society of Delaware

In this painting by William Clark,

the most remarkable feature may be

the view of an 18th-century Delaware

barn and stable complex.

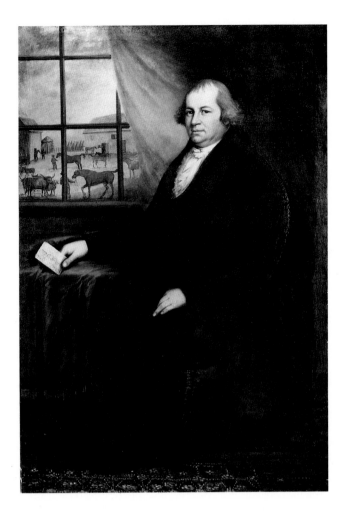

The society's picture collection includes a number of works that combine artistic merit and Delaware historical significance. A choice example is William Clarke's portrait of Captain William Frazer, done in 1798, the very year in which Old Town Hall was built. Frazer, a prosperous farmer and militia commander of New Castle County, is sitting by a window that overlooks his farmyard. What may be of more interest than Frazer's self-confident (if somewhat stolid) visage is the rare view of eighteenth-century Delaware farm life outside his window, a vignette including dependencies, farmhands, animals, and haystacks. It is a mine of anthropological information, and the only such view known to exist. In the same year, 1798, Clarke painted Frazer's wife at a delightfully capricious seaside, garbed in a colossal headdress.

Bass Otis was a peripatetic and highly competent artist who worked mostly in Philadelphia but settled in Wilmington from 1838 through 1840. Several of his portraits are here, as well as a cityscape called *Brandywine Mills*, fascinating for its historical image. Wilmington artists Alexander Charles Stuart and Jefferson David Chalfant are recalled in several works, as is Robert Shaw, who painted in Wilmington his entire career. The Historical Society owns a large selection of his work, including the romantic landscape *Fairy Glen*, the panoramic *New Castle from the River,* and the etching *Old Barley Mill.*

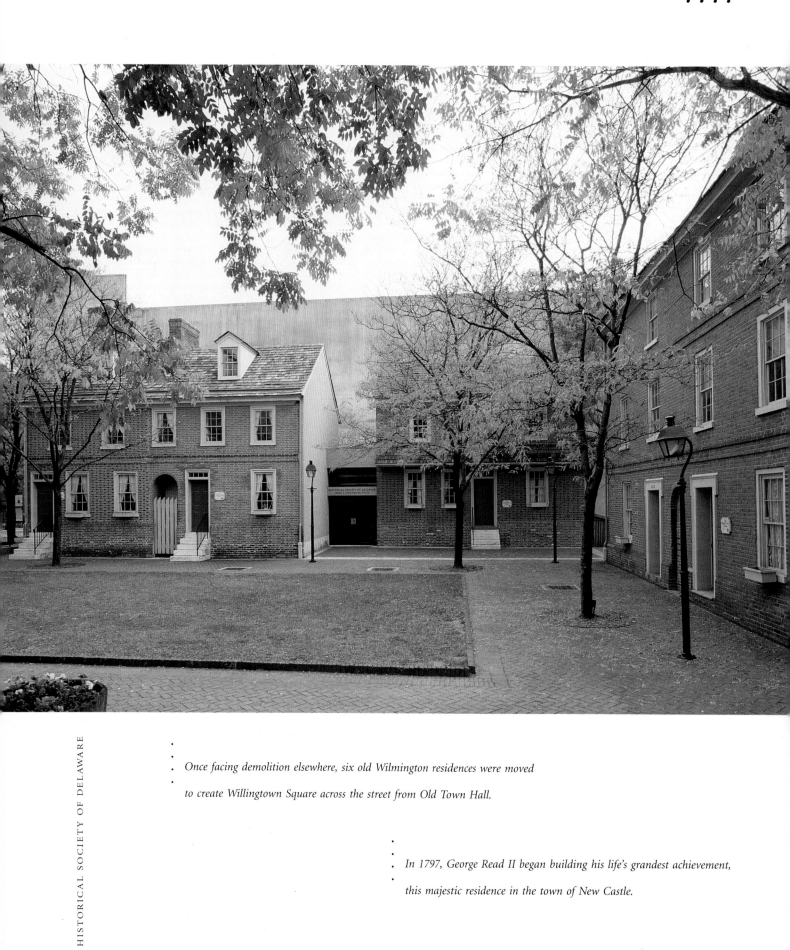

Once facing demolition elsewhere, six old Wilmington residences were moved

to create Willingtown Square across the street from Old Town Hall.

In 1797, George Read II began building his life's grandest achievement,

this majestic residence in the town of New Castle.

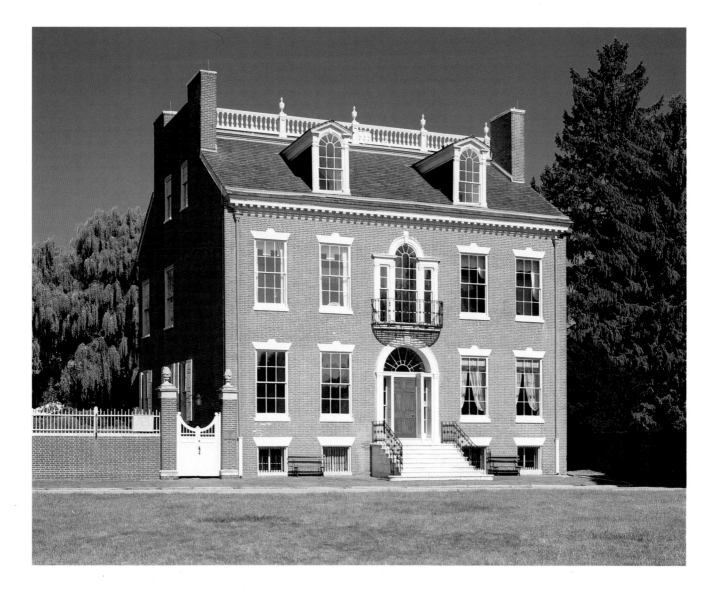

By the 1960s, it was obvious that the increasingly overcrowded Old Town Hall could not continue as sole shelter for the collections and the society's growing program of activities. The library and administrative offices moved first to nearby rented quarters. Then, in the early 1970s, the society bought and renovated the Art Deco Artisans Bank building, just across Market Street from Old Town Hall Museum.

That was only an introduction for dramatic developments of the 1970s. In cooperation with the city of Wilmington, six eighteenth-century Wilmington residences, all derelict and facing demolition, were moved to a plaza adjoining the new headquarters and reincarnated as Willingtown Square, named for Thomas Willing, the man who laid out the original town of Wilmington. Such a project would have taxed the resources of many larger historical societies, yet within a year the organization would accept another major challenge.

Since the beginning of the nineteenth century, the George Read II House had overlooked the broad Delaware River from the town of New Castle, 7 miles south of Wilmington. Owned by just three families since construction began in 1797, the

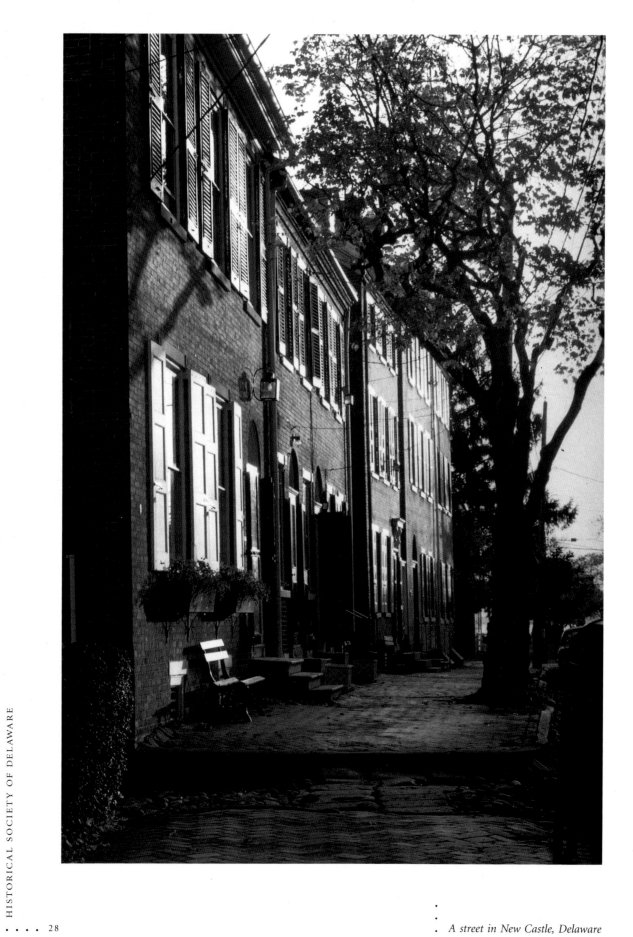

A street in New Castle, Delaware

majestic residence had survived relatively unchanged and in good condition. When the last private owner, Mrs. Philip D. Laird, died in 1975, she bequeathed the property and some of its furnishings to the Historical Society of Delaware.

The society was now the owner of one of the great houses of the United States, and it began plans for a restoration of maximum scholarship and quality. Work began on the exterior in 1978, and the interior in 1981. Careful cleaning revealed a beautifully uniform dark pink brick in perfect condition. Indoors, sophisticated paint analysis discovered the original paint colors, mahogany finishes, and stenciled ornaments. Clear outlines of missing plaster mantel ornaments magically reappeared, as did traces of gold leaf and faux wood graining. The researchers were helped along by the house's relatively serene, almost charmed life history.

The original paint colors had been covered by paper and were still there to be copied. The restorers weren't faced with multiple changes spanning one hundred eighty years. Things had either been altered by the Lairds in the 1920s or were original to the construction of the house. Moreover, the Historical Society had copious original records.

Indeed, if ever a historic mansion was ideally suited as a historical society project, it was the Read House. Already lodged in the society's library before the restoration began were 133 letters and 40 bills and contracts, all pertaining to the house's construction between 1797 and 1804. And the house was rich in historical and architectural significance. Not only was the Read House in the fascinating old town of New Castle but it was the home of George Read II, the scion of one of Delaware's most distinguished families.

The scenario's only faint letdown was this: George Read II never seemed to measure up to the stature of his father, who had been a signer of both the Declaration of Independence and the Constitution, United States senator, and Delaware chief justice, clearly a giant of eighteenth-century Delaware. George II had similar ambitions, but they never worked out.

But in building his great house, young Read (thirty-two when he began) created a masterpiece. In style, it is an early Federal town house, typical of contemporaneous Philadelphia fashion. It featured a raised basement, first and second stories with 13-foot ceilings, and a finished attic. So particular was young Read that he employed the Philadelphia plasterer who had done a ceiling for Congress Hall in 1793. Read went to painful, haggling extremes seeking perfection in such details as silver-plated door hardware, which had to be done without blemish before he was satisfied.

He installed a radically new hot-water vegetable cooker and meat roaster, both based on the plans of the adventurous Tory inventor Count Benjamin Rumford. Fortunately for posterity, the Rumford kitchen technology was superseded in about ten years, and by 1813 the fixtures were covered over by alterations, waiting to be rediscovered in the 1980s restoration. The dark, smudged artifacts were a sensation. Researchers have come from all over to study these extraordinary rarities.

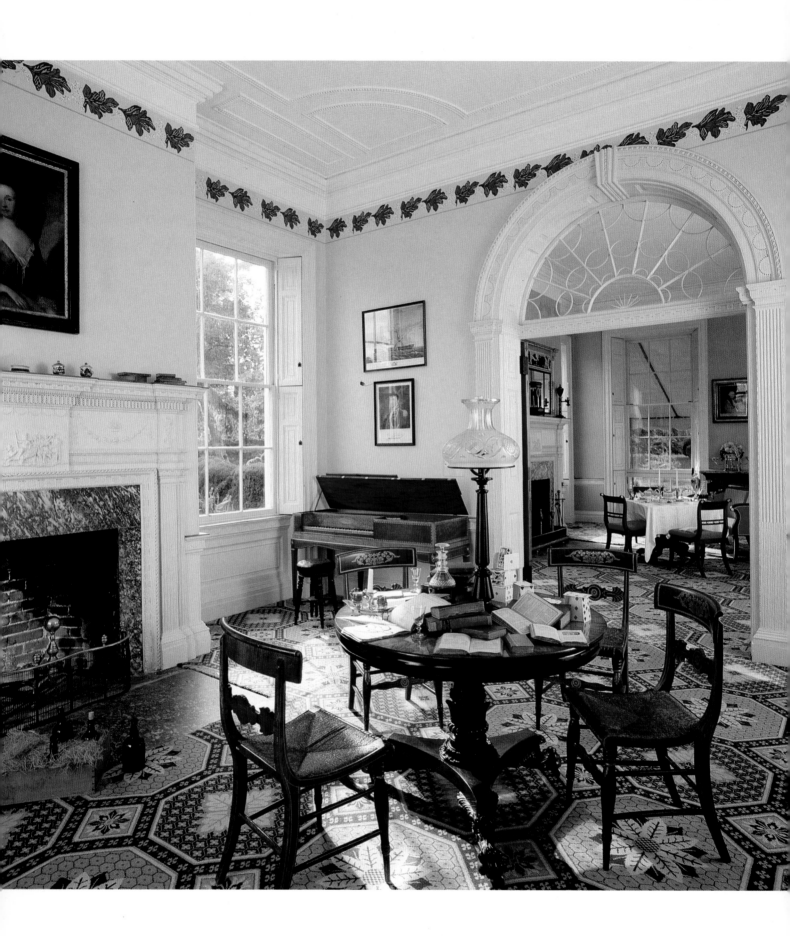

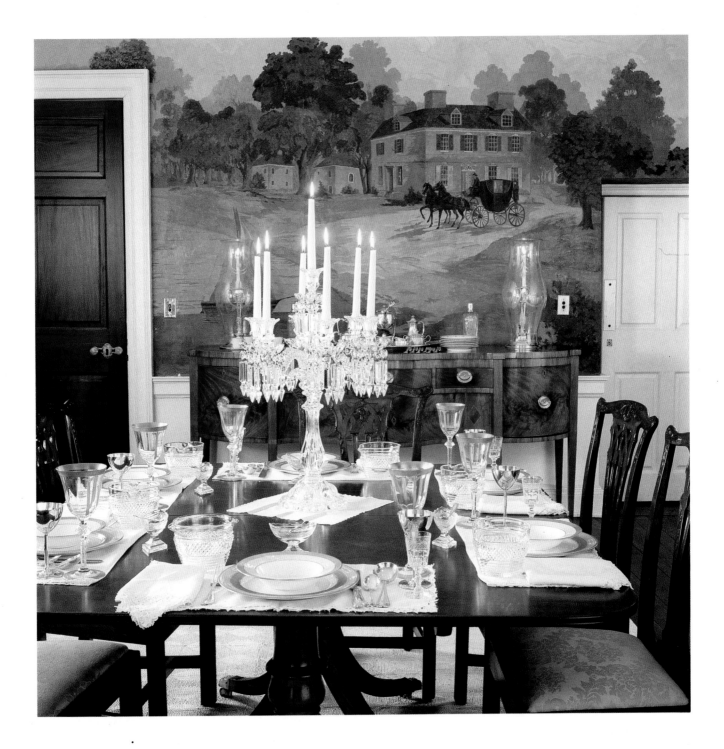

A neoclassical arch connects the front and back

parlors of the George Read II House.

Hand-painted wallpaper of the Read House

dining room dates from the Colonial Revival era.

To embellish his great mansion, George Read II employed a plasterer

who had worked on Philadelphia's Congress Hall.

Restoration of the interior revealed such authentic original shades as the lime green now covering the walls of the airy stairwell, which features a noble Palladian window at the landing. The most difficult restoration decisions concerned some early twentieth-century decorating touches added by the last private owners. Mr. and Mrs. Philip D. Laird's Colonial Revival decorating principles were done with such flair and integrity that the restorers decided to keep the dining room, master bedroom, and rumpus room as they were. It is a subtle and appealing salute to the Colonial Revival era, to which the Lairds made significant and trend-setting contributions. The dining room especially, with its commissioned hand-painted wallpaper of New Castle scenes, was a famous room in the 1920s and 30s, featured in the era's top decorating magazines.

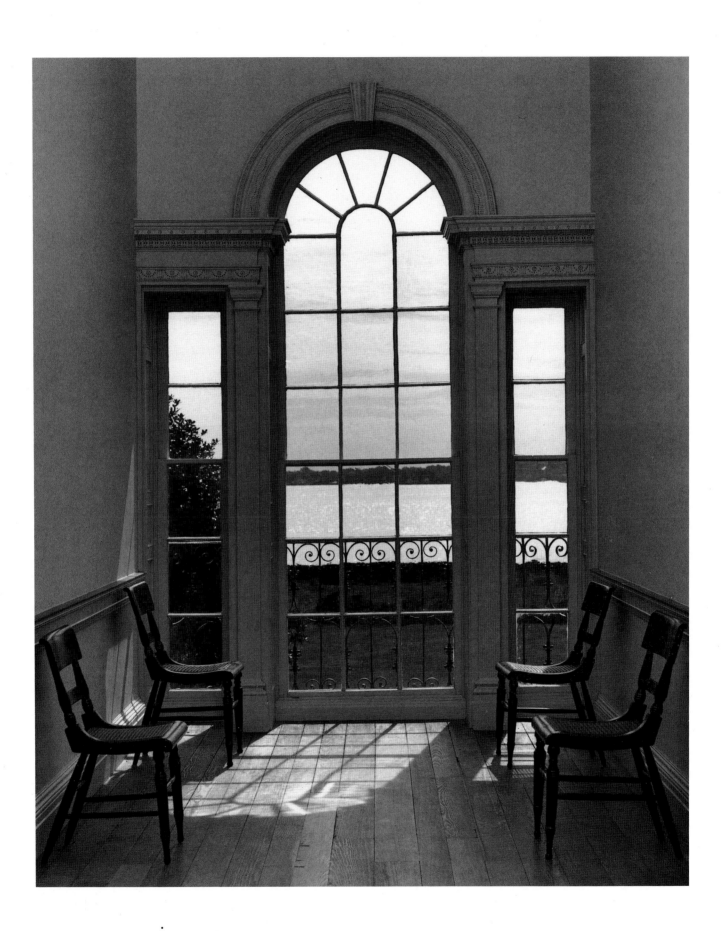

A second-story Palladian window overlooks the Delaware River from the upper hall.

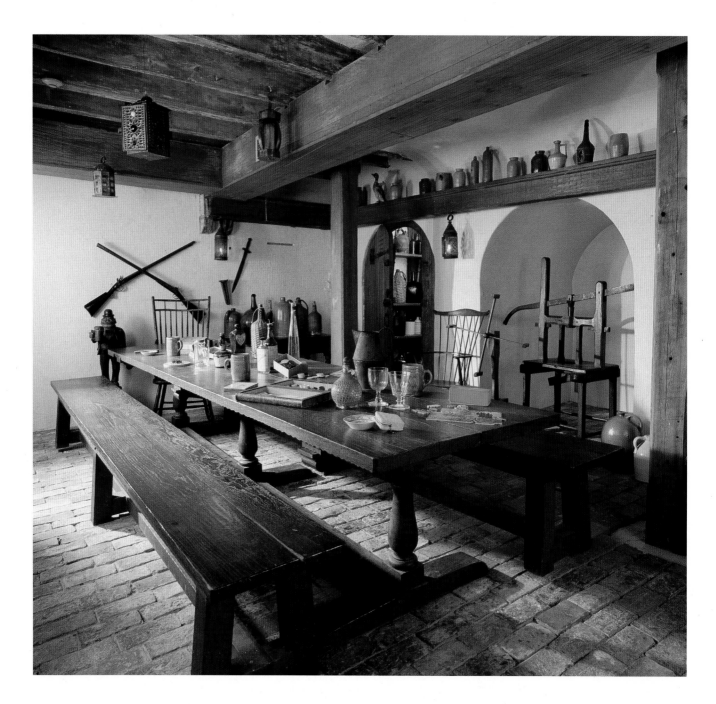

The Read House's tap room survives intact

from the era of Mr. and Mrs. Philip D. Laird.

Installed in the 1840s, the Read House garden

is attributed to Philadelphian Robert Buist.

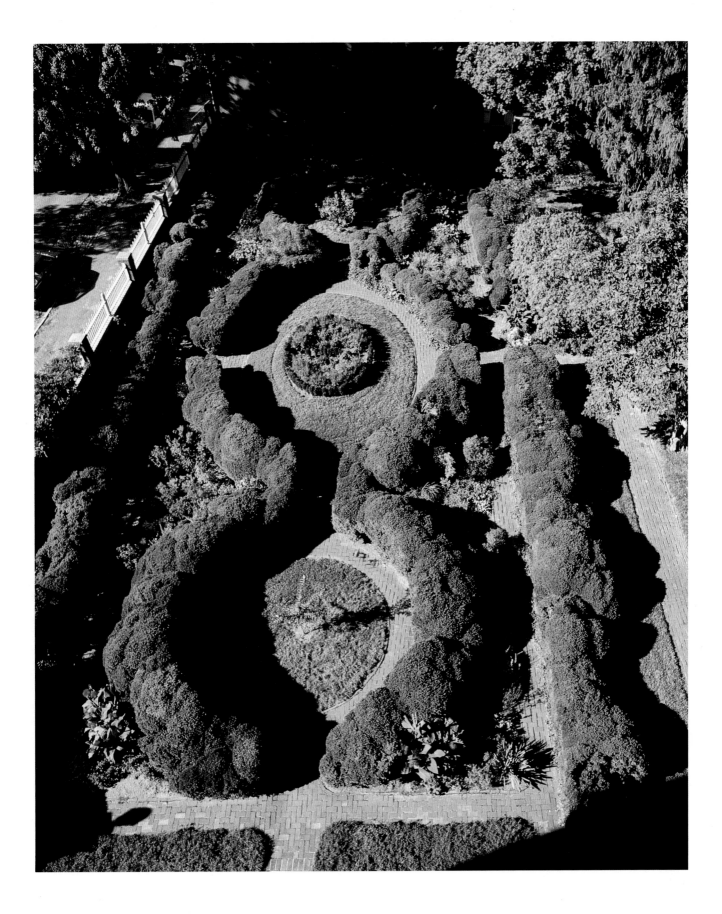

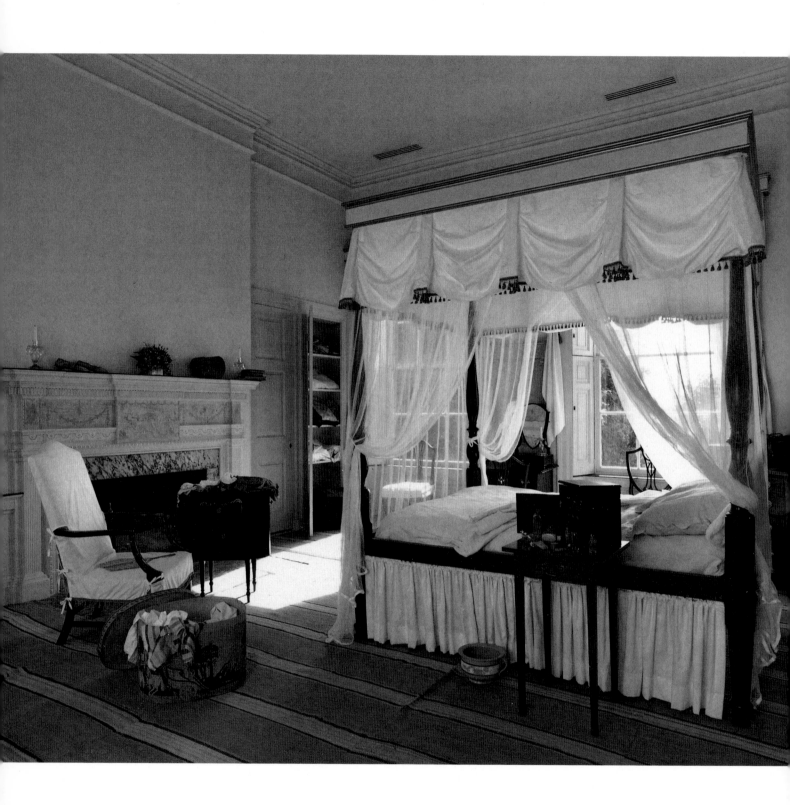

In recent years, the society's interpretation of the house to the visiting public has been marked by a similar but updated sophistication, with educational efforts centering around life-style or social history. Visitors may certainly learn something about the decorative arts, but that is not the main point. The house is always a lively study in social and fashion history. For example, the house was once in mourning, the coffin was laid out and the house was draped in black crepe. Another time, almost the entire interior was carefully prepared for a wedding.

The look of the house is changed regularly to follow the seasons as well. In summer, the beds are moved to the middle of the floor, as Delawareans once did to catch the breeze. Mosquito netting is unfurled, and the curtains are tied in summer knots.

One of the bonuses of the Read House is its lush gardens, installed by the second owner of the property, William Couper. Described as the merchant prince of New Castle, Couper grew up next door to the Read mansion and developed a veneration for the place. Having made his fortune in the China trade, Couper purchased the "old-fashioned" house in 1846 and changed virtually nothing. The grounds, however, were a different story. They were not in good condition and needed much work. The "new" garden design and installation are attributed to Robert Buist, the foremost nurseryman in Philadelphia at the time. The one and a half acres inside the garden wall were laid out in 1847 with formal flower beds enclosed in boxwood hedges and an informal, parklike specimen garden. The design also included formal fruit and vegetable sections. The garden has been featured, like the house, in national magazines and retains its original design.

The Read House is located on the Strand, the prime street of the atmosphere-drenched old town of New Castle, now a national landmark historic area. New Castle was Delaware's colonial and first state capital, and it remains much as it was in its eighteenth and early-nineteenth-century golden age. Ironically, one of the few significant losses—to fire, in 1824—was the home of the first George Read, a modest affair that stood next door to his son's grand residence. George II's other achievements may have been relative washouts when compared to those of his illustrious father, but his one great success in life, a house for the ages, has endured.

Mrs. Read's bedroom manifests the administrators' authentic use of fabrics.

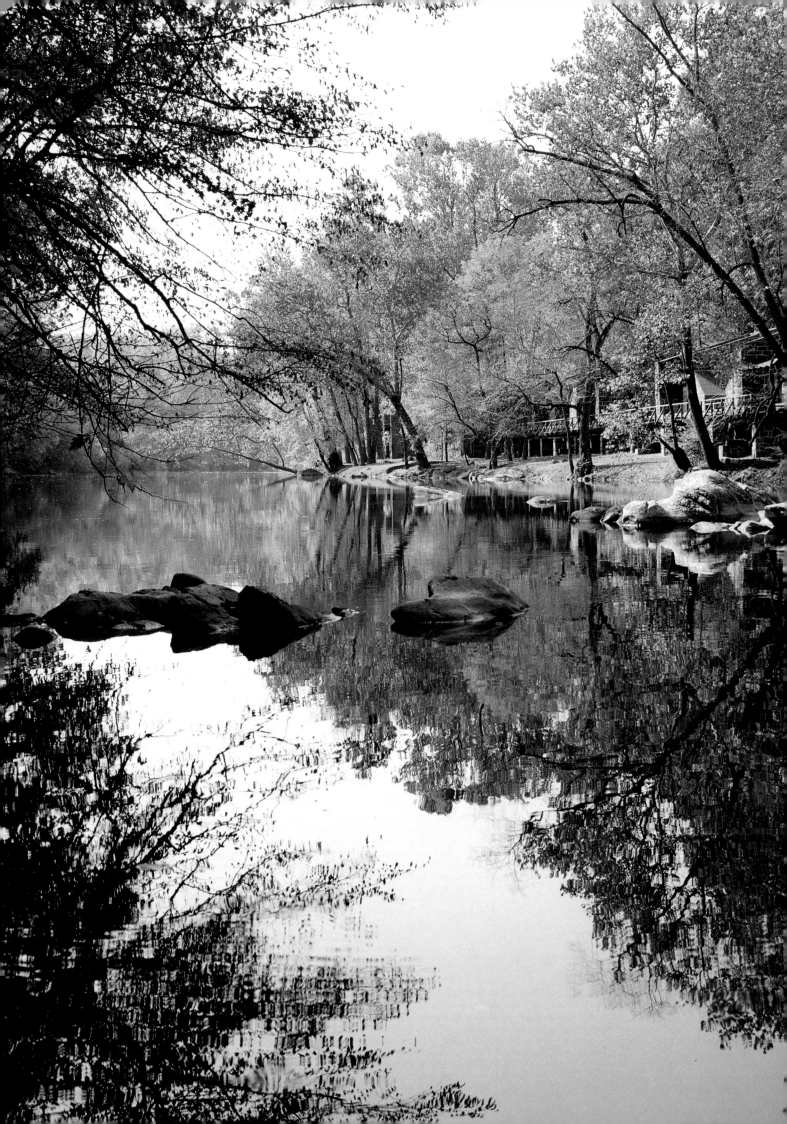

T·H·E

H·A·G·L·E·Y M·U·S·E·U·M

America's growing fascination with its industrial past conjures up complex and remote images, as if probing a group memory fixed forever in the nineteenth century, or studying the faces and scenes in 140-year-old daguerreotypes, spellbinding in their magnetism yet somehow just beyond the full reach of our understanding. We are dealing with potent subjects here, often paradoxical, depending somewhat on the focus. The images may portray or suggest mechanical and architectural ingenuity, individual opportunity, common material progress, and occasional great wealth. They may also reveal exploited workers, wasted resources, and formidable danger.

If we were to picture a factory scene that represented much of the best in American industrial history, we might imagine a place something like Hagley, a 240-acre site on the banks of the Brandywine near the northern edge of Wilmington. It seems almost too beautiful now, framed in enormous stately trees beside the chuckling, rocky river. At first view a visitor can hardly imagine that here was not only the beginning of the du Pont empire but one of the great industrial centers of the American colonies and early United States. Today it is a National Historic Landmark, and an independent, nonprofit educational institution.

The very smallness of the Brandywine, combined with its fairly rapid descent, made it an ideal source of waterpower. As early as 1651 the last Swedish governor of the Delaware colony, Johan Rising, mused that the Brandywine could support a variety of mills, and the most profitable of all—he said with a definite touch of precognition—would be a powder mill. But the Swedes gave way to the Dutch, who gave way to the British, and the first millers, bearing English names, made flour.

The largest were clustered near Wilmington (founded in 1731 by Thomas Willing), and the industry prospered and grew throughout the second half of the

eighteenth century. Brandywine flour became a world export, famous for its whiteness and purity from Boston to Calcutta. Meantime, mills of other types—cotton, paper, linseed oil, snuff, bark for tanyards—also found the Brandywine a faithful and manageable source of power. It was not difficult to dam the stream, construct millraces and sluice gates, and set massive wooden wheels in the path of rushing waters.

By the turn of the nineteenth century, industry on the Brandywine at and above Wilmington was a long-going concern, and its advantages obvious to young Eleuthère Irénée du Pont. Yet industry was a second choice of careers for the du Pont family, which reached the United States on New Year's Day of 1800. Thirteen in all, they were led by a true patriarch, the French economist and physiocrat Pierre Samuel du Pont de Nemours. A friend of Thomas Jefferson, Pierre had been an important figure in prerevolutionary France and in the early years of the revolutionary government. He broke with its increasingly radical leaders and emigrated, hoping in the new United States to give free reign to his physiocratic ideas. That dogmatic school of economics held that all wealth began with the land, agriculture alone could expand wealth, and industry and commerce were relatively sterile fields. Pierre's dream was to establish a rural dominion to prove the theory and support his family; but none of it worked out. The du Ponts' salvation proved to be son Irénée's prior experience as an apprentice to the French chemist (and guillotine victim) Antoine Lavoisier, learning to make gunpowder. In consummate irony, Irénée's very success at manufacturing would help demolish the physiocratic doctrine, soon to be as dead as belief in a flat earth. But the opportunity to enjoy America's industrial dawn apparently held scant allure for father Pierre. He returned to Napoleonic France in 1802 and helped President Thomas Jefferson negotiate the Louisiana Purchase. He would return to the United States, however, in 1815, and live two more years.

In April 1802, after searching in five states for suitable sites, Irénée bought 65 acres on the Brandywine, a tract that already had supported a cotton mill and a sawmill. The site was perfect. It had ample waterpower for powder mills and willow trees to make charcoal, a key gunpowder ingredient. Saltpeter and sulphur, the other necessities, could be shipped in easily. A final selling point was that the area's substantial community of French émigrés offered a comforting ethnic familiarity. Irénée immediately began building a powder mill and, just above it on a low but steep hill, a house for himself, his wife, Sophie, and their three children.

Page 38. *The Brandywine is at its scenic best at Hagley,*

where the river powered the beginning of the Du Pont empire.

Irénée had a clear vision of his future master plan for managing this enterprise. The house, he wrote, "should be situated on the highest elevation of the property and in one of the angles of the factory confines in such a way that the windows may overlook the entire factory area, and the exterior factory gate may be placed beside this house."

The house was completed in 1803, its design and construction supervised by Peter Bauduy, an émigré from Santo Domingo. Large and of pleasing proportions, the house was neither innovative nor even au courant; it was a stuccoed (over stone) Georgian echo of the eighteenth century, with two stories and a dormered attic, and four massive chimneys. Meanwhile, below the house on the stream bank, construction was completed on the first powder mill. It was a strange-looking structure with massive stone walls on the front and sides, but at the rear—facing the stream—was a low wooden back wall and sharply raked roof, a profile designed to minimize the main force of an accidental explosion by directing it over the water and away from other buildings. It was an oddly modernistic-looking shape that would be repeated in all du Pont's Brandywine gunpowder mills.

Thus began du Pont's industrial activities. So integrated were house and factory that the entire property was called Eleutherian Mills (after the founder's first name). Yet as the powder-mill wheels started grinding, du Pont was launching complex agricultural ventures. A massive stone barn was erected simultaneously with the house. Lying between them was a 2-acre garden, which he designed in French Renaissance style, brimming with vegetables, flowers, herbs, berry bushes, and bordered by espaliered fruit trees. Irénée du Pont was as enthusiastic a gardener as he was an industrialist. He identified himself as "botaniste" on his passport.

An endless parade of visitors, and Irénée's large family (he and wife would have a total of seven children), generated a cosmopolitan, upbeat atmosphere. Rarely has the life of a house been documented as thoroughly, and delightfully, as that of Eleutherian Mills, which was sketched and painted from 1806 onward. Old Pierre himself got into the act with a detailed floor plan in 1816. Irénée's daughters produced a long-running cartoon treatment called "Scenes on the Tancopanican," proto-comic book in form, based on home life along the Brandywine. These delightful episodes not only provide views of how things looked but priceless insights into the humor and erudition of the family, which sparkled through even the homeliest domestic situations. Surviving letters and accounts document the furniture, paint, wallpaper, and carpeting that was added through the years.

It was Irénée's good fortune to begin making a high-grade explosive just as the demand for it was accelerating. Beyond the need for gunpowder by the military and by civilian armies of westbound pioneers, huge engineering enterprises beckoned on the nineteenth-century horizon, demanding powder to blast highways, canals, railway tunnels, mines, and stumps from fields. By 1813 du Pont needed to expand,

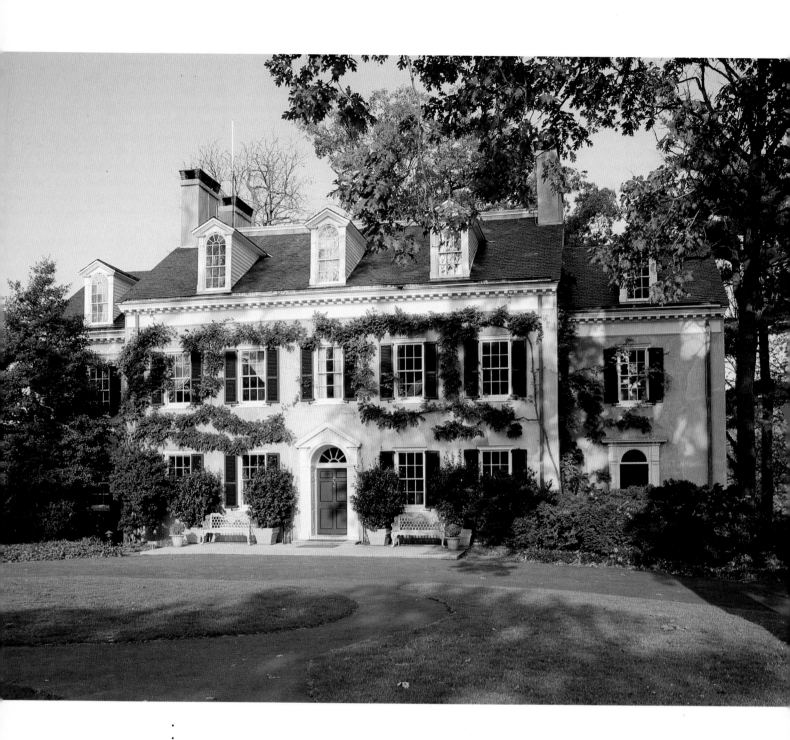

Eleuthère Irénée du Pont completed his house

overlooking the Brandywine in 1803.

Original Du Pont gunpowder mills were designed

to minimize destruction from accidental explosions.

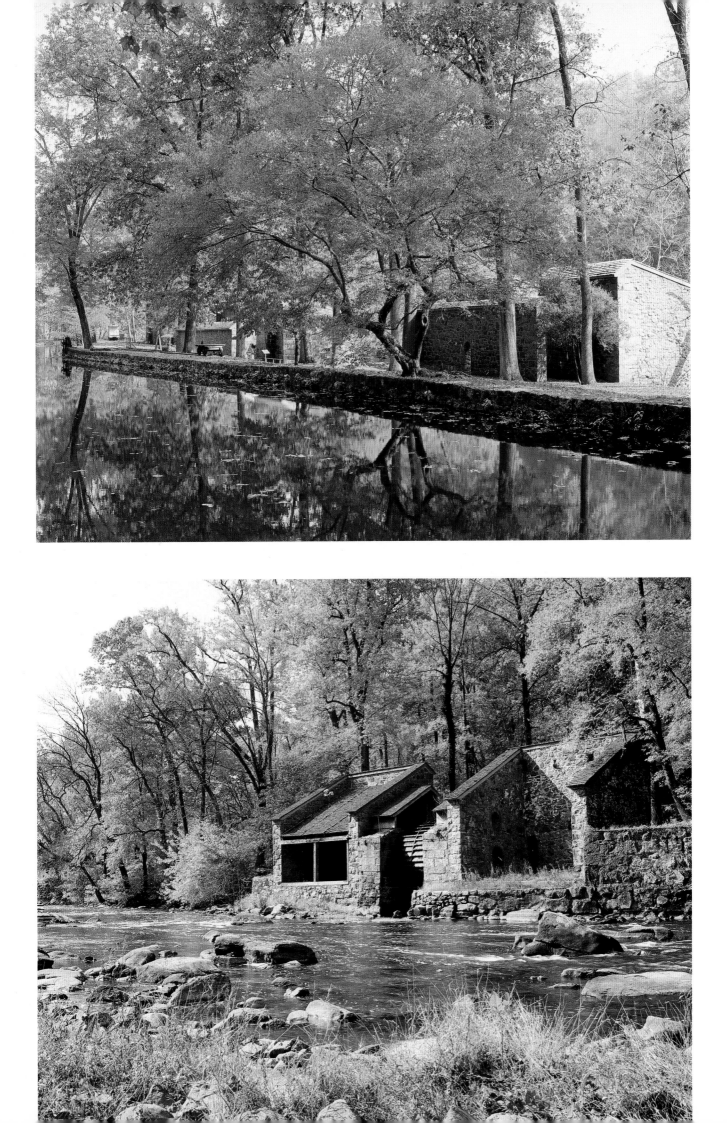

and he bought the adjoining downstream property. Called Hagley by an earlier owner (probably for England's Hagley Park, an estate of noted beauty), it was considered the most improved grounds on the Brandywine, containing a fine mansion as well as a sawmill, flour mill, and iron-slitting mill.

Irénée died on a Philadelphia business trip in 1834 at age sixty-two. His son Henry became head of the factory and master of the house in 1850. His year of accession was punctuated by a severe explosion in the mill. Periodic detonations from the riverside were part of life at Eleutherian Mills since the first one in 1807. Some, like the blast of 1847, were so violent that the house was badly damaged, and by 1853 it required major repairs. Henry made some additions and alterations at the same time, adding wings and raising the roof, yet the fundamental character of the house was unchanged. Another big blast struck in 1861 and blew out most of the windows and a dozen doors, shattering plaster and breaking glassware and china. In 1890 came an explosion so destructive—it was felt in Philadelphia—that the family finally moved. Three years later, the residence became a clubhouse for Du Pont workmen.

By 1921 it was in poor repair again, coinciding with a momentous event. After almost 120 years, the du Ponts ended their manufacture of black powder along the Brandywine. No more would the danger of frightening explosions hang over Eleutherian Mills. It was time for a du Pont to return to the old house, and Henry A. du Pont, one of Irénée's grandsons, bought it for his daughter, Louise Evelina du Pont Crowninshield. The transaction led to one phase of a remarkable brother-and-sister act in the world of antiques and historic preservation.

For Louise was the sister of Henry Francis du Pont, and both had grown up at nearby Winterthur, where Henry would remain to build the world's finest collection of American antique furnishings. In 1900, Louise married Francis Crowninshield of Boston; yet she retained close ties to the Brandywine, returning often to visit her father at Winterthur. Now she would spend two months of each year as the doyenne of Eleutherian Mills. She was devoted to preserving the family home, and she had the taste and drive of a born collector. She was, by all accounts, a warm and hospitable hostess whose flower-filled rooms radiated a sense of comfort and welcome.

Today, the house's main floor and basement, or terrace level, remain essentially as she left them. The mood is that of a lived-in home, not a museum. Her taste in American furniture—displayed in the wide center hall, rose and green parlor, informal smoking room, French scenic papered dining room, and morning room— ran mostly to a comfortable blend of northeastern American Queen Anne, Chippendale, Federal, and Empire styles. Her enthusiasm for colorful hooked rugs created warmth and informality everywhere. A grouping of rare locomotive lithographs from the 1850s accents the morning room. The entire production is gathered together by a sprinkling of du Pont family antiques, such as a graceful French rococo wine jug of 1783, originally owned by Pierre Samuel du Pont.

On a lower ground level, the terrace room is unchanged from its days as Mrs. Crowninshield's favorite setting for luncheon gatherings. The slate floor, big country fireplace, and collections of pewter and rustic cooking utensils still exude a sense of warmth and welcome; indeed, each New Year's Eve the room does welcome a traditional get-together of du Pont family members.

The second-story rooms have been furnished as period rooms with family pieces to represent the five generations of du Pont habitation. Oil portraits of various family members add the dimension of human personality. In a light and graceful room reflecting the childhood of Irénée's daughters is a grouping that captures much of the house's character with its interaction of first-class antique furniture, family memorabilia, and historic minutiae. Here, as if awaiting their owner, is a pair of gloves worn by a sister to an 1824 ball for General Lafayette. On a mahogany worktable from the shop of Duncan Phyfe is an unfinished watercolor of the Hagley granite quarry, from which came much of the du Pont building material.

The adjoining Blue Room is furnished with objects owned by Irénée or otherwise used at Eleutherian Mills. They include a Philadelphia-made desk, a Windsor chair made by a Wilmington craftsman, and a portrait of Irénée's youngest daughter, Sophie Madeleine, by Rembrandt Peale. Past a toy-stocked nursery, in the bedroom of Irénée and his wife, the canopied mahogany bed is believed to be one bought from its Philadelphia maker before 1810. Across it, the curators sometimes casually display E. I.'s leather breeches and a cotton shirt. On the wall hangs an important 1840 painting of the mills by Bass Otis.

The library's decor is the most modern in the house, reflecting the ethos of the middle and late nineteenth century. It also recalls one of the family's most famous members, Admiral Samuel Francis Du Pont, who brought back some of the room's oriental furniture on a naval voyage to Japan, China, and India before the Civil War. He was noted for his military career, which ended in some controversy in 1863 after his failure to take Charleston by sea, and for a personal idiosyncrasy. He was the first—and perhaps the only—du Pont to capitalize the "d" in the family name.

Louise Crowninshield deserves all her many accolades for restoring her great-grandfather's house. But her husband, Francis, also participated in the Eleutherian Mills renaissance in a highly creative way. It was he who designed the classical garden at the foot of the hill, beside the Brandywine, incorporating ruins of the original powder-mill structures.

Eleuthère Irénée du Pont ran the business from a desk in his home and by shouting orders through a megaphone from his porch to the mills below. But in 1837 a separate office was built within hailing distance of the family front door. This small stone building, exactly 28 feet square, would be the epicenter of Du Pont's powder-making enterprise until 1891. Today its restoration recalls the 1850s and the presi-

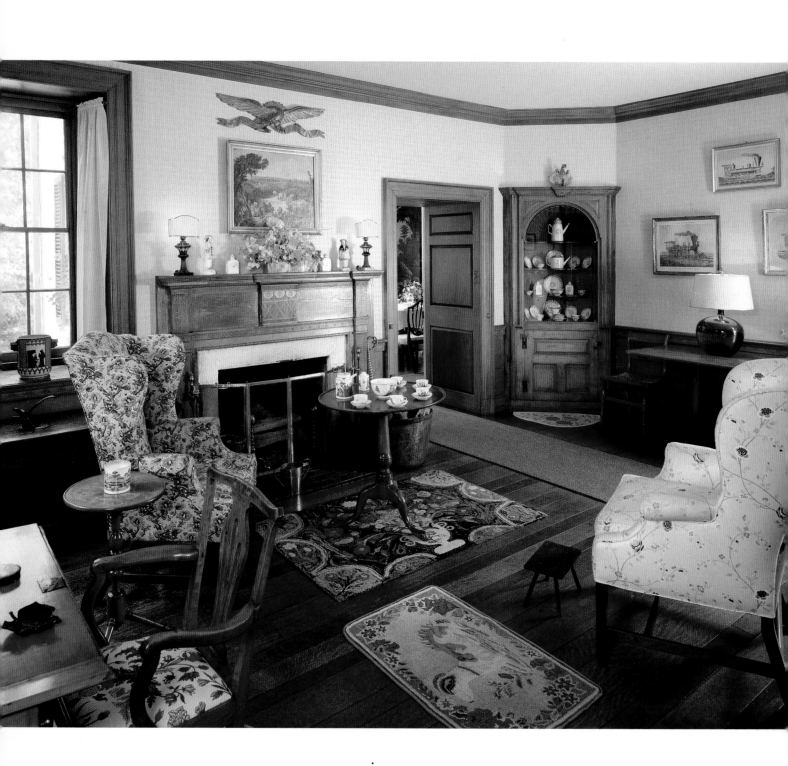

The main floor parlor at Eleutherian Mills still reflects

the decorating taste of Louise du Pont Crowninshield.

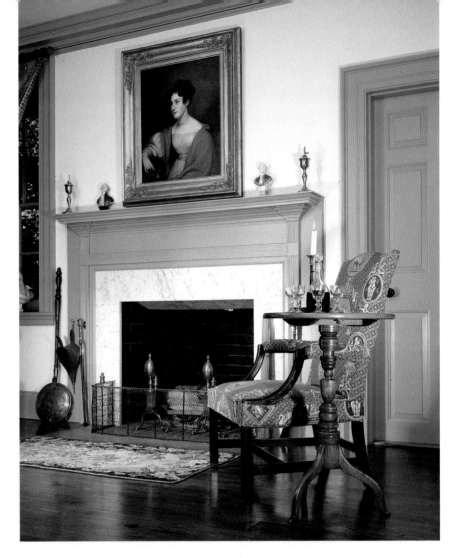

•
•
•
•
Eleutherian Mills' "blue room"
contains some of E. I. du Pont's
own furniture; the rest is of
the same period.

•
•
•
E. I. du Pont's bedroom looks much
as it did early in the 19th century.

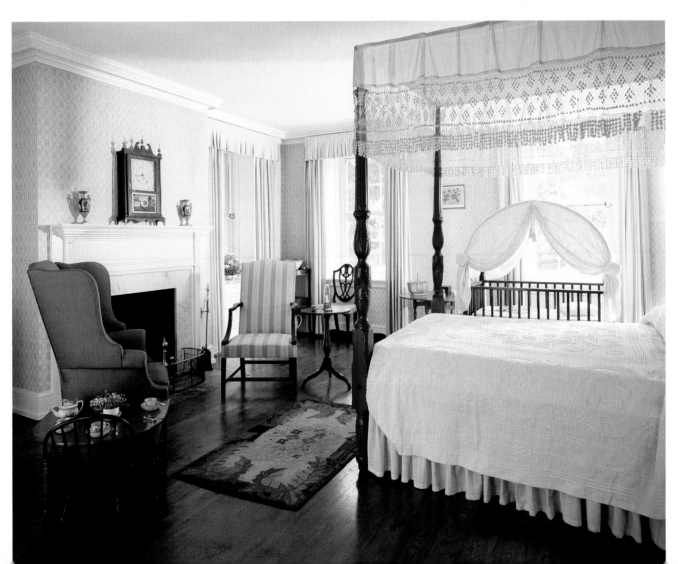

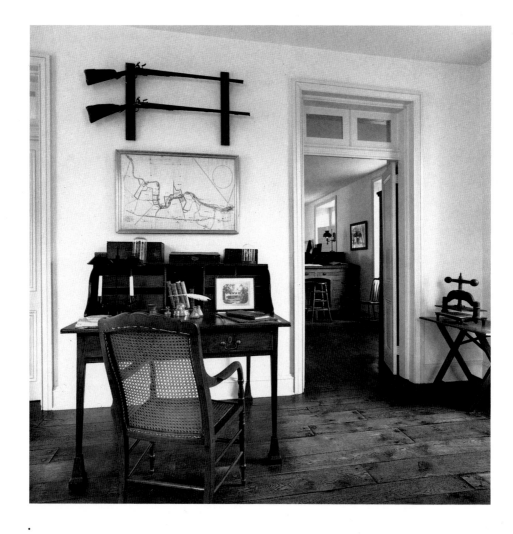

.
.
. *The first Du Pont office, built in 1837, stands close to the family home.*
.

dency of Henry du Pont, son of Irénée. His office retains some of his furniture. A daybook on Henry's desk is opened to a long-passed day, and nearby an early telegraph receiver recalls that the Du Pont office was linked with the outside world by wire in 1855.

Irénée's garden of vegetables, fruit, flowers, and ornamentals fronts both house and office. It was recorded in accurate and loving detail, beginning in 1804, and its gradual subsequent changes were well documented. By the late nineteenth century the garden had evolved considerably, but in recent years—armed with the written evidence and archaeological study—it was returned to its original state.

The great stone barn, also overlooking the garden, embodies all the original structure built by Irénée and additions from the 1840s. Even here, substantially protected from the menace of explosion by the hill's brow, the barn was heavily buttressed and bunkered for protection. The structure had a long and busy life, for each generation of du Ponts seemed nearly as interested in agriculture as in manufacturing. The family quickly expanded its land holdings, raising a variety of crops and breeding flocks of beef cattle, horses, and sheep, the latter originating with a prize Merino ram bought by Irénée. Today the barn shelters a collection of antique vehicles, all bearing some du Pont connection, like the stately blue Conestoga wagon representative of basic freight wagons of the period. A glittering red and black Du Pont explosives wagon sits beside a selection of carts, buggies, and cutters that seem charmingly naive by comparison. The du Ponts' taste for the best of every era shows itself in an immaculate 1911 Detroit Electric car, towering and dignified, displayed as for a shooting picnic with baskets, shotguns, and plenty of Du Pont ammunition. And the du Ponts did not always content themselves with buying the luxury cars of other manufacturers: from 1920 to 1932, they could buy one with the du Pont name on it. Built in Moore, Pennsylvania, by E. Paul du Pont, production totaled only 537. They were first-class autos, and one of the best—the personal car of E. Paul himself—is here in the barn. The 1928 four-door convertible's tan fabric top played a role in industrial history. In 1950 Du Pont Orlon was placed on the car during that product's experimental stage; now, Orlon is extinct but the top endures.

A harbinger of the Du Pont company's future in such synthetic products stands in a small wooden building across the garden. The Lammot du Pont workshop, built around 1850, was the laboratory of "our chemist," as his uncle Henry referred to young Lammot when he joined the company in 1850. Lammot, fresh from the University of Pennsylvania with a degree in chemistry, went on to a successful and creative career, with a special expertise in nitroglycerine, an explosive that led the way out of the black-powder age.

But the black-powder age is what is recalled at the Hagley Yard, where Irénée made the first expansion of Du Pont's long history. Of the stone powder mills he built by the Brandywine, twenty-three remain, as well as more than a dozen other early industrial structures. Thus it is possible to imagine how the manufacturing area looked at its peak during the Civil War, when some two hundred and fifty employees worked here.

The 1860s were indeed the apogee of black powder, although in those days—and for the prior five hundred years or so—it was called, simply, "gunpowder." Etymologically, "black powder" is a fairly recent term, arising after the late nineteenth-century development of "smokeless powder," based on nitrocellulose. That totally different product quickly took over most of the functions of gunpowder and rendered it obsolete.

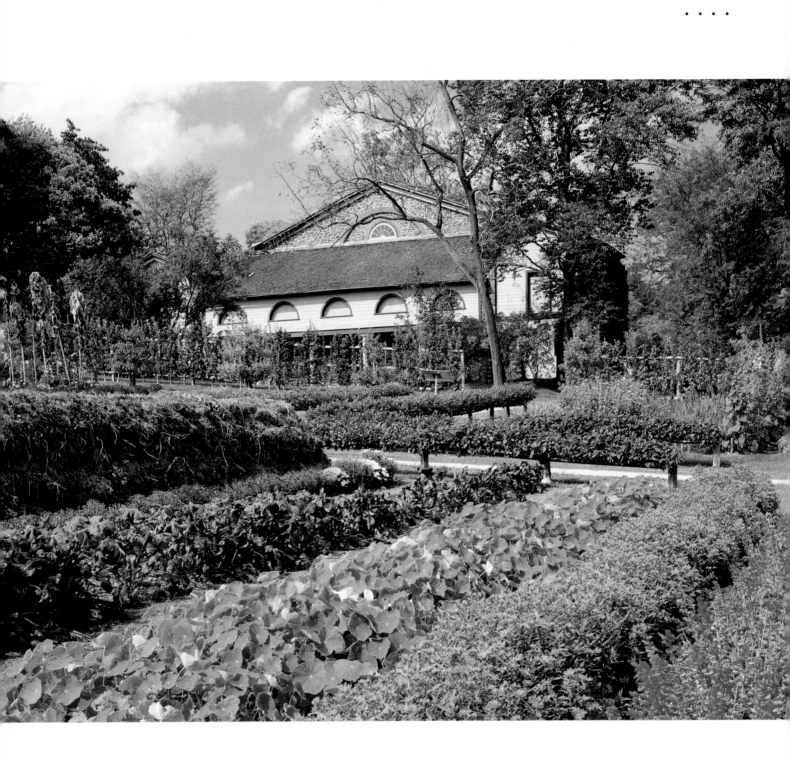

E. I. du Pont, who described himself as a botaniste, laid out this 2-acre garden and erected the massive stone barn beyond.

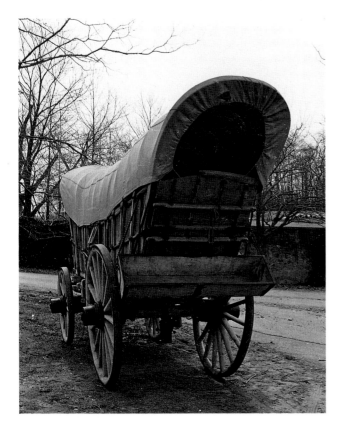

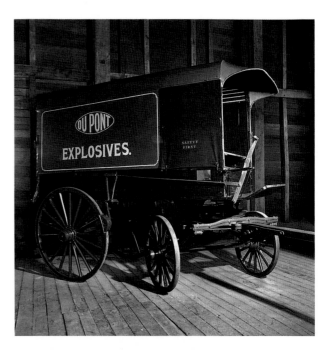

The collection of vintage vehicles includes
this rare original Conestoga wagon.

This Du Pont powder wagon was retired long
ago to the safety of the Eleutherian Mills barn.

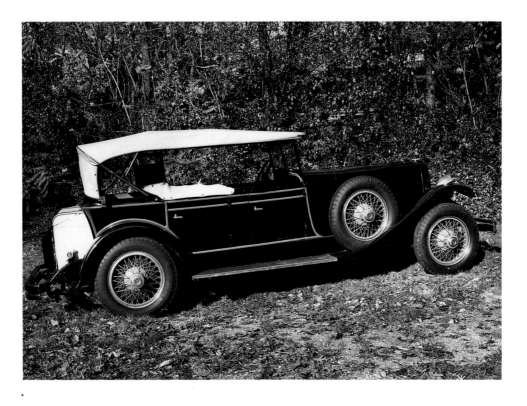

E. Paul du Pont built excellent autos, like this
model at Hagley—and not very many of them.

In its long life, black powder was an extraordinarily useful and lethal concoction. Known to the Chinese, its probable inventors, as early as the ninth century, it reached Europe in the thirteenth or fourteenth century. This mixture of potassium nitrate (saltpeter), carbon (charcoal), and sulphur is not terribly difficult to make; but it is highly dangerous. As we have seen, a frightening series of accidental blasts occurred in the powder yard, despite the specialized construction of the mills with their 3-foot-thick granite walls on three sides, and lightweight roof and rear, coupled with rigorous safety practices and specialized tools. The record shows that 228 fatalities occurred in the nearly 120 years that Du Pont made gunpowder on the Brandywine. Of the three ingredients, only charcoal was made locally. Willow branches, gathered from the property and burned in a controlled fire, were the usual source. Saltpeter and sulphur, imported respectively from India and Sicily, required fairly complex refinement on the site. Then the components were conveyed to the roll mills in wooden barrels on wooden carts. The carts had iron wheels, so they rolled on a system of wooden rails close to the mill buildings to avoid making sparks.

Today, one of the original roll mills remains fully equipped with the ponderous machinery that rolled—or mixed—the gunpowder ingredients. Two gigantic cast-iron wheels, churning majestically in a big bowl, mix 600 pounds of powder at a time. Such a quantity of powder was clearly a force to be reckoned with: according to nineteenth-century quality standards, one ounce of black powder had to be capable of sending a 24-pound cannon ball a distance of 250 yards.

The power system that drove these mills is still in perfect working order, a spectral survivor of pre-Civil War technology. Visitors to the site may see how it worked, via regular demonstrations conducted by staff members who are often retired engineers with profound understanding of the machinery and its history. The water of the Brandywine was tapped by a series of dams and sent in a millrace down the front side of the row of riverbank mills. In front of each mill was a giant valve, or gate, that diverted water into a rapidly descending sluice. In the early days, the water turned a simple waterwheel, such as the 16-foot breastwheel still in place at the Birkenhead Mill, one of the original thirty-three powder mills. In the 1840s, however, a new and substantially more efficient kind of power drive arrived: the turbine.

At the Eagle, the only fully equipped roll mill of the remaining twenty-three, a power demonstration begins at the gate valve. Turning a large iron spoked wheel resembling a ship's wheel, the staff engineer activates a rack and pinion. Water booms and hisses to a counterpoint of metallic clanks and echoes as the turbine goes to work. The engineer explains that the turbine is fundamentally a waterwheel turned on its side and fully encased so that the water's full power is directed and used, with nothing spilled. One 30-inch turbine could do the work of two 16-foot waterwheels. Visitors watch enthralled as ancient ring gears above the turbine spin

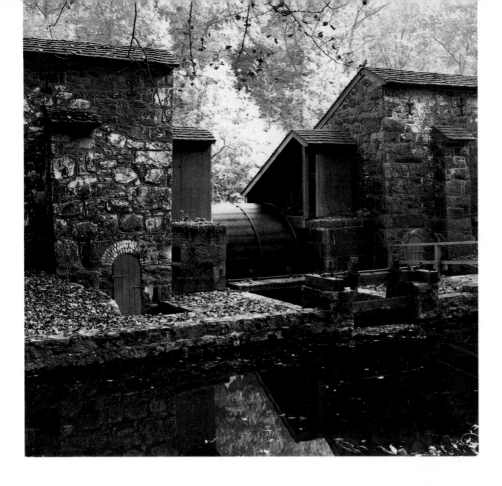

In Hagley mills like this, du Pont made gunpowder for nearly 120 years.

Giant wheels of the Eagle Roll Mill still turn, demonstrating the powder-mixing process.

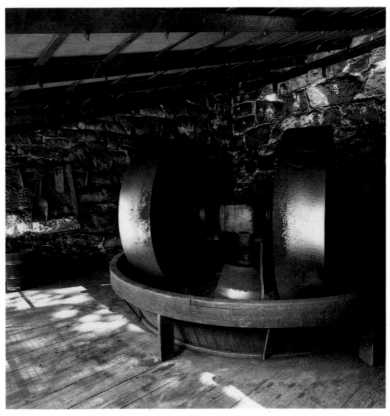

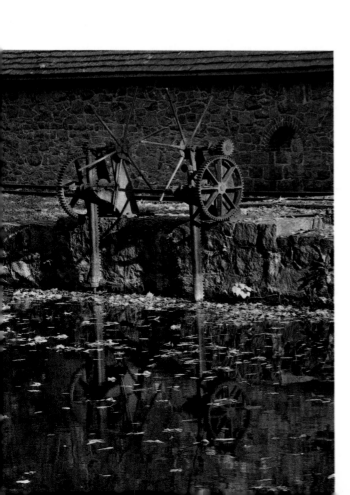

Gate valves like this one drew water off the Hagley millrace and diverted it to the turbines that powered the powder mills.

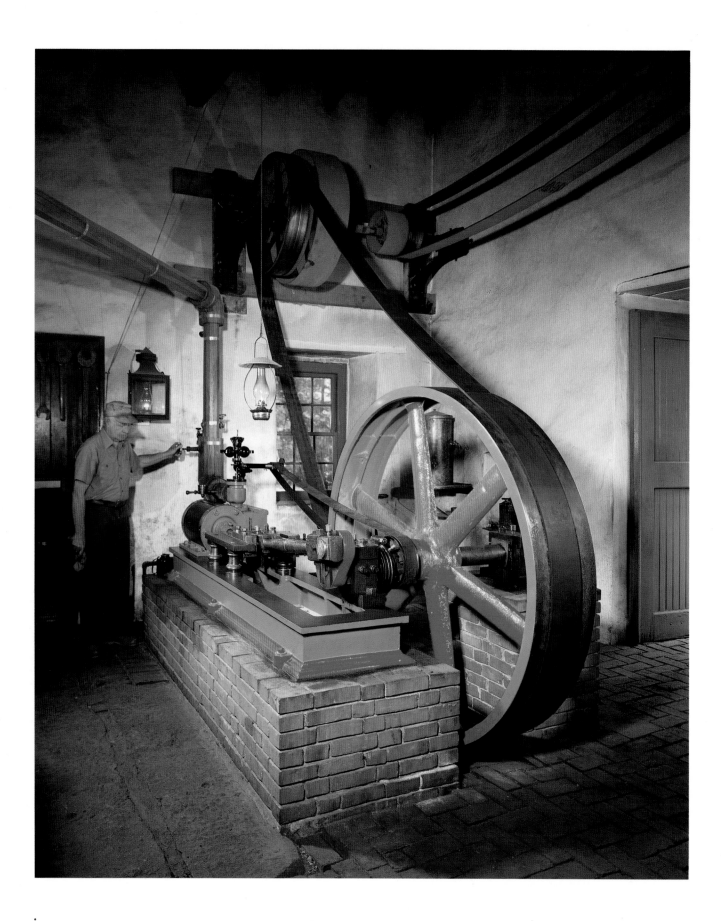

As the 19th century lengthened, the Hagley Yard's water power was supplemented with steam engines.

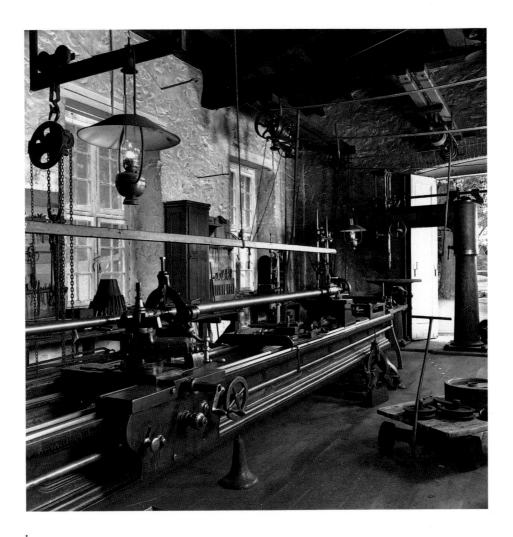

Much of the machine shop's equipment was made around 1870.

into dark blurs, transmitting the water's force into drive shafts that turn the ponderous powder-mixing wheels.

Yet even as the turbine was replacing the waterwheel, steam was taking over as king of power. As Du Pont's powder factory grew through the middle of the nineteenth century, the Brandywine was no longer up to the demands on it, particularly in dry weather. In 1855 the first stationary steam engine was installed. Today, one vintage steam power plant still works in demonstrations at the Engine House, its puffing exertions amazingly modern in contrast with the clanking, roaring machinery of waterpower.

Some nineteenth-century machinery and equipment had a sculptured beauty unknown today. In the Millwright Shop, or machine shop, a full complement of

lathes, milling machines, and drills display the sinuous legs and classical columns of furniture of their time, clear evidence that the Victorian era applied aesthetic standards to its machinery. At Hagley these devices still work beautifully and are demonstrated for visitors. The shop is presented as a time capsule of about 1870, when the machines were made. The interior is even illuminated by two-wick industrial kerosene lamps.

It may certainly be argued that for such a lethal product as gunpowder, the record of 228 fatalities was surprisingly good. For the workers and their families, life at Hagley was probably among the better examples of paternalism in American industry. The workers—mostly Irish, French, and Italian—were paid relatively well. Their housing and medical care were inexpensive or free, their garden plots ample, their children's education encouraged, and their widows and orphans provided for when the dreaded explosions occurred.

Significant traces remain of the lives of Brandywine's powder workers. Du Pont built six workers' communities within walking distance of the powder mills, and one, partially restored, is part of the Hagley experience today. It lies just up Blacksmith Hill, above the original gate that separated the mill from the housing areas. The most significant window on domestic life is at the Gibbons-Stewart House of 1846, the home of a foreman and his family. Its exterior is tall and gaunt, but inside it seems warm and comfortable. Of several other surviving houses and utility structures, the most important is the Brandywine Manufacturer's Sunday School of 1817, a handsome classical structure donated by the founder, Irénée. Although classes were only held on Sunday, it was nevertheless the primary educational facility for Hagley workers' children, and at the yard's peak some two hundred students were in attendance.

The residential hillside is charming and parklike today, and a visitor must exercise some restraint—as well as imagination—to visualize the place as it really was. Most of the rows of simple habitation that once jammed the hillside are gone, and what is left may suggest more Brigadoon than company town. Luckily, some surviving photographs provide images of life in the workers' community. Such material is on display at the visitor reception center in the Henry Clay Mill, an 1814 cotton-spinning mill later used to make Du Pont powder canisters. The haunting pictures show a proud, apparently well-fed, not badly dressed people who daily stared down the gunpowder genie and, perhaps, were not afraid. But they could not endure in a world where du Pont was making powder more cheaply in the modern, widely scattered factories of its growing empire. The cradle of it all, Hagley and Eleutherian Mills, became an anachronism. In 1921, the 8-ton wheels of the Brandywine powder mills ceased grinding powder forever.

This schoolhouse of 1817 was long the primary educational facility for Hagley children.

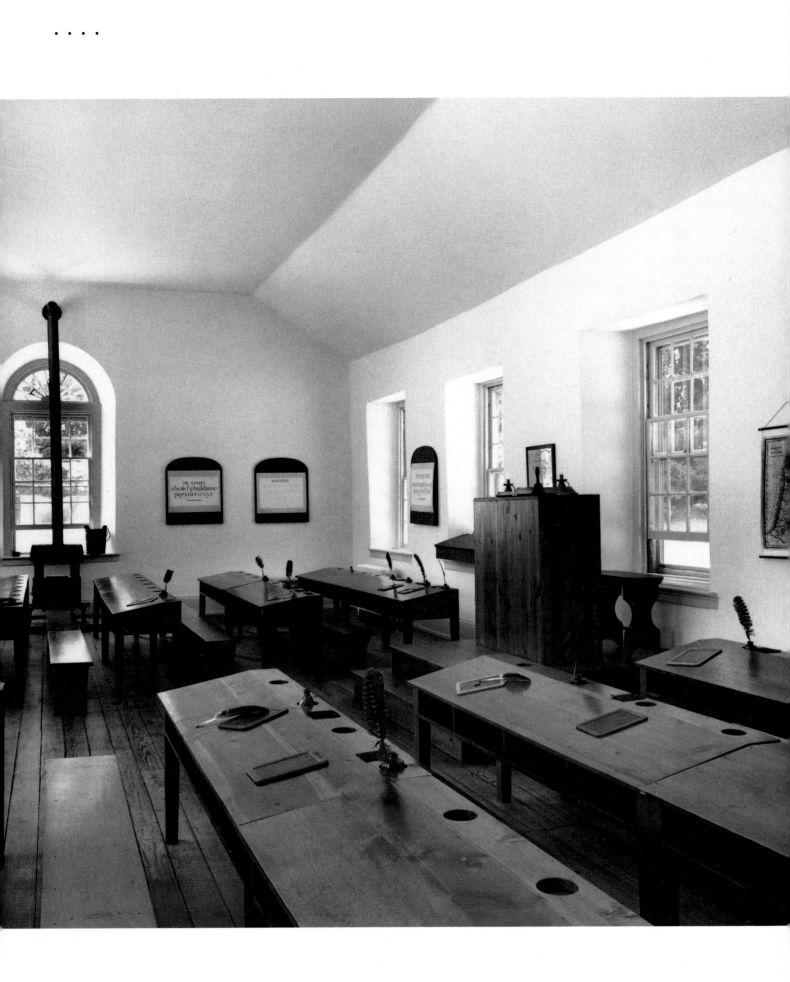

Blacksmith Hill was typical of Hagley workers' communities above the powder yards.

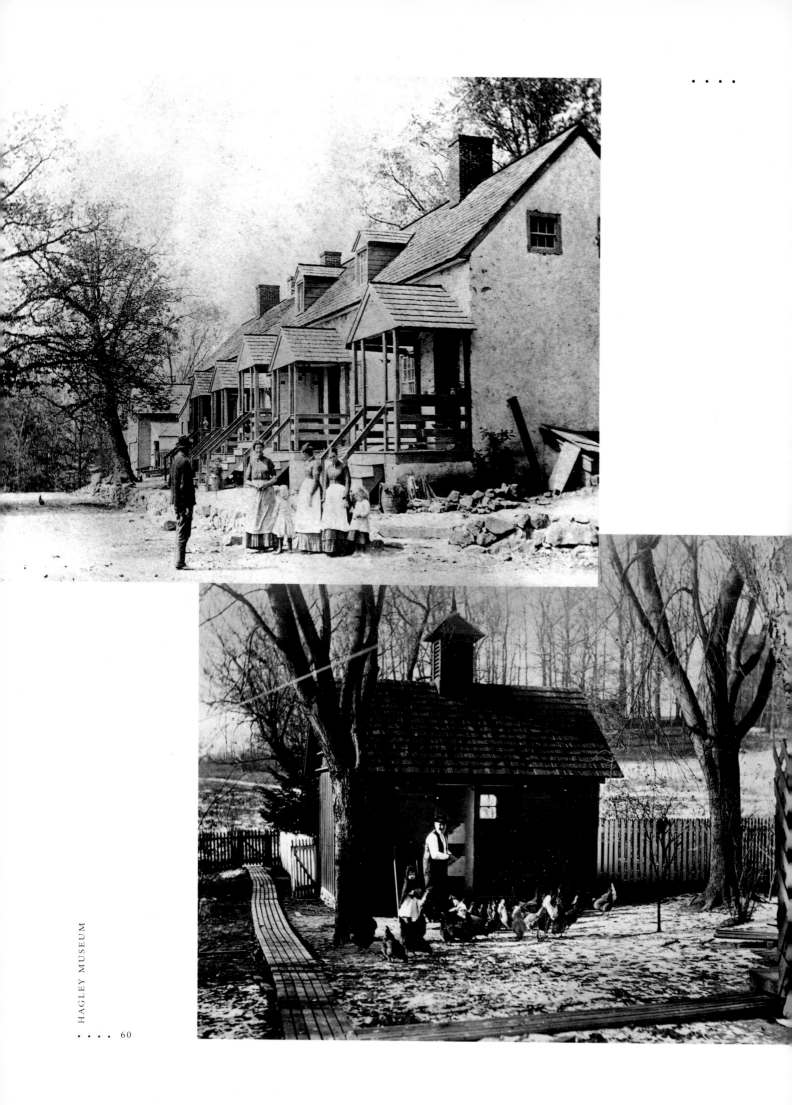

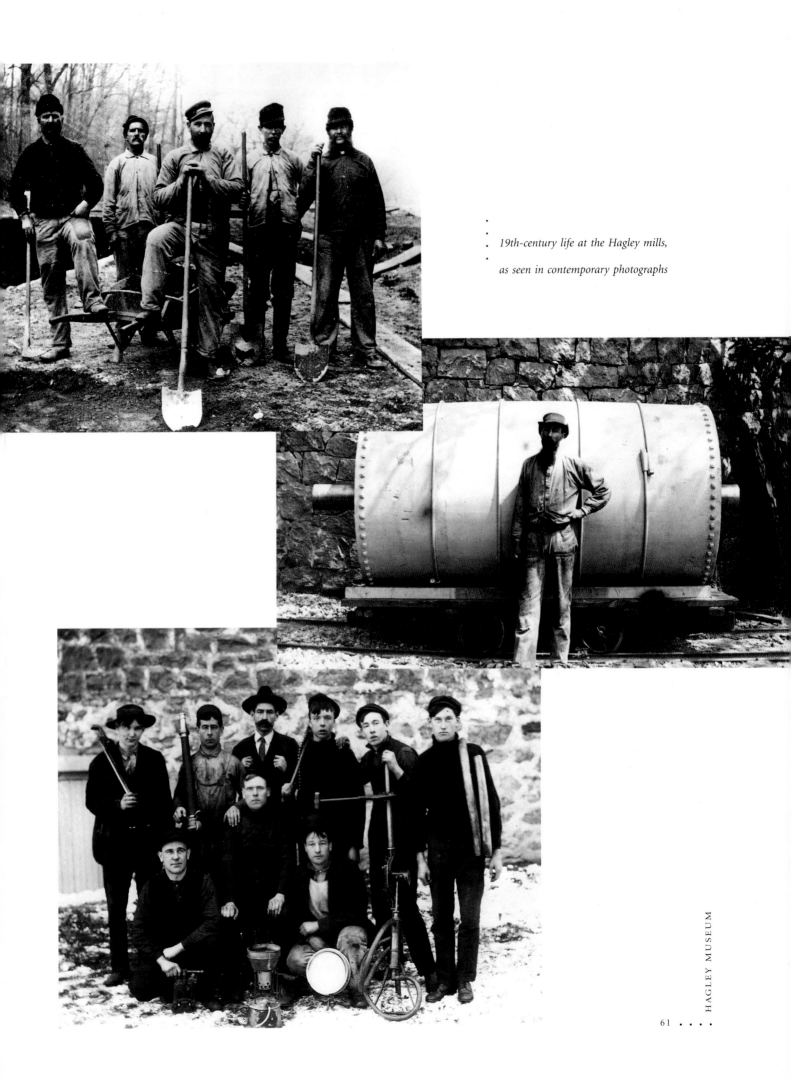

19th-century life at the Hagley mills,

as seen in contemporary photographs

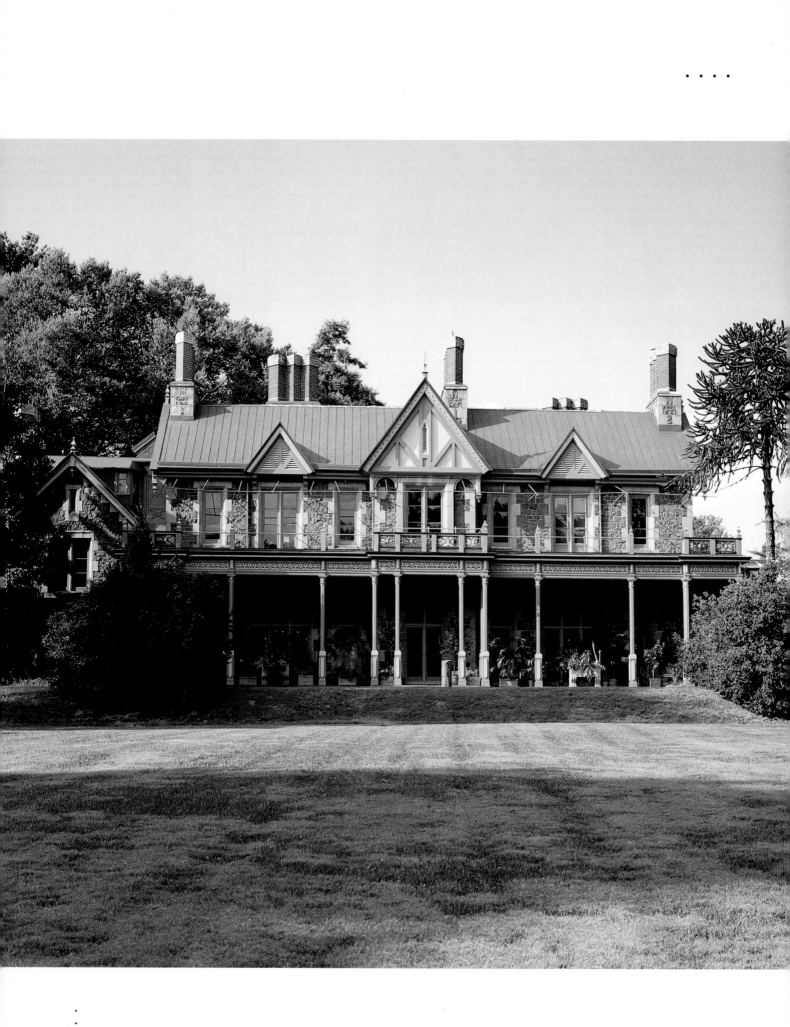

Seen here from the south lawn, Rockwood is a masterpiece of the Rural Gothic school.

R·O·C·K·W·O·O·D

He was, if we may judge by his 1855 photographic portrait, a bit of a dandy, a man who wore his majestic checkered foulard and splendidly fitting suit and waistcoat with a familiar yet offhand air, his face sharp-nosed, long in lineament, hinting at humor in the corners of a wide and confident mouth. The viewer senses a man of character, intelligence, and worldly knowledge. We can make such speculations about Joseph Shipley with some boldness and facility because, not only do we have his photograph to go by, we know something of his life's history. And then, we have his house.

Shipley's Rockwood is a paragon of Anglo-American "rural Gothic" architecture, unique in the Brandywine region and certainly ranking among the best in the United States. But the house would be an incomplete picture without its original landscaping, in that style of romantic naturalism called "gardenesque." Surviving intact, Shipley's rural villa and grounds cast a rare example of this highly specific and refined early Victorian style. It began as a thoroughly English expression, although it would enjoy a vogue in America before a sudden crash into obscurity. Rockwood was a perfect statement of this transatlantic aesthetic. How did it come to be, and why did it survive so long, here in the rolling hills of northeast Wilmington?

Joseph Shipley may have enjoyed the life-style of an English gentleman, but he began (like he ended) as a Wilmingtonian of prime credentials. His great-great-grandfather, William Shipley, was one of the city's founders. The Shipleys—Quakers of Pennsylvania origin—built and operated flour mills on the lower Brandywine starting in the first half of the eighteenth century. Joseph was born in Wilmington in 1795. Well educated, he demonstrated an ability with figures and a liking for early nineteenth-century Romantic literature. In 1819, barely settled in a new job with Philadelphia merchant James Welsh, he sailed for Liverpool on a business trip. The journey extended into a thirty-two-year career in transatlantic trade, much of it

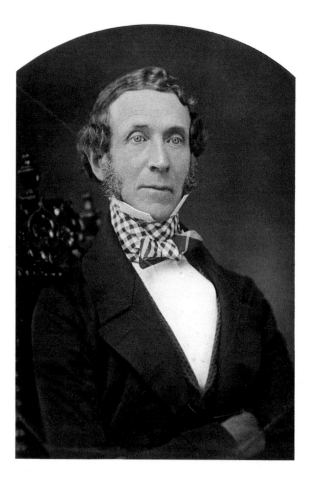

Joseph Shipley, 1855. Rockwood Museum Archives.

Joseph Shipley and his dog at Rockwood's

north facade, c. 1861. Rockwood Museum Archives.

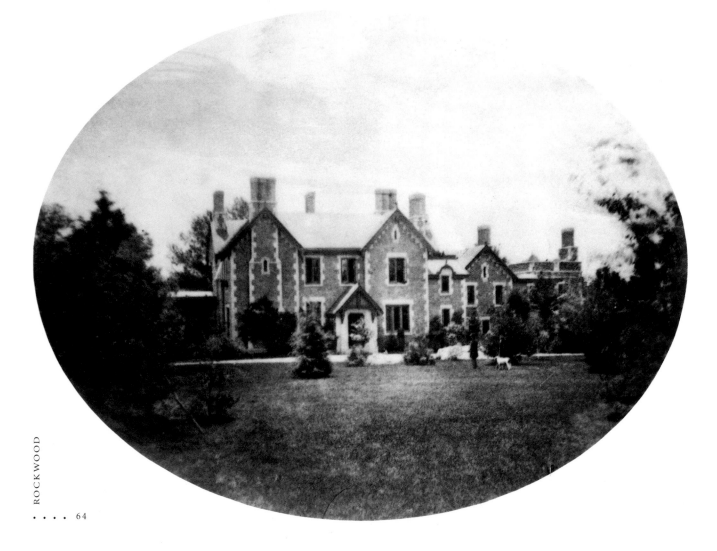

engaged in importing cotton from the Southern states. Shipley grew rich and then, in a series of catastrophic financial events beyond his control, almost lost it all. His firm, William and James Brown & Company, was spinning into bankruptcy, in part because of President Andrew Jackson's feud with the Bank of the United States, culminating in the Panic of 1837. Shipley importuned the Bank of England with such determination that he pried forth an unprecedented loan of almost £2 million, saving the firm's fortunes . . . and his own.

In 1846 Shipley rented a new estate just outside Liverpool: Wyncote, designed by Liverpool architect George Williams. According to curator Becky Hammell, Williams worked with Joseph Paxon, who would play a part in designing the Crystal Palace of 1851. Williams obeyed the broad tenets of the Gothic Revival, a movement dictated in detail by A. W. N. Pugin and John Ruskin, and highly popular around Liverpool. But the house embraced a variation called "rural Gothic," in which a romantic overlay was enhanced by Italianate details and by creative landscaping called "gardenesque," which sought to blend the beautiful and the picturesque. This school of thought had been developed by a Scottish botanist and landscaper, John Claudius Loudon, and enthusiastically imported by Andrew Jackson Downing to the United States. Downing's books on rural architecture and landscaping became overnight classics.

Much as he liked his Liverpool house, Shipley was planning a return to Delaware almost from the moment he moved. He began negotiating for property in the region known as Brandywine Hundred through his brother, Samuel, until by 1851 he owned 300 acres. The terrain presented a nice combination of smoothly rolling hills and fields, and some boulder-strewn ravines and streams. In 1851 Shipley returned to Delaware to stay, bringing with him plans for a new house by George Williams. The position of the house had been coordinated by the Liverpool architect, who had sketches of the site on hand.

To describe Rockwood as architecturally complex is to grossly understate matters. The well-fitted exterior stone walls of rough gray Brandywine granite are trimmed with finished light gray granite on quoins and surrounds. Roofs are steeply pitched and surmounted by elaborate stacks of clustered brick chimneys. Other exterior details include carved cornices, Gothic doors, bays and gables with ornate barge-boards and pendants, and porches supported by pencil-thin Gothic columns, balustrades studded with cast-iron finials in nine different styles. Experts can even pick out Jacobean touches in a square tower with an arched gable. On the east end, a connecting conservatory is supported by cast-iron Gothic shafts. The overall effect is surprisingly friendly. Yet the house is no vision from Currier and Ives; it is British to the core. Even the cast iron came from England.

No sooner did Shipley move in (1854) than he began tinkering with the house. Unlike Thomas Jefferson at Monticello, who planned everything himself, the squire of Rockwood again sought the help of architect Williams. Soon a new west wing

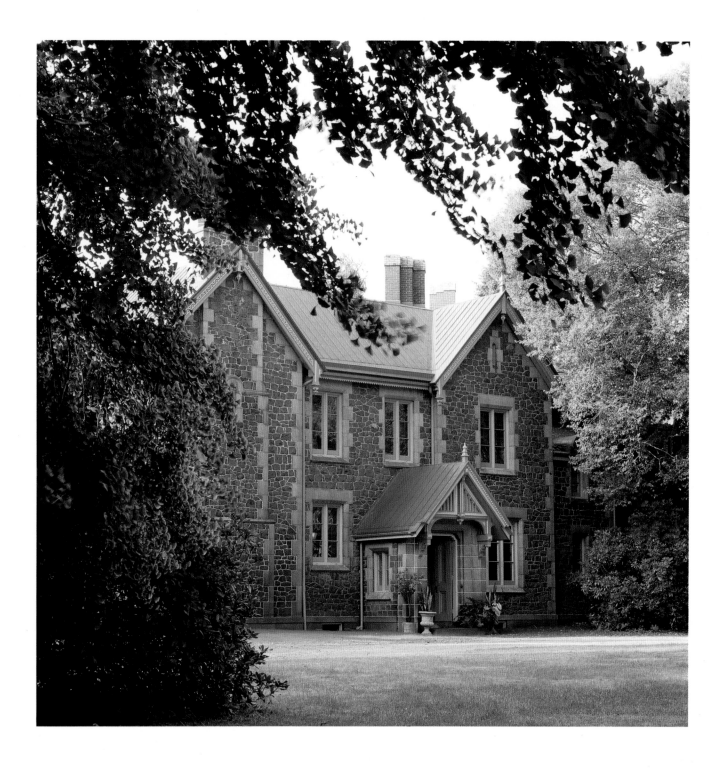

In the days of the Bringhursts, Rockwood's

main entrance was the gateway to social felicity.

Rockwood's big stables helped Edward Bringhurst

live as the complete country gentleman.

appeared, providing three additional servants' bedrooms, a dining room, and more kitchen space. Meanwhile, Shipley added a porter's lodge, gardener's cottage, carriage house, stable, and ice house.

Shipley's most personal contribution may have been the active supervision of Rockwood's gardening and landscaping. He purchased some 1,200 plants, including tropicals, totaling more than 160 species and varieties. He apparently understood the fine points of the "gardenesque"; his library included the major tomes covering that philosophy, and contemporary photographs, plus surviving original trees planted by Shipley, support the view that he was enthusiastic for the genre. As set forth by its primary champion, Loudon, the style blended two concepts. The "beautiful" was composed of flowing, rounded shapes, like round-topped deciduous trees and smoothly curving paths and roads. The "picturesque" accentuated rough, irregular outlines, as provided by pointed evergreens and angular paths. The idea was to improve on nature, but so discreetly as to be hardly noticeable. Spacious lawns, framed naturally by trees, were encouraged for enjoyable viewing and for outdoor activities. Planting of shrubs and flower beds close to the house was formal. The ha-ha was a strong feature of the gardenesque philosophy, and Shipley's example of that useful sunken barricade endures, still capable of keeping unwanted farm animals away from the house.

In 1857, four years before the Civil War began, the *Delaware Weekly Republican* visited Rockwood and described ". . . a beautiful lawn, ornamented with flowers . . . gardens and greenhouses filled with the choicest plants, fruits, &c., then sloping on every side to quite a deep wood, forming a delightful retreat, and making a most picturesque and lovely place."

Joseph Shipley lived thirteen years in his dream house, and when he died in 1867, the old bachelor willed Rockwood to his two maiden sisters who had resided there with him. When sister Hannah, the last to go, died in 1891, the house was almost exactly as Shipley himself had left it, original furnishings intact. But now Rockwood was on the verge of a new career. Hannah wanted to bequeath property to so many relatives that her entire estate had to be sold at auction and divided. Bidding on the Rockwood real estate were Edward Bringhurst, Jr. and his wife, Anna, a couple in their fifties. Edward was a great-nephew of Hannah Shipley and had enjoyed visiting the old lady at Rockwood. His successful bid of $43,500 for the house and 73 acres was cloaked in intrigue. Bringhurst was executor of the estate and found it necessary to arrange for a colleague to do the actual bidding, instructed by secret signals. And there would be more code involved in this transaction. The family excitement over buying Rockwood emerges in a cryptographic telegram to two of their children, Mary and Elizabeth (Bessie), who were in Ireland at the time. It read, "Sally 44."

"Hurrah! Hurrah! Hurrah!" Bessie immediately wrote her mother.

What did it mean, this odd exchange? According to Rockwood scholars, the party who put up the money, and to whom Rockwood was deeded, was Bringhurst's

mother, Sarah Shipley Bringhurst, niece of Joseph. It does not require James Bond to make the educated guess that "Sally" was the maternal financier, and that "44" conveyed the approximate purchase price. The scholars also believe "Sally" was later repaid.

Rockwood's furnishings were auctioned separately, and excited great local interest. Despite high prices, the Bringhursts secured a variety of original Joseph Shipley pieces. But the new owners, apparently in the van of the Colonial Revival movement, had already gathered an excellent collection of antique furniture, which they moved into the house. As of October 1892, the Bringhurst era began at Rockwood.

They were lively, intelligent, style-conscious, and sociable people, according to museum director John H. Braunlein. Coincidentally, they continued the transatlantic tradition begun by Uncle Joseph. Bessie had married an Irish merchant in 1886; they spent the winters in New York and the summers at Kilwaughter Castle in Ireland. That accounts for the exchange of messages with Bessie and Mary in Ireland, for Mary was visiting Elizabeth at the castle.

As the elder and possibly most glamorous member of the family, Elizabeth apparently took the lead as decorating arbiter of Rockwood. The house's archives bulge with hundreds of her letters from Ireland, recommending decorating ideas. She was concerned that Rockwood reflect the kind of atmosphere popular in the great houses of England and Ireland. Today, director Braunlein and other staff scholars, with tongues firmly in cheek, refer to the turn-of-the-century period as "early Bringhurst." It comes on early indeed, at full strength, when a visitor enters the mansion's front door. The stair hall, under a full two-story ceiling, is a mixture of styles and eras. The oak staircase and second-floor balcony mingle Classical Revival and Jacobean elements. A gathering of chairs, chests, and cupboards bridges four centuries; on the walls, portraits cover at least three, concluding in the twentieth with Edward Bringhurst III. All the stair hall objects are of either Shipley or Bringhurst provenance, but mostly Bringhurst, for Joseph apparently kept the hall rather bare.

One compelling reason to preserve the mansion approximately in its fin-de-siècle state is the well-documented social history of the Bringhursts. They were bountiful entertainers, did everything to the dernier cri, and kept meticulous records. Their highly developed sense of hospitality demanded that their guests would always be treated with utter and individualized courtesy. There was even a Rockwood diary that recorded each social function, the names of attendees, the menu served, and a list of flowers displayed, so that when the same people were invited to future events, there would be variety. Christmas and Fourth of July meant the most elaborate festivities at Rockwood, but some social activity occurred almost daily. More often than not, from 4 to 6 P.M., the Bringhursts were at home for social calls, occasions that demanded tea. As informal as these occasions may have been, there was always a silver tray extended to guests by the butler in the great stair hall, followed by a snowy flutter of calling cards.

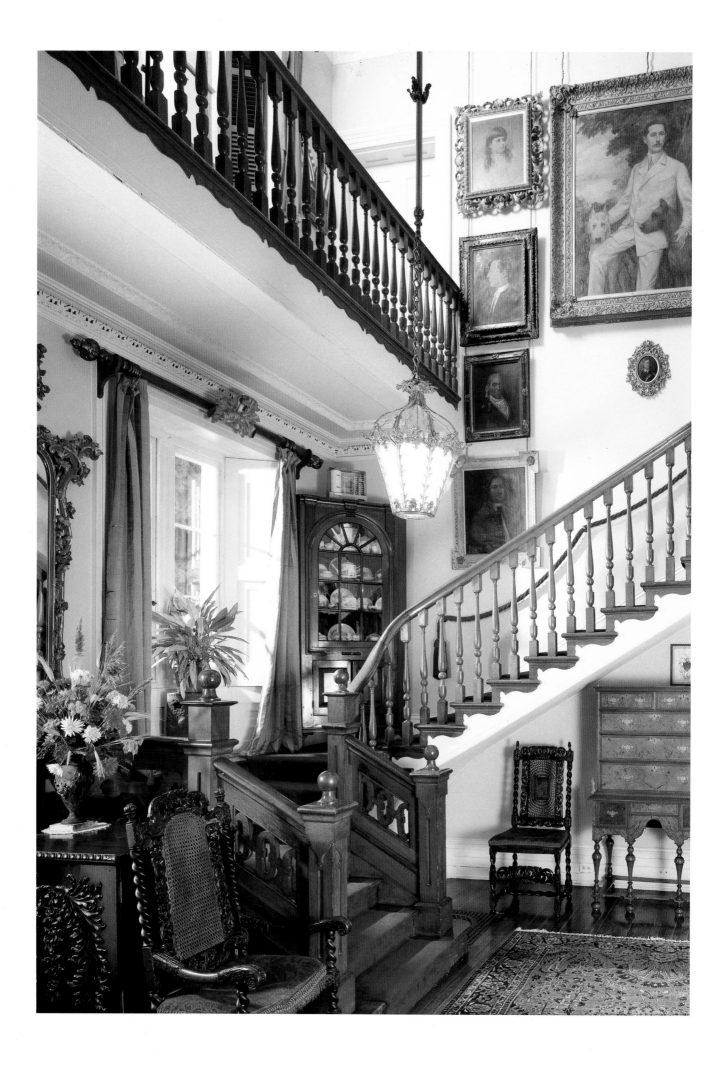

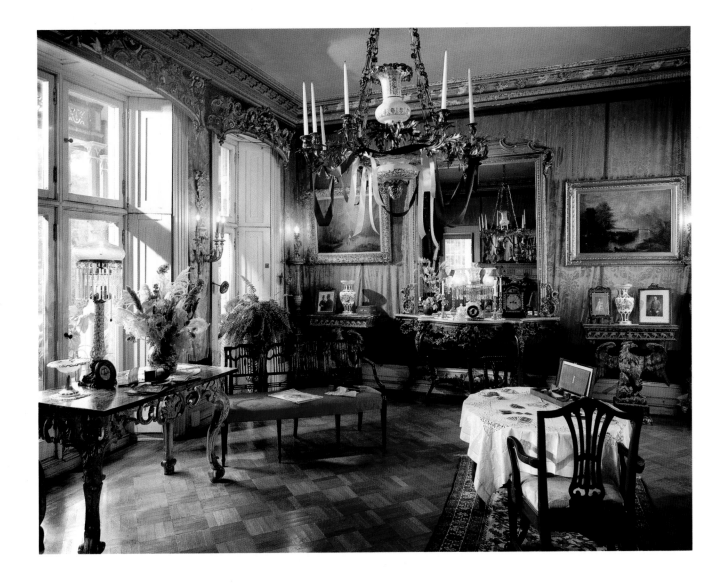

The entrance hall mingles different styles

of furniture and art.

In the Bringhurst era, the drawing room was the

focus of a spirited yet highly organized social whirl.

The drawing room was the scene of much of this social activity, formal or casual. For formal tea receptions it was decorated with flowers and cleared of some furniture. After Mrs. Bringhurst's guests passed along the receiving line, everyone repaired to the dining room for an assortment of sandwiches, cakes, ice cream, and other delicacies. Today the house's two principal rooms remain much as they were. The drawing room, eclectic to a fault, somehow—perhaps in its gold and white trim—manages to suggest French rococo despite the fact that most of its furniture is American, English, and Irish. The dining room seems more frankly Victorian, with its American and English furniture, Sheffield plate, a gasolier, and (as in the drawing room) kerosene lamps of a particularly gaudy confection of ruby and white known as "overlay glass." Among the dining-room furniture are the house's prime original Joseph Shipley objects, including banquet table, chairs, and sideboard.

In such rooms, the Bringhursts' aura seems to hover closely around omnipresent family portraits, including one of Bessie Bringhurst arrayed as the Queen of Lorraine, a fancy dress impersonation that must have pleased her very much. It hangs in the reception room, between the entrance hall and the drawing room, so everyone can see it. Obviously, the reception room came under intense scrutiny, for the records show it was redecorated five times in quick succession at the turn of the century. According to Rockwood legend cited by curator Hammell, Bessie tended to be especially gracious to guests of title, wealth, or rank.

Upstairs, Rockwood displays a mixture of furniture curious to many modern tastes, but totally authentic to the history of the house. Mingled with original Joseph Shipley pieces, which tend to be of excellent quality, are sundry Bringhurst contributions, a centuries-long span of decorative arts. One of the most appealing ensembles, in the Lafayette Bedroom, features a heroically scaled bed that has generated some debate.

The bed, with its carved and scrolled headboard and soaring fluted columns holding up a majestic canopy, is worth coveting for itself alone. But when in 1903 Edward Bringhurst bought it from a Baltimore estate, the story that came with it identified the bed as one made specially for the marquis de Lafayette's Baltimore hotel room on the old Frenchman's sweeping American tour of 1824. The Bringhursts proudly installed the bed in what became instantly known as the Lafayette Bedroom. Modern research has cast cold water on the Lafayette connection, indicating that the Maryland hotel had replaced its original furniture in the 1840s or 50s, and that the bed dated to that era. But after eliminating one bit of provenance, the revisionists added an intriguing new prospect: the bed, made around 1840, bore indications that it might have come from the shop of Prudent Mallard, the legendary New Orleans craftsman whose massive, ornate creations were the rage of wealthy Deep Southerners in the 1850s.

The Bringhursts, like Uncle Joseph Shipley before them, could not resist tinkering with Rockwood for long. In 1912, a year that could be said to represent the apogee of

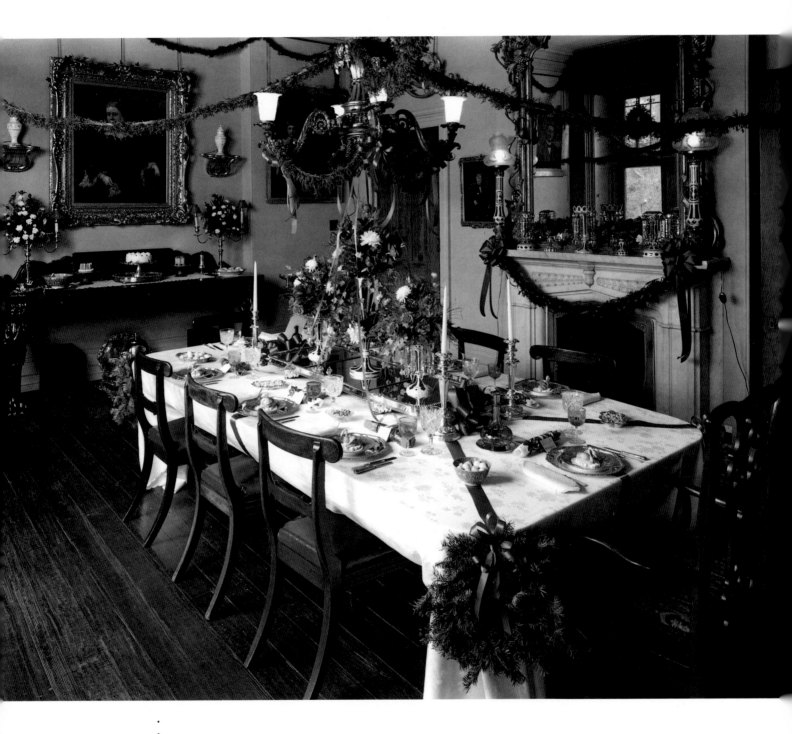

The Rockwood dining room, set for a party

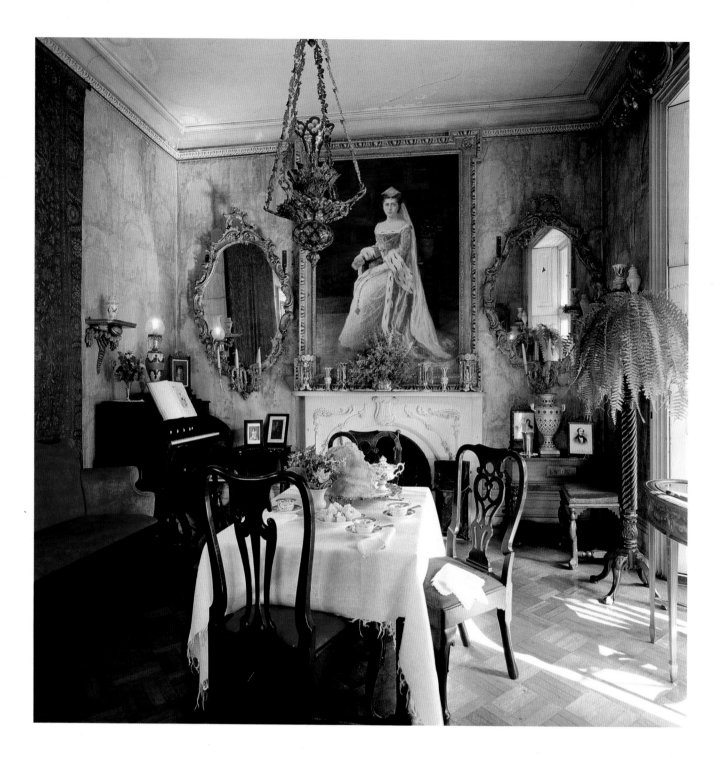

A portrait of Bessie Bringhurst as the Queen

of Lorraine hangs in Rockwood's reception room.

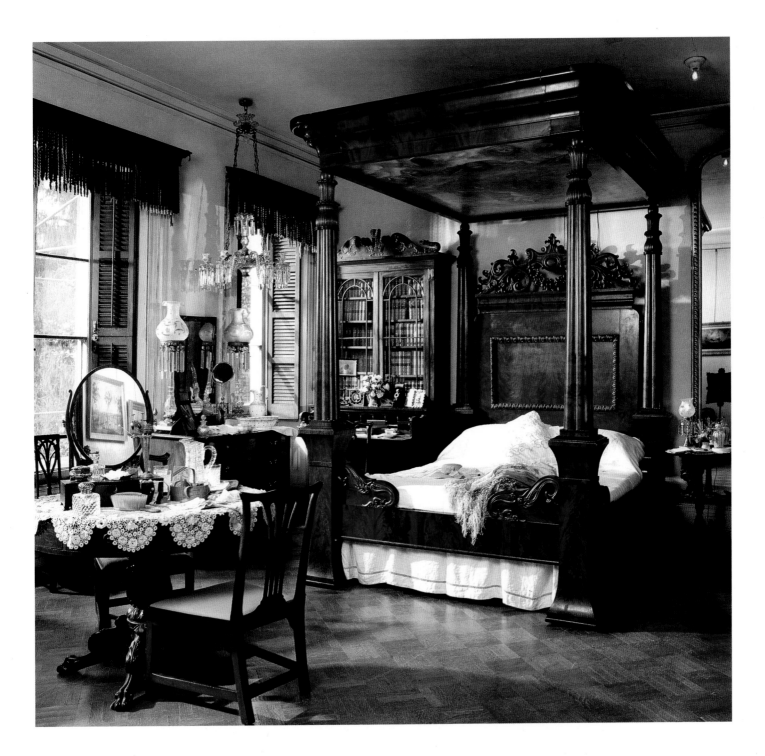

The Lafayette bedroom is named for the great

bed in which Lafayette, alas, probably never slept.

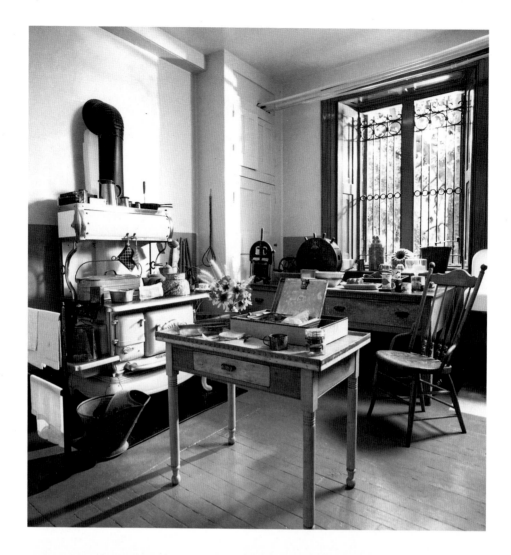

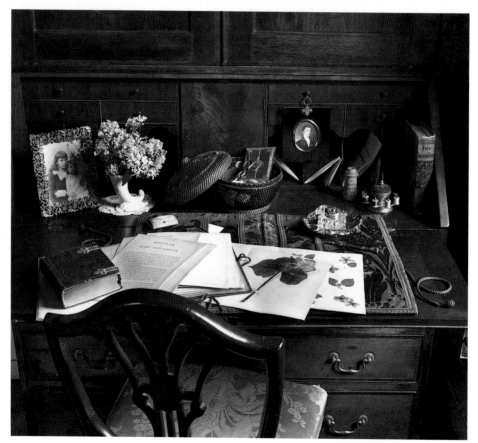

the house's second incarnation, they added a new west wing, with nine principal rooms, to the small one that Uncle Joseph put on in the 1850s. In 1920, after numerous visits across more than two decades, a widowed Bessie Bringhurst returned to Rockwood, joining her sister, Mary, and brother, Edward III, who for reasons unknown had changed his name to Edward V. When Mary, last of the Rockwood Bringhursts, died in 1965 she willed the estate to a niece, Nancy Sellers Hargraves. In 1972, she passed the mansion and almost 7 acres of grounds to an unspecified charity. A 1974 Court of Chancery order deeded the property to New Castle County to be operated as a museum, and in 1976 it was named to the National Register of Historic Places. In 1984, a new organization called the Friends of Rockwood helped state and county authorities buy in the surrounding 66 acres, heading off a possible town-house development and permanently assuring the integrity of Rockwood's setting.

Indeed, it detracts nothing from the fascination of Rockwood's interior to say that, for many visitors today, the grounds challenge it in interest. Joseph Shipley's Victorian landscape is being revived in all directions. A self-guided walking tour takes the visitor to key points where the gardenesque style emerges clearly. Expanses of lawn are outlined by curved banks of shrubs and gently curving drives. The gardenesque tenet of accent plants to lend dramatic interest is recalled by some of Shipley's own plantings, such as a weeping beech and a maidenhair tree, and the spiky profiles of his Norway and blue spruces contrasting with the rounded tops of maples, oaks, and magnolias.

Then, looking back at the house from Rockwood's front lawn, which Joseph Shipley called his pleasure garden, the rightness of combined grounds and architecture becomes clear. The house may be an exotic element in American architecture, but it belongs to its setting. And in a broader sense, as well, the cultural anomalies here seem insignificant, despite all the transatlanticism of both Joseph Shipley and the Bringhursts. After all, the cosmopolitan Shipley was never an expatriate; he returned to Delaware in his own good time, to construct on ancient home turf the estate that he undoubtedly considered a monument to good taste. The Bringhursts were patriotic Americans and even Bessie ended her Irish sojourn and returned home. Little Edward III (or V) was born on the Fourth of July, and in the 1890s the Bringhursts staged huge birthday celebrations on the Rockwood front lawn. As the estate continues to enhance and honor its traditions with a modern schedule of activities, it is pleasing to note that one of the most popular is Rockwood's annual July Ice Cream Festival, held smack in the middle of Joseph Shipley's pleasure garden.

Rockwood's busy social history demanded hard toil in such rooms as the scullery.

Artifacts of Rockwood's vanished life-styles

cluster in evocative vignettes throughout the house.

W·I·N·T·E·R·T·H·U·R

Northbound from Wilmington, along the Kennett Pike, the landscape swells and tumbles with a pleasing, tailored irregularity. Roadside hedges, fences, and gates appear discreetly expensive, as if demarcating a kind of paragon of Mid-Atlantic suburbia. About six miles into this zone of increasingly civilized real estate, a lane curls eastward through hills all golden and nodding with massed beds of daffodils, past banks of Dexter rhododendrons and Italian windflowers, along forest floors spangled with trilliums and phloxes. Or, depending on the time of year, the welcome mat might include scarlet and crimson viburnum berries, lavender colchicums, New England asters, and autumn crocuses. Through vistas like these, spanning a mile or so, a visitor makes his approach to the main house at Winterthur, one of the most astounding former residences on earth.

Winterthur is as large as a medium-size hotel, nine stories of the palest buff stucco crowned by umber-tiled roof peaks, towering chimneys, and Georgian dormers. And yet, so cunningly restrained is Winterthur that its huge slab-sided bulk seems almost intimate among the giant trees. Strangely, the visitor's sense of it evokes the discovery of some pleasant but mysterious cottage within a deep enchanted woodland. In sum, the total production is fully as subtle and reticent as Henry Francis du Pont, who built it, whose home it was, and who ultimately filled its almost two hundred rooms with the world's premier collection of American decorative arts.

Extraordinary as it may be, Winterthur fits easily into the overall Brandywine scheme and, like other stars in the local galaxy, has its own direct link with the earliest du Pont days and intervening family history, a matter of surprisingly few generations. Eleuthère Irénée du Pont himself obtained the land early in the nineteenth century when the company's founder was expanding his agricultural activities, an enterprise that interested him as much as powder making. In 1816 one of du Pont's daughters, Evelina Gabrielle, married James Antoine Bidermann, the son of

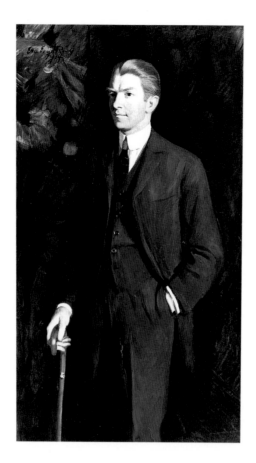

Page 78. *Starting with a relatively modest 1839 Greek Revival house, Henry F. du Pont concluded with this hotel-size home.*

Henry Francis du Pont was 34 when Ellen Emmet Rand painted him in 1914.

one of du Pont's financial backers. While the younger Bidermann worked for the company, the couple lived near the powder mills, but in 1837—three years after E. I. died—Bidermann retired from that explosively dangerous environment to become a farmer. He bought a tract of land from the du Pont family and in 1839 built a squarish, Greek Revival house on a hillside by Clenny Run, a tributary of the Brandywine.

In 1865, the Bidermanns' son inherited the property and in 1867 sold it to Henry du Pont, his mother's brother. Henry's son, Colonel Henry Algernon du Pont, took over the property in 1876 and made extensive additions and renovations in 1889 and 1902. Then Colonel Henry's son, Henry Francis du Pont, born at Winterthur in 1880, began helping with the estate early in the century. There remained a close relationship with the original du Pont seat at Eleutherian Mills: as children, young Henry and his sister, Louise Evelina du Pont, visited frequently when their grandparents were alive. Later, as Louise du Pont Crowninshield, she returned to Eleutherian Mills and (with her father, the colonel, who had bought the property) supervised its restoration.

With young Henry's help, the old colonel was still making improvements at Winterthur as late as World War I. In 1915 Henry Francis du Pont became farm manager, and in 1927 he inherited the property. By then, du Pont was fully committed as a collector of American antiques, having converted from a bent toward European objects around 1923, when he and his wife (née Ruth Wales) were living part-time in New York. One of his first acquisitions was a walnut chest of

drawers, made in Pennsylvania in 1737. By 1929 his collection had grown to the point that, to accommodate it, he tripled the size of Winterthur. The old house of 1839 was essentially cocooned within a gigantic new mansion.

The 1920s were a heyday for collectors with the foresight and taste to see their opportunities and gather wisely. Although a degree of interest in American antiques had begun to stir with the Centennial Exposition of 1876, it did not begin in earnest until the start of the Colonial Revival era, roughly corresponding with the end of World War I. Now-legendary collectors like Henry Ford, John D. Rockefeller, Jr., and Ima Hogg began building their private treasuries with the help of such pioneer antiques dealers as Israel Sack. Henry Francis du Pont, their younger contemporary, was arguably the greatest collector of all—and a formidable competitor at auctions and private sales.

While he occasionally sought the advice of curators and other expert collectors, he relied chiefly on his own unerring eye, a talent he was simply born with. He once said that he seemed to notice "everything that is attractive and beautiful." Armed with that sure instinct for the best specimens, he bought American furniture ranging from simple cottage rustics to refulgent masterpieces from Newport, Philadelphia, and Baltimore. He gathered naive paintings from anonymous folk artists and the glamorous works of Peale and Trumbull. His collection ranged from pewter porringers to glittering silver tankards by Paul Revere, from simple stoneware crocks to ethereal porcelains. He ventured ever farther afield, collecting domestic accessories of every variety: ceramics, metalwork, books, newspapers, needlework, craftsmen's tools. He added foreign-made products (like Chinese export ware, and French fabrics) to the degree that they were commonly imported and used in the colonies and early United States. In most cases he did the buying himself. When a reporter once asked the name of his agent, du Pont replied, "You're looking at him."

Before his huge expansion of the Winterthur house in 1929, he determined to display his treasures not as massed museum collections but in period-room settings. He began scouring the eastern United States for original interiors—paneling, staircases, doorways, chimneypieces, wallpaper, complete ceilings and walls—that could be moved to Winterthur and reincarnated. It was a practice that brings distress to preservationists of today's school, yet it should be borne in mind that the preservation movement as we know it today did not exist in the 1920s. There was no significant commitment to preserving venerable buildings in situ. From the Deep South to New England, significant old structures were collapsing in neglect or being demolished to make way for new projects. In the main, it was from such buildings that he obtained original architectural features for his rooms.

Just as Henry Francis du Pont had the telling eye—that instinctive sense of when a piece was or was not right—he had an equal feeling for where each piece should go to do its part in creating a harmonious whole. He operated on the principle that if one object in a room attracted attention to itself (which automatically detracted from the

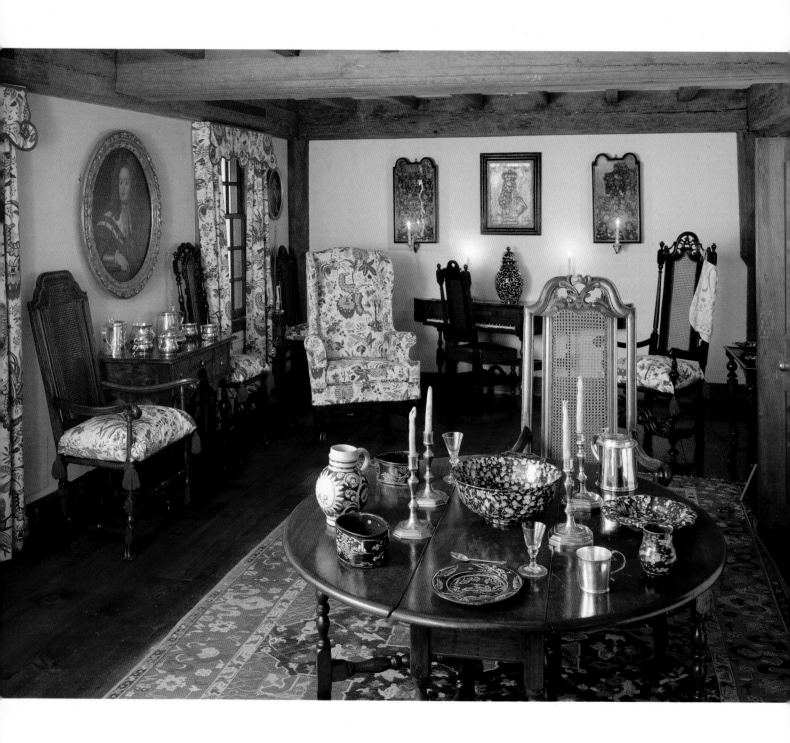

The Wentworth Room, representing the very early

18th century, displays William and Mary style furniture.

Federal furniture, and architectural features

from Maryland and Virginia, blend with du Pont

family antiques in the Du Pont Dining Room.

others), it didn't belong there. Du Pont's judgment was so infallible, and his resources so vast, that his period-room ensembles may be substantially better, aesthetically speaking, than their roughly corresponding forerunners from 1640 to 1840. Even in wealthy, style-conscious homes there was—just as today—often some mixture of period, want of balance, or clash of color, and the concept of harmonious groupings hardly existed. Henry Francis du Pont settled only for perfection. It is virtually the only criticism ever heard about Winterthur.

The Du Pont Dining Room, so called for its use as such by the family, is broadly representative of du Pont's collecting and decorating scheme. The paneling and chimneypiece, painted a delectable pale bisque, came from eighteenth-century houses in Maryland and Virginia. The furniture defines the era known as Federal, an American neoclassical style embracing Sheraton and Hepplewhite. Sideboards from New England and New York, an eagle-medallioned dining table from Baltimore, and side tables and a cellarette from Charleston are major objects and date from 1790 to

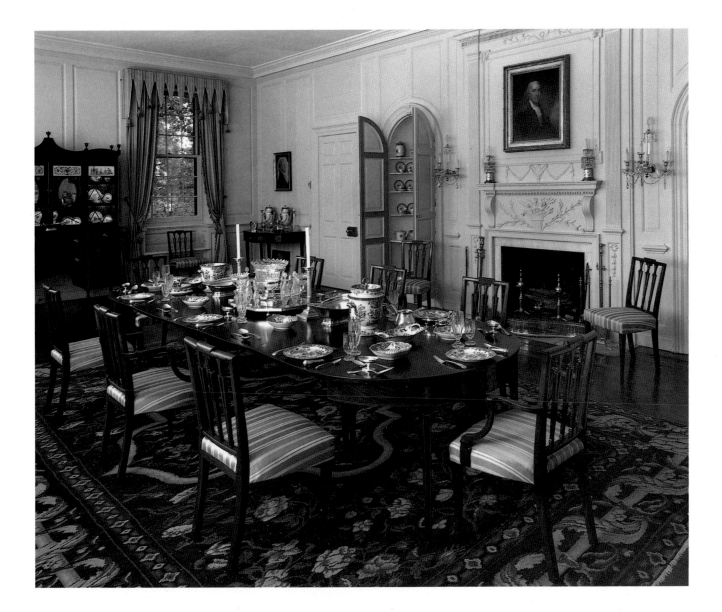

Silver tankards made
by Paul Revere grace
a sideboard in the
Du Pont Dining Room.

The largest piece of furniture in the
collection, this desk and bookcase in the
Lake Erie Hall was made in 1796.

1815. And there is an ancient family connection: twelve of the side chairs were purchased in New York in the 1790s by a du Pont serving as attaché to the French legation. The room reeks of top-rank Americana. On one sideboard are six silver tankards by Paul Revere and a pair of knife urns once owned by merchant king Elias Hasket Derby. Above that ensemble is an unfinished painting by Benjamin West of the signing of the Treaty of Paris in 1783. By one account, West couldn't finish it because the British representatives did not show up for the sitting.

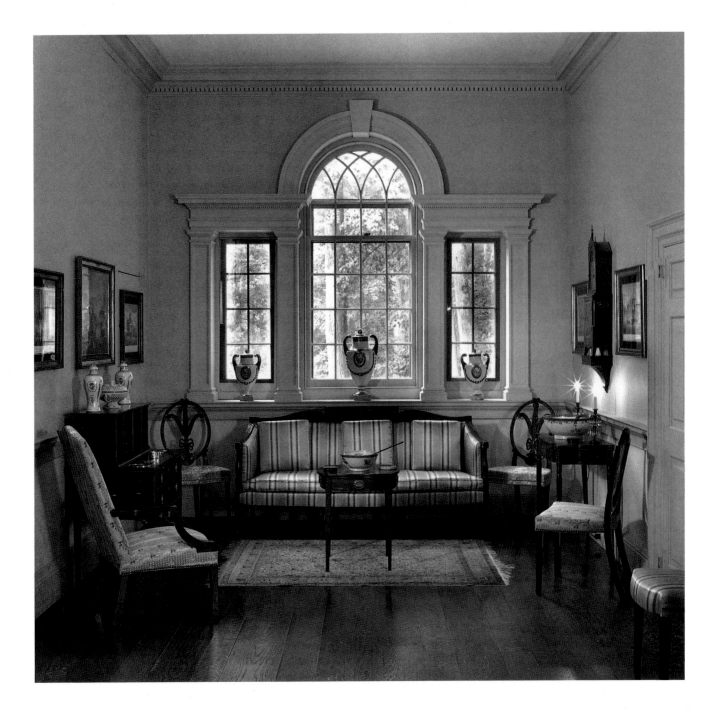

The Dining Room Cross Hall features a Palladian window from Port Royal, near Philadelphia.

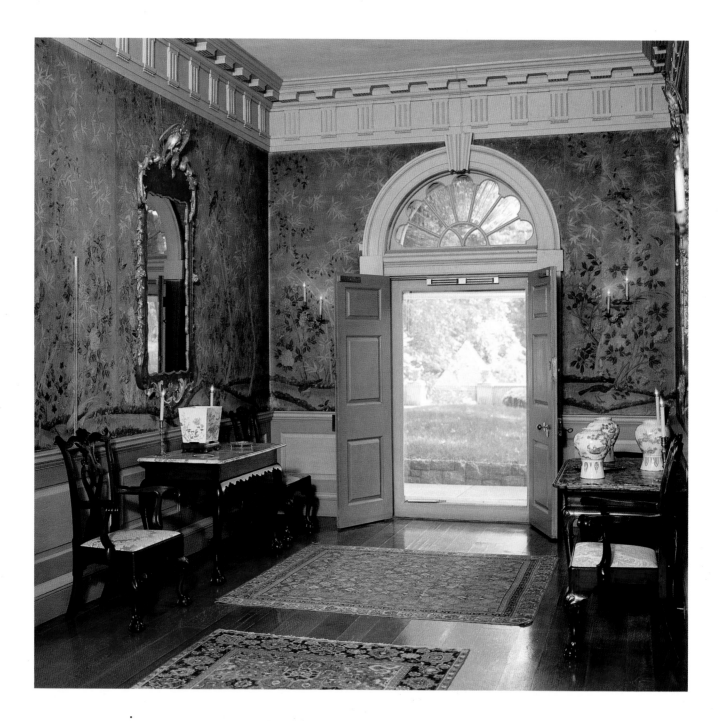

The Port Royal Entrance Hall came from a house

in the Frankford section of Philadelphia, Pennsylvania.

Woodwork of the Cecil Bedroom was in a Maryland home

of about 1730; the furniture is from New England.

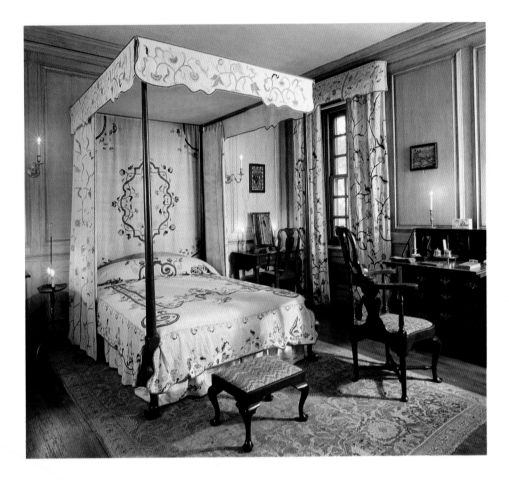

Winterthur lore, as well as the evidence, suggests that of six distinct design periods featured in his rooms, Henry F. du Pont preferred the Queen Anne, Chippendale, and Federal. Many of today's visitors seem disposed toward Chippendale, of which the Port Royal Parlor is a superlative, perhaps supreme, expression. This majestic room's cornices, pediments, and pilasters came from the 1762 country house of wealthy Philadelphia merchant Edward Stiles. On either side of a magnificent fireplace, Philadelphia Chippendale furniture of the highest quality re-creates the symmetry demanded by the Classical Revival era. Among the furniture is a matched pair of sofas once owned by John Dickinson, a Revolutionary-era patriot, statesman, and author. The pair had been separated; du Pont bought one, heard of the other, and tracked it down. Philadelphia chairs and two elaborate highchests are among the room's other distinguished objects.

The Port Royal Parlor should feel at home at Winterthur, for to keep it company du Pont installed woodwork from the original entrance hall of the same Frankford, Pennsylvania, mansion. In it hangs a pair of rococo looking glasses from a prominent Boston mansion of the mid-eighteenth century, and the walls are covered with centuries-old Chinese paper. Du Pont liked the Port Royal Hall so well that he made it the main Winterthur front entrance from 1930 to 1950, possibly the time when he was most enjoying the property. He also re-created a Port Royal Bedroom, displaying Philadelphia Chippendale furniture of more restrained design than that in the parlor, as well as rare pieces from Lancaster, Pennsylvania.

The Blackwell Parlor, while smaller than the Port Royal Parlor, exceeds it in the ornateness of its high-style Philadelphia Chippendale rococo, with mahogany gleaming like dark velvet. The room's pastry-like fireplace, chimney breast, and pedimented doors came from a Philadelphia town house of 1764, certainly a prime year for the genre. The furniture includes eight pieces with rare (for America) hairy paw feet.

The great parlor of a Maryland country house seems quiet after such high style. The Marlboro Room, incorporating green-painted paneling from a house built in 1744, provides a cool elegance for some extraordinary furniture and art. Two voluptuously curved wing chairs draws the most attention: all four legs of each chair are a match in their shell-carved, cabriole style. Paintings include two portraits by Charles Willson Peale, and likenesses of some eighteenth-century du Ponts.

Furniture of an understated design perfection seems to have suited du Pont best. His own bedroom reflects a fairly early—even relatively plain—taste for the Queen Anne style. But his pursuit of historic interiors was altogether catholic, as if he had an obligation to honor the artifacts of every economic scale. A pair of 1755 rooms from Berks County, Pennsylvania, echos the lives of German settlers, whose influence on Pennsylvania was a major factor in colonial American ethnography. The Kershner Rooms, with their archaic (for 1755) stylings, suggest forms of the German Renaissance. Pennsylvania German furniture, pewter, and fraktur complete the collections in these rare rooms.

And there are other magical views into the lives of Thomas Jefferson's "middling sort" of people. A reconstructed courtyard surrounded by vintage façades seems to take the viewer not only back in time but out of doors, although the entire Court ensemble (on the ground floor) is thoroughly embraced by the rest of the massive Winterthur building. The Red Lion Inn, an early nineteenth-century Delaware structure, contributes one colorful front to the Court, as well as interior room settings for the display of collections of Windsor furniture, decorated tinware, and Staffordshire. The Blue Staffordshire Room displays a large collection of English transfer-printed pottery, which was exported to North America in large quantities. The collection's emphasis is on rare examples decorated with arms of the original states and Lafayette commemoratives.

Other courtyard structures also serve as more than picturesque backdrops. The doorway of the Connecticut River Valley House, an early eighteenth-century structure, leads to Schimmel Hall and its collection of carved eagles, tavern tables, seventeenth-century chests, and eighteenth-century chairs. And, there is Montmorenci, built originally in North Carolina about 1822. In this case, du Pont distributed Montmorenci's original riches vertically through several floors of Winterthur. The plantation house was especially notable for its wonderfully graceful staircase, curling upward through an elliptical well. This was reinstalled on the fifth floor, where it is a perennial favorite. The curving beauty of the free-hanging

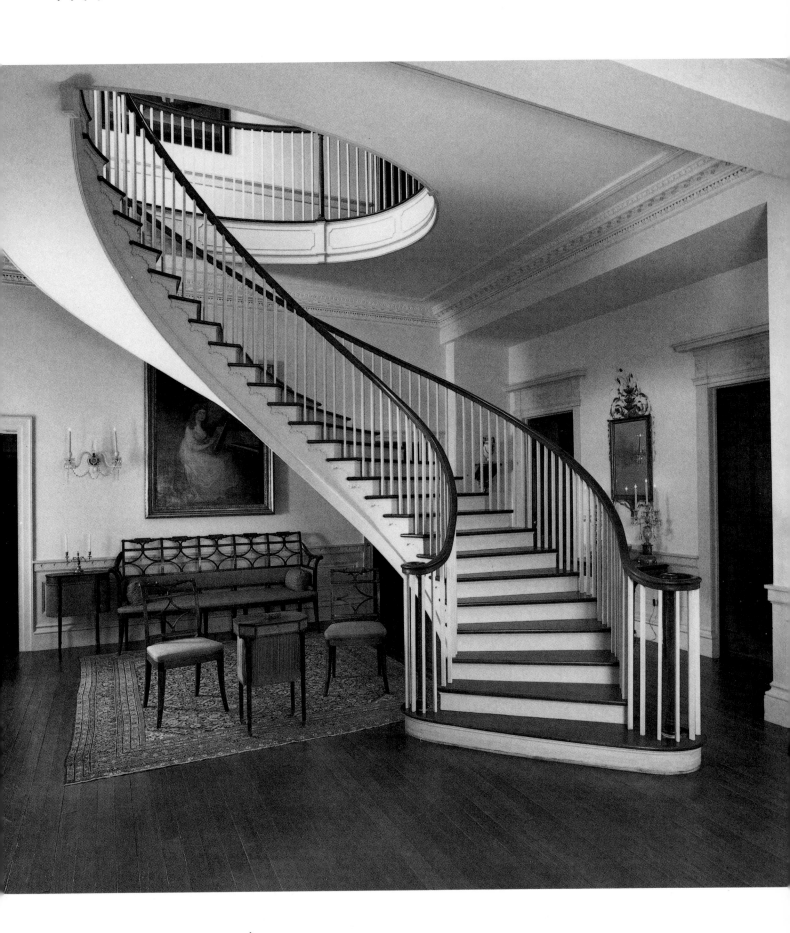

The Montmorenci Staircase came from a North Carolina house of about 1822.

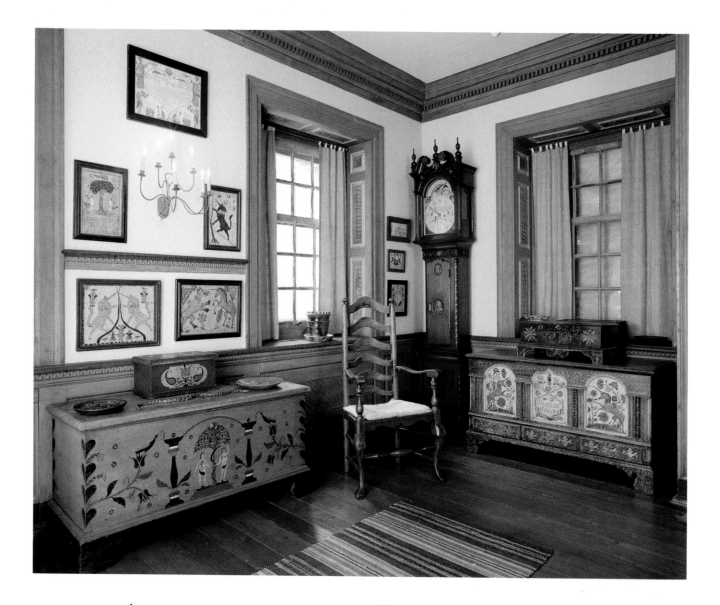

Named for the colorful Pennsylvania German
pen drawings on its walls, the Fraktur Room
was installed in 1952.

The Empire Parlor, exemplar of a late period
for Winterthur (c. 1839), uses elegant woodwork.

The Empire Bedroom demonstrates the
monumental quality of the Empire style, as
interpreted by American craftsmen.

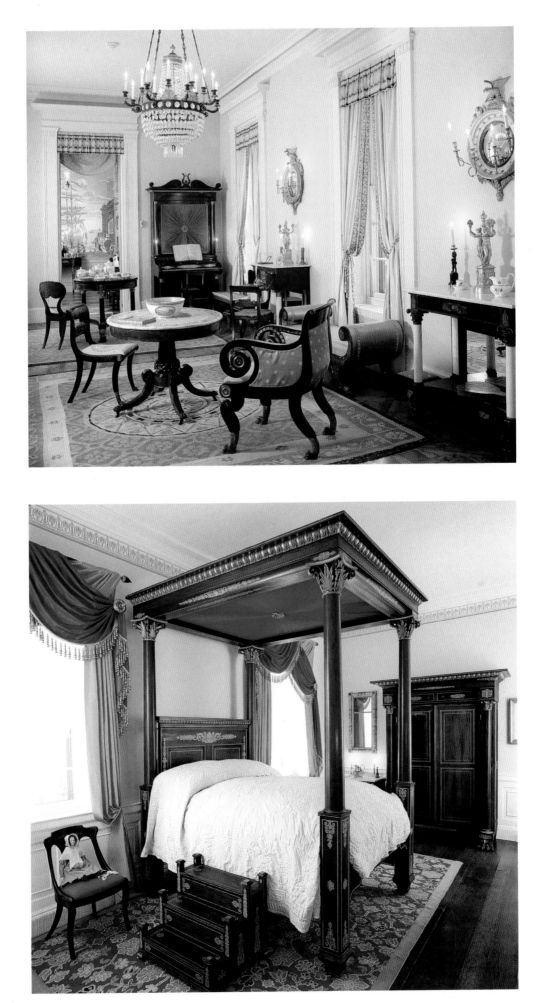

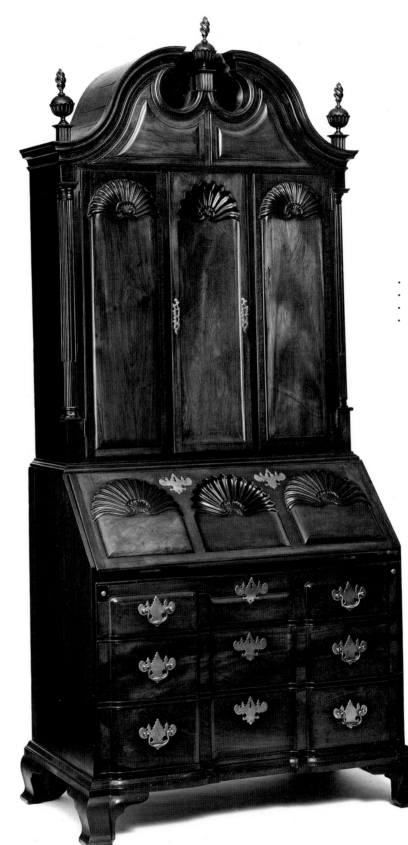

This Rhode Island desk and bookcase was probably made in the Townsend-Goddard shop.

staircase is enhanced by groupings of crisply styled Federal furniture from New York and New England.

Henry Francis du Pont adhered faithfully to his dictum that no object in a room should stand out, that the overall harmony of the room was the important thing. Yet on close examination some articles simply radiate star quality. In the Queen Anne Dining Room, du Pont's collection of New York silver is a case in point. Here is some of the best there is, including one of the largest-known engraved beakers, a trefoil handled porringer made only in New York, and a repoussé two-handled brandy bowl. And other rooms have objects of supernal beauty and rarity that may call out, in well-modulated tones, to those with the eye to recognize their quality. A case in point is the Chestertown Room, so named for its architectural elements from a wealthy, historic community on the Eastern Shore. The room holds furniture from some of the finest craftsmen in the American colonies: a tea table by John Goddard, and a breakfast table by John Townsend, both of Newport, Rhode Island. Yet the best of all may be a blockfront desk and bookcases attributed to the Goddard and Townsend family groups. The blockfront form was raised to its ultimate beauty by the confidently restrained masters of eighteenth-century Newport.

Unlike Henry Ford, whose collecting was clearly disposed toward artifacts of the Northeast, du Pont's interest—though certainly tilted northward—ranged eagerly up and down the original thirteen states. Perhaps his roots in the Brandywine Valley, close to the Mason-Dixon Line, helped give him a Mid-Atlantic viewpoint. In any case, he did not neglect the South. The features from Montmorenci influence a number of Winterthur settings, and the Chippendale Room is one of the finest rooms of all, with woodwork carved in wonderful refinement and authority. It came from the home of a Charleston nabob, built on Broad Street in 1772. The furniture is in the Queen Anne and Chippendale styles.

The South provided Henry Francis du Pont's final period room, although he died before it was installed. The Georgia Dining Room came from an 1837 house in Milledgeville and is furnished in the American Empire style. The period was not du Pont's favorite, yet it was part of the golden age of American craftsmanship, and the end of the 1640–1840 period represented by Winterthur. Another expression of the mid-nineteenth century is the Empire Parlor, with its woodwork—including satiny doors of cherrywood—from an Albany mansion. The furnishings, including a rare upright piano, reflect a body of styling that had become very complicated: inspiration from ancient Egypt and Greece, as rediscovered and interpreted by the French. Many would say that the Empire Parlor shows the nineteenth century at its best, but others might prefer the Phyfe Room, a parlor set up around woodwork that came from a New York City town house of 1806. The early Duncan Phyfe furniture coincides perfectly with the late Federal architectural trim.

Du Pont's ties to the Brandywine must have brought him extra satisfaction with the installation of the Shipley Room. This was a clearly important relic of pre-

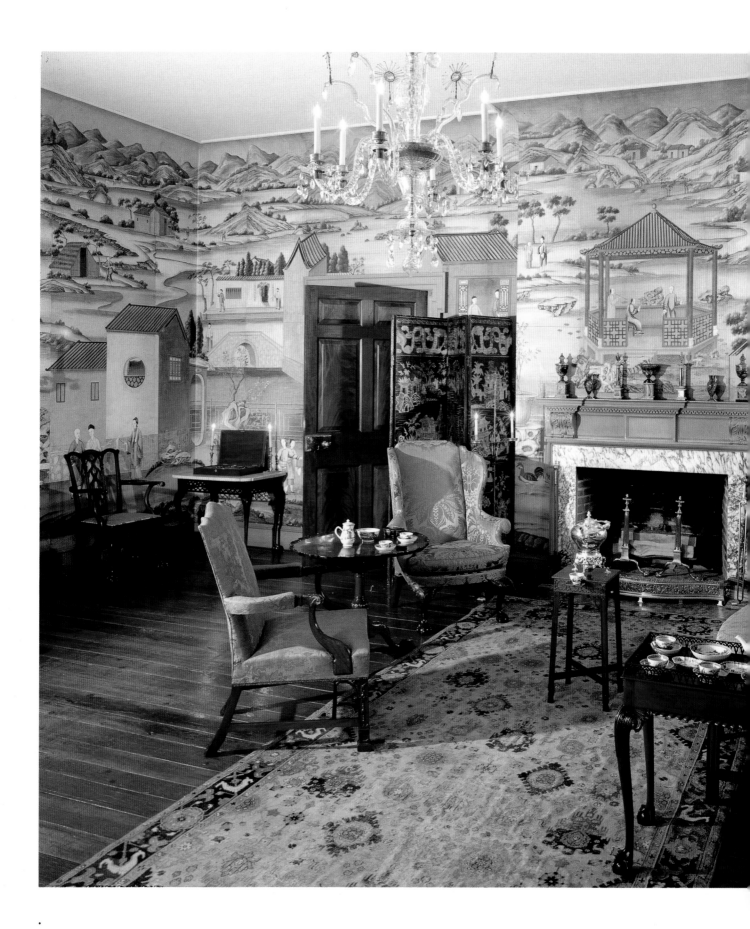

The wallpaper of Winterthur's supreme setting of chinoiserie, the Chinese Parlor, was hand painted around 1770.

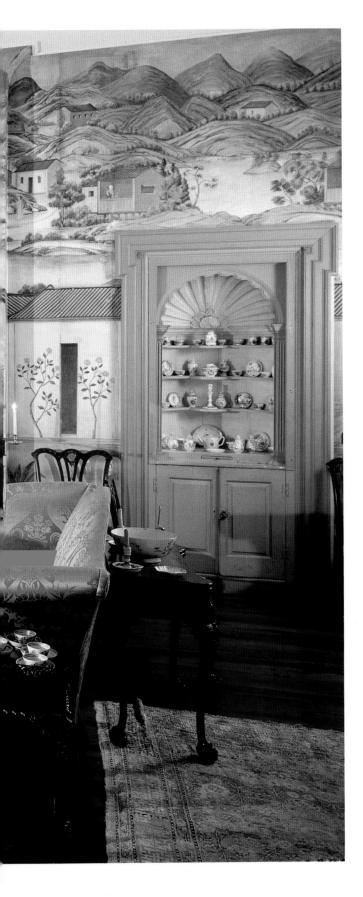

Revolutionary Delaware, the home of a prominent family of Quaker flour millers. Moreover, it was from the very house, at 16th and French streets in Wilmington, where Joseph Shipley, the builder of Rockwood, was born. Today, the room is filled with Delaware-related furnishings.

Eighteenth-century Americans enjoyed a fascination with all things Chinese, and they adroitly bedaubed oriental designs on such articles as tall case clocks and high chests of otherwise standard Queen Anne and Chippendale styles. The Readbourne Parlor, whose clean chiseled paneling came from a 1733 Maryland house, accents this capricious vogue as it appeared in the Queen Anne era, highlighted by an amazing pseudolacquer Boston high chest of the 1740s. Yet Winterthur's supreme display of Chinoiserie is the Chinese Parlor. The theme is set against a background of wallpaper hand-painted in China around 1770. The furniture, which is primarily Chinese Chippendale, demontrates how various Philadelphia, Newport, and Charleston craftsmen interpreted Chinese themes in mahogany.

The Baltimore Drawing Room illustrates a favorite du Pont technique, reincarnating the look and the ambience of a specific place and time. The Drawing Room's Baltimore-made furniture of the turn of the nineteenth century includes a cylinder-front secretary and sofa that brilliantly demonstrate the Baltimore style of simple, almost severe, elegance. Baltimore furniture relied on the perfection of its proportions, complex inlay and veneer, and consummate craftsmanship.

Winterthur is so vast, the overall impact of its period rooms so hypnotic, that some

nonresidential exhibits rarely seem to get the notice that they deserve. Shop Lane, for example, is a third-floor complex of period commercial ventures. The Counting Room demonstrates the way an office was set up early in the nineteenth century, in the manner of a small office outbuilding or dependency. The End Shop reincarnates a country store, and shows du Pont's ingenuity in gathering widely scattered architectural elements and assembling them into something interesting. He found the store window in Middleburg, Virginia, the door in nearby Chadds Ford, the interior in New York City, and the counter in Red Lion, Delaware. All this comes together as background for a storeful of goods: pewter and britannia ware, tinware, brass, toys, porcelain, hardware, and textiles.

The Kingston Shop was reconstructed around an 1830s shopfront and door from Kingston, New York. Inside, it holds a collection of Staffordshire dinnerwares from the store's original period, many transfer-printed with American themes. The Baltimore Shop features a complete façade from the Maryland port city and functions as a showcase for a collection of American and European copperware. An earlier era is recalled by the Peck's Slip Shop, which began its life in New York City at the end of the eighteenth century. It displays a selection of Staffordshire salt-glazed stoneware, mostly from the eighteenth century.

Fanciers of Chinese export porcelain might well insist on seeing the China Shop, a composite of architectural features from Alexandria and Fredericksburg, Virginia. It displays a superb collection of oriental wares, concentrating on the famille rose design that was hugely popular in America after 1760. Another aspect of our pioneering oriental interest emerges in the China Trade Room, based on woodwork from a 1763 house in Smithtown, New York. The room displays a collection of Chinese lacquered furniture and paintings of scenes inspired by the China trade, and is presented as du Pont's idea of the office, or garden house, of an American trader of the early 1800s.

It staggers belief that Henry Francis du Pont's passion for gardening was fully equal to his love for antiques. Yet much of the time he spent at Winterthur—chiefly spring and fall—found him outdoors, planning, revising, and working on his landscape.

"I was born at Winterthur and have always loved everything connected with it," he said. As a boy he poked into "everything that was going on," including the milking of cows. His father, the colonel, an enthusiastic gentleman farmer and horticulturalist

The Baltimore Drawing Room demonstrates

the superb refinement of Baltimore-made furniture.

Installed by du Pont in 1948, Shop Lane

demonstrates commercial ventures of the early republic.

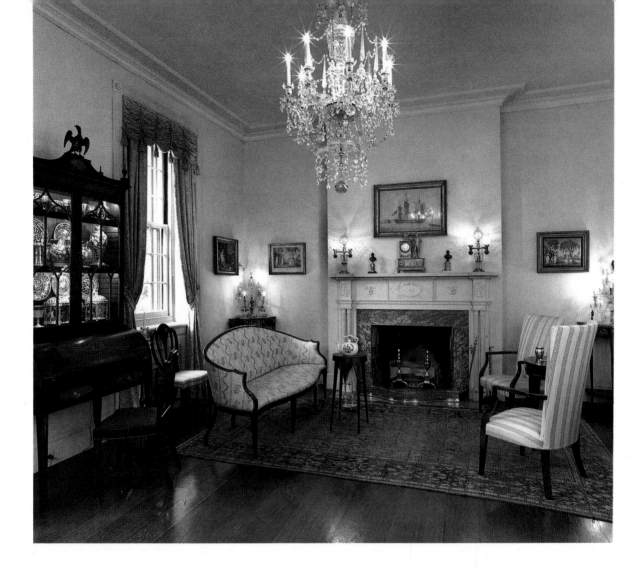

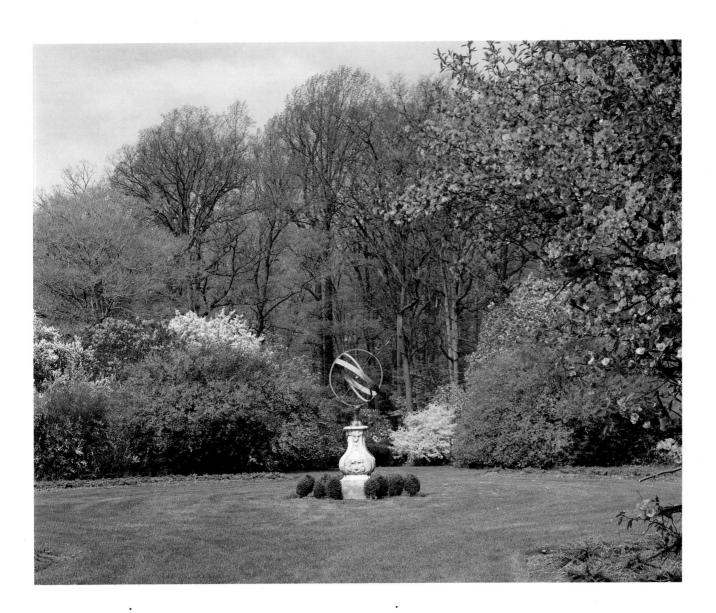

Covering eight acres, the Azalea Woods are shaded by giant tulip poplars, beeches, and oaks.

The Sundial Garden was installed in the 1950s on the site of erstwhile tennis and croquet courts.

who made sure little Henry and his sister knew the Latin designations of all the estate's plants, made him farm manager in 1915. The thirty-five-year-old launched a long and successful upgrading of Winterthur's dairy herds and crop operations. But horticulture and garden design, which he had studied at Harvard, interested him as much as cows.

At Winterthur he pursued his ideal of the natural and informal garden. Du Pont, who referred to himself as "head gardener," was forever revising his grounds. At its

maximum in the 1920s, Winterthur covered 2,400 acres and employed 77 full-time gardeners; today's figures are 980 acres and about 20 gardeners, still a fabulous enterprise and one that remains faithful to du Pont's plan.

The heart of it is a 200-acre tract, with some 60 acres of highly refined gardens around the main house connected by a network of garden lanes and featuring eleven specialized garden areas. The 8-acre Azalea Woods tract dates to the 1920s, when the chestnut blight wiped out many of the large native trees that grew here. With gaps in the remaining forest of beech, oak, and tulip poplar, Henry Francis du Pont saw an opportunity for an azalea garden and began planting Kurume azaleas, an ancient hybrid from Japan. Then he added Japanese torch azaleas, Dexter hybrid rhododendrons, and wild flowers. Here, perhaps, du Pont's sense of color—"the thing that counts more than any other," he once said—reached its highest expression. In May, the Azalea Woods is a spectacular testimonial to his talent, when billows of color surge under the cathedral-like columns of towering tulip poplars.

The garden area called Magnolia Bend recalls the tree planting of Colonel du Pont, Henry Francis du Pont's father. Large saucer magnolias unveil their pink and white blossoms in April, followed by lilacs, azaleas, and camassias. It is also spectacular for its April daffodils and forsythias. Nearby, in the Winter-Hazel Area, du Pont planted winter-hazels and Korean rhododendrons, creating an April color blend of yellows and mauves. The pinetum is another reminder of Colonel du Pont: he began this grove of cedars, firs, pines, and spruces early in the century; it now totals more than fifty species and varieties. Henry Francis du Pont, with his extraordinary color sense, improved on his father's grove with an addition of flowing shrubs, including quinces.

Where the du Ponts once had tennis and croquet courts, Henry Francis created the Sundial Garden in the 1950s. Star magnolias, spireas, cherries, and Chinese snowball viburnums are some of the spring-flowering stars of this fragrant setting. In the 1960s, du Pont was distressed to see a great sycamore in ill health; he ordered a tree surgeon inside to administer treatment and pour in 19 tons of bricks, rubble, and concrete. It worked, and perhaps in celebration, he designed the Sycamore Area around the recovered tree, a gallery of flowering summer shrubs, like late lilacs, deutzias, and styraxes. Still planning new delights in the 1960s, du Pont transformed an abandoned quarry into the Quarry Garden, a refuge for shade-loving perennials such as candelabra primroses. A section of man-made ponds provides homes for waterfowl at the foot of Oak Hill, and brilliant displays of summer color from Japanese dogwoods, deutzias, and native azaleas. Lavender colchicums and yellow fall daffodils, to mention a few, continue the blasts of color into the fall. One of his tenets was to mass the same kinds of flowers for maximum effect.

Closer to the house, the Reflecting Pool Area ornaments what was the family swimming pool, built by du Pont as part of the great Winterthur expansion of the late 1920s. It is adjoined by a woodland rich with wild flowers and ferns. On higher

ground just north of the house, du Pont began some of his earliest garden experiments in 1902, recalled today in the garden area known as the March Bank. It is famous today for its mauve crocuses, scillas, chionodoxas, and wild flowers. Finally, the Peony Garden contains some of the most historic plants at Winterthur. Here are tree and herbacious peonies that date to the 1940s, and azaleas that go back to the 1930s.

In 1951, du Pont turned the house over to the Winterthur Corporation, a nonprofit educational institution. Henry and his wife moved out of the main house and into a new, smaller residence a few yards away. They had been living in the midst of construction for decades, and it was not over yet: in addition to garden improvements, he launched massive new additions to the museum house, which he simultaneously opened to the public. In 1959 and 1969 new additions again swelled the massive house, and du Pont continued collecting until his death, which came at Winterthur in 1969. By then his collection of furnishings had reached almost 60,000 items.

And there was more construction to come: a new exhibition building, completed in 1992, contains about 22,000 feet of exhibition space in three galleries. The new structure, connected to the original museum building with an appropriate blending of architectural features, relocates the entrance to the entire museum complex and enhances the garden's accessibility.

One of his contemporaries, a man who knew him well and who was also a major collector and museum expert of impeccable credentials, said of his personality: "It was hard to grasp. He was a private person. You don't find a sense of his personality remaining at Winterthur, except in the magnificence of his collections and the taste of his gardening." And there is perhaps no rational accounting for the magnificent obsession of a great collector such as Henry Francis du Pont, who probably did not understand the passion any better than ordinary mortals. It is worth noting that in 1931 he wrote a fellow enthusiast that his house was almost complete, his collecting about done, and he only needed a few small items to finish up everything.

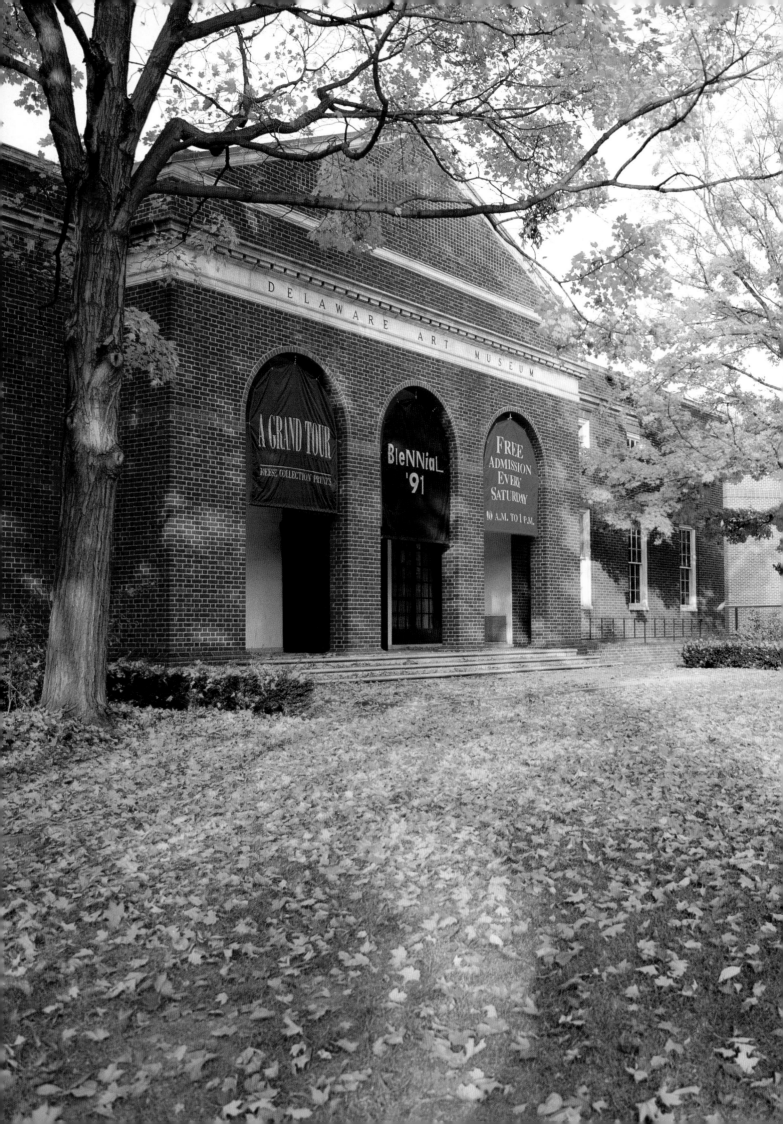

T·H·E

D·E·L·A·W·A·R·E A·R·T

M·U·S·E·U·M

I n the first year of the twentieth century, the acknowledged king of American illustrators resigned from the art faculty at the Drexel Institute in Philadelphia and opened his own art school in Wilmington. In that same year, a Wilmington industrialist made the latest of his many voyages to England, buying Pre-Raphaelite art with practiced eye and passionate dedication. There was no connection between the two artistic missions, and the men's respective visions were not totally congruous. Yet the legacies of Howard Pyle and Samuel Bancroft were locked on courses that would meet decades later in a happy fusion. You might say that posthumously, and inadvertently, Pyle and Bancroft founded the Delaware Art Museum.

It is still a relatively young institution, set in hilly northern Wilmington on the Frederick Olmstead-designed Kentmere Parkway, which traverses a neighborhood of handsome fin-de-siècle homes up the hill from the Brandywine River. The original building, behind a triple-arched Georgian façade, dates from 1938 and was more than doubled in size by a contemporary wing that opened in 1987. It is an unusually active, energetic museum with vital links to Delaware's contemporary life. Its collection of American art from 1840 onward includes star-quality entries from every decade. But somehow, the spirits of Pyle and Bancroft seem to permeate and flavor the institution, from the most dignified gallery to the children's room for shape-and-form experiments called Pegafoamasaurus. If we would understand the Delaware Art Museum, we must get to know the works of Howard Pyle and the Pre-Raphaelite collection of Samuel Bancroft.

Any art museum seeking an ideal inspirational figure might well select Howard Pyle, an artist of extraordinary gifts, famous in his day and increasingly appreciated as he is rediscovered by each new generation. He was, furthermore, a native Wilmingtonian, born in 1853 to a prominent family: his father was a leather

manufacturer, and his Quaker-born mother was active in Wilmington's cultural and literary affairs. The youth grew up during the Civil War, doubtless hearing epic stories of battles a scant 125 miles south. He devoured King Arthur stories, German fairy tales, Robinson Crusoe, and the works of Dickens and Thackeray. At age sixteen he began commuting to Philadelphia for art instruction at a European-style academy, and also studied anatomy with a Philadelphia doctor. In 1872, at nineteen, he opened a studio in Wilmington and began giving drawing lessons. In 1876 his first illustrations were accepted for publication by *Scribner's Monthly.* He moved to New York City, continued producing magazine illustrations, and attended classes at the Art Students' League. His circle, in the late 1870s, included Edwin Austin Abbey, William Merritt Chase, and F. S. Church.

Pyle returned to Wilmington at age twenty-six, opened another studio, married, and began a long career as family man, pillar of the community, and author and artist of prodigious output. Much of his early work seems inspired by medieval German woodcuts, Pre-Raphaelite illustrations then fashionable, and even the works of Renaissance artist Albrecht Dürer. Most of his early illustrations were designed for young readers, and not only did he illustrate books of children's tales, he wrote the books. In 1887 his first pirate stories appeared in *Harper's Weekly* and *Harper's Monthly Magazine.* For decades, Pyle's pirates would comprise his most popular work.

In 1894 Pyle began teaching a class in illustration at the Drexel Institute in Philadelphia. By then he was acknowledged among the leading American illustrators. He became friends with Frederic Remington. He illustrated magazine works by Woodrow Wilson and Henry Cabot Lodge. In 1904 even Mark Twain asked that Pyle illustrate his latest story for *Harper's Monthly,* "Saint Joan of Arc." Yet the more he succeeded, the more he seemed to want to teach. In the summer of 1898, he had begun offering summer art classes at Chadds Ford, Pennsylvania. And in 1900 he opened the Howard Pyle School of Art in Wilmington.

Pyle's mastery of historical themes led him to mural painting, and in 1905 he painted the Battle of Nashville for the Minnesota State Capitol. In 1907, at age fifty-four, there were signs that his youthful enthusiasm for medieval romances was beginning to fade. After a well-reviewed New York exhibition of his paintings in 1909, he turned again to murals but became dissatisfied with his grasp of the genre and decided to sail to Italy and study the murals of Old Masters. He leased a villa in Florence and settled in for what could have been a culminating phase of his career. But he was ill with Bright's disease, and after slightly less than a year in Italy he died on November 9, 1911.

Almost immediately, Wilmington began organizing to protect the legacy of Howard Pyle. The Delaware Art and Library Association was organized one month after his death with a twofold purpose: it would buy sixty-seven paintings and sixty drawings by Pyle from the artist's widow—to keep them in Wilmington—and it

Page 102. *The original building of the Delaware Art Museum opened on Kentmere Parkway in 1938.*

The atrium of the Delaware Art Museum

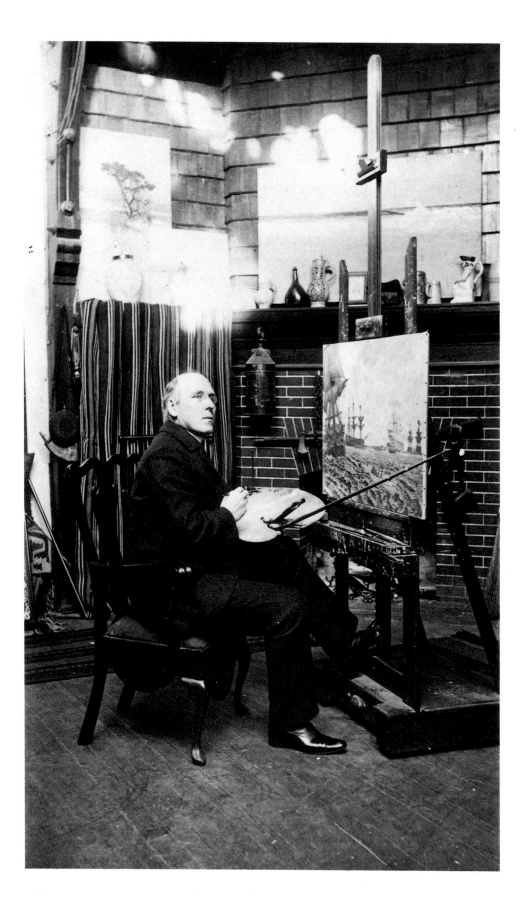

Howard Pyle in his studio at work on

The Evacuation of Charleston by the British,

c. 1898. Delaware Art Museum,

Howard Pyle Archive Collection.

Howard Pyle and his students, about 1903.

Standing, left to right: George Harding,

Gordon McCouch, Thornton Oakley,

N. C. Wyeth, Allen True. Seated: Howard Pyle.

Delaware Art Museum, Howard Pyle Collection.

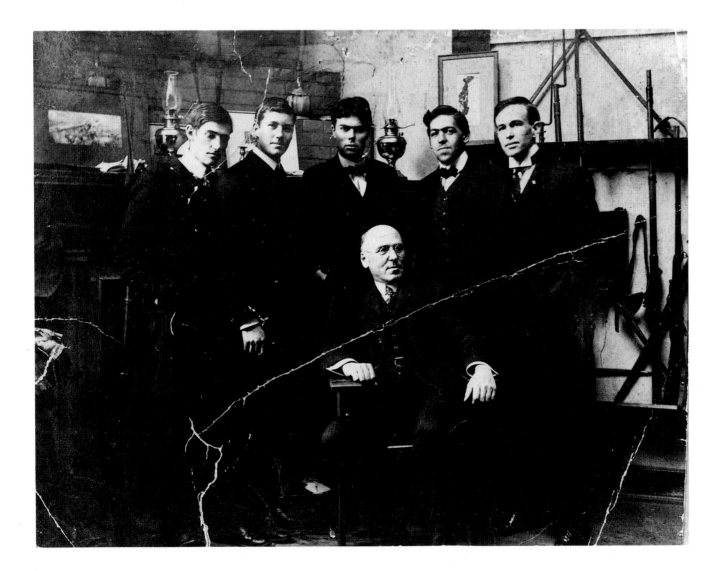

would help build a new public library, which would include a gallery for the paintings. In 1912, the organization incorporated with a new name, the Wilmington Society of the Fine Arts, and then it staged the first exhibition of Pyle's work ever held in Wilmington. The schedule had to be extended to accommodate the crowds. After that promising start, it would be more than a decade before permanent gallery space was available in the new library, and then another fifteen years (1938) before the first building of today's Delaware Art Museum was built on Kentmere Parkway. By then, the Howard Pyle collection of Wilmington had grown from 127 to 457 works.

There have been other major artists who also managed to be beloved local personalities, but Pyle's case is singular. How do we account for his enduring popularity?

First, he was so clearly a good citizen and devoted family man. He was a founder and member of literary and theatrical clubs, served as church officer, voted Republican, sang in chorales, gave commencement addresses, designed the Christmas Seal for the American Red Cross, pitched in when needed in the family leather business, and frolicked with his children at their summer place at Rehoboth Beach, where he ceremoniously raised flags on the boardwalk. Yet beyond the pleasant if burgherish stereotype, Pyle's supernal talent combined with boundless energy and shrewd direction to carry him to fame at the top of a difficult and competitive craft. And not only was he king of the illustrators, he was a born teacher, generous with his skills and insights.

Pyle thought the day's prevailing art-education techniques were repetitive and unimaginative. His idea was that, while a student must learn to draw, the imagination must be stimulated and involved. "After you have chosen a general subject, submit it to the crucible of your own imagination and let it evolve into the picture. Project your mind into it. Identify yourself with the people, and sense, that is, feel and smell the things that naturally belong there."

That quality of imagination gets to the heart of Pyle's talent, which is, more than the supporting pillars of personal probity and teaching skills, the keystone of his enduring fame. The child whose parents read to him Robinson Crusoe, King Arthur, and German fairy tales, and the youngster who saw Civil War troops march through Wilmington, clearly was predisposed to legendary, dramatic themes. Then, with his natural ability honed by timely instruction, he had the good fortune to launch his adult career just as the golden age of art illustration was beginning. It was a time when great magazines like *Harper's Monthly, Scribner's, Century,* and *Collier's* reached ever-widening audiences. The public taste was evolving, shedding some aspects of Victorian sentimentality, and developing a new historical sensibility. It was Pyle's genius to draw or paint period scenes that were gripping but not overwrought; correct in detail but not prosaic. And somehow, his imagination communicated itself to the viewer. He not only captured a moment, he managed to suggest the drama of

Howard Pyle

Marooned, *1909*

Oil on canvas

Delaware Art Museum,

Howard Pyle Collection

what had gone before, and what might happen next. And even beyond that, the best of his paintings radiated a sense of independence or universality. They may have been illustrations, but they could also stand alone. They contained self-sustaining dynamos of psychological impact. There is emotion here. *Marooned* is more than a picture of a sailor who has been stranded, probably without hope, on some lonely beach, it is a glimpse of all the hurts of human alienation, an image of boundless, subtle anguish. Although it was an illustrative subject, it represented Pyle's successful contention that painting technique was not bound by the rules of printing. Some consider *Marooned* his masterpiece; it is clearly one of the stars of the museum's permanent collection. Then again, some viewers prefer *The Mermaid*. Who could study it without feeling the intermingled throbs of magnetism and pain of a hopeless love? *The Mermaid*'s haunting passions become especially affecting when the viewer learns that this painting, on Pyle's easel when he died at fifty-eight, was his last, hinting at aspects of mystery that may have been his future direction. We should add, too, that *The Mermaid* was not done as an illustration. Pyle painted it for himself.

He must have had a singular weakness for pirates, for he painted them like no one else save his great student, N. C. Wyeth. One of Pyle's masterpieces of the genre, *So the Treasure Was Divided,* illustrated one of his own stories in 1905. It depicts a crew of scroungy pirates squatting on a beach, splitting up the swag. So remarkable was Pyle's insight into these characters that producer Steven Spielberg relied on the work during the research for his film, *The Goonies*. Pyle had an astounding gift for believability. We can almost feel the grit of the tawny sand under his pirates. He liked big, open foregrounds, which gave his pictures a deceptive simplicity. In some works he used it to heighten a sense of crisis or menace, as in *The Salem Wolf*. More than half the painting is snow, under a sinister sky; between them, terrified Pilgrims cower before the wolf.

His historical pictures were immaculately researched at a time when such care was unusual. The Revolutionary War battle scenes he painted for Lodge's series in 1898 were so effective that Pyle said he could smell burnt gunpowder in his studio while working on them. The museum's *Attack Upon the Chew House* demonstrates how the detail of his paintings never detracted from their emotional impact, never hindered the drama, never impeded the priceless quality of imagination.

Pyle's favorite artists, whom he extolled and commended to his students, included Edwin Austin Abbey, John Constable, Albrecht Dürer, George de Forest Brush, George Inness, Frederic Remington, sculptor Augustus Saint-Gaudens, and a significant trio of Pre-Raphaelites: Ford Madox Brown, John Everett Millais, and Dante Gabriel Rossetti.

In 1880, about the time that young Howard Pyle was becoming engaged to Anne Poole of Wilmington, a forty-year-old cousin of Anne's named Samuel Bancroft was making his first voyage to England. Bancroft's father had been an English immi-

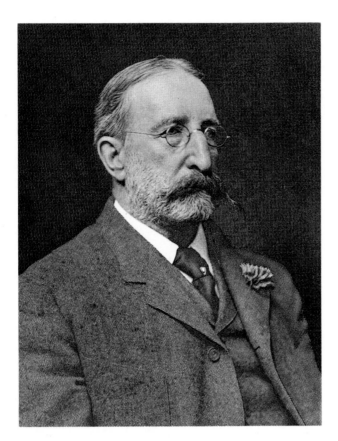

grant, but his mother's family, the Pooles, were connected with most of the promi-
nent Quaker families of Wilmington. Among Samuel's relations was Bayard Taylor, a
widely read mid-nineteenth-century poet, novelist, and travel writer from nearby
Kennett Square, Pennsylvania. The Bancroft family business was cotton milling, and
they lived by the Brandywine near the factory. Samuel was a progressive and
successful manufacturer, but he had developed a hankering for broader horizons.
Reaching England and seeing his first painting by Dante Gabriel Rossetti, he was
"shocked with delight."

The Pre-Raphaelite movement was an English phenomenon, but it coincided with
a period of the closest Anglo-American interaction in many years, and art-conscious
Victorian Americans were ready to be ravished by it. The Pre-Raphaelites were allied
with the Gothic Revival and Arts and Crafts movements. Their sensitive aesthetic
antennae detected ugliness in the styles and factory-produced manufactures of the
industrial age, and they determined—with art critic John Ruskin cheering them
on—that appropriate refuge could be found in a return to the medieval world for
inspiration. Craftsmen of furniture and other decorative objects followed the Arts
and Crafts compass of William Morris and Sir Edward Burne-Jones. The Pre-
Raphaelite founders were Dante Gabriel Rossetti, W. Holman Hunt, and John
Millais. "Pre-Raphaelite" referred to medieval painters whose works (the Victorian
artists insisted) were happier in their innocence and simplicity than the orthodox

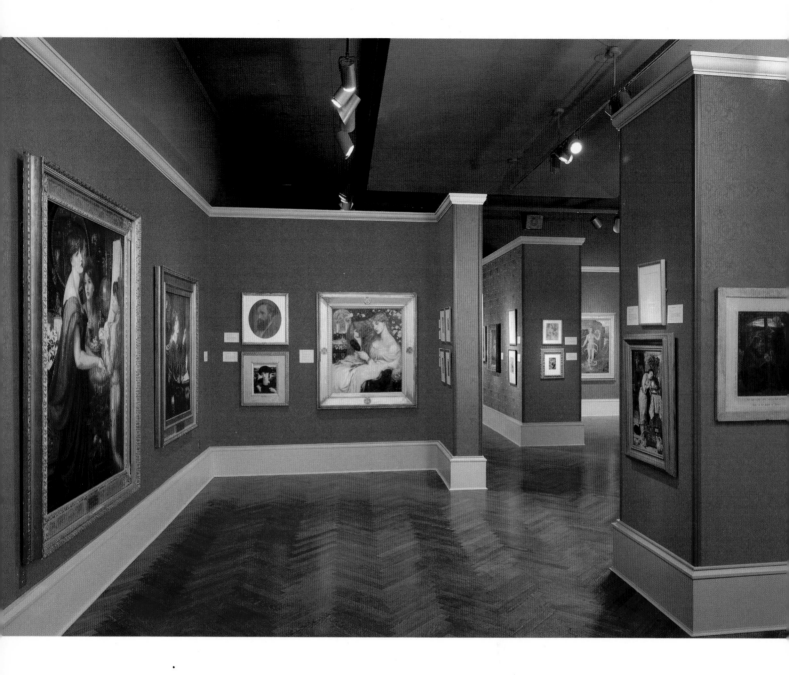

The finest English Pre-Raphaelite collection in

the United States hangs in its own gallery at the

Delaware Art Museum.

Dante Gabriel Rossetti

Found, 1853/59

Oil on canvas (unfinished)

Delaware Art Museum,

Samuel and Mary R. Bancroft

Memorial, 1935

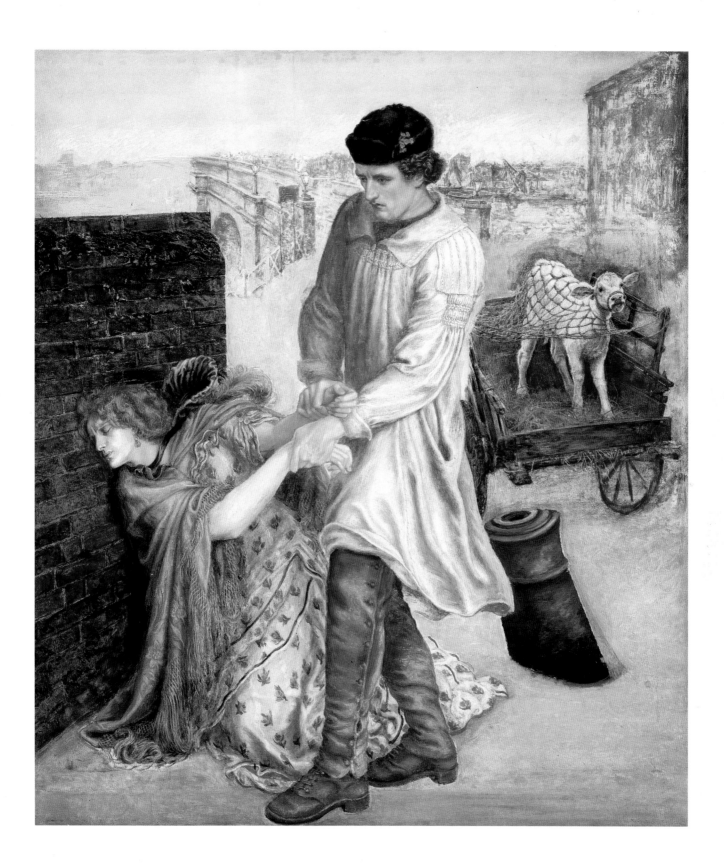

modern product being cranked out by academicians. The Pre-Raphaelites adopted medieval symbolism and imagery, which they often applied to biblical themes. Of course, much of their work quickly found its own level of mannerism. The paintings often portrayed strong-featured, full-mouthed women pulsing with sex appeal. Pre-Raphaelism became an exotic, authentically new style, not the re-creation it had set out to be. Meticulous in detail and bright in color, Pre-Raphaelite paintings twanged vaguely nostalgic chords in the Victorian Christian mind, but they also sparkled with something more and something ineffable.

Through an English cousin who knew Rossetti, Bancroft became captivated by the artist and his colleagues. He returned to England almost annually and began collecting art, meanwhile making friends in English literary and theatrical circles. His first major purchase, Rossetti's *Water Willow,* was the equivalent of hitting a home run his first time at bat. Despite its name, *Water Willow* is a portrait, specifically of Jane Morris, William's wife. As Rossetti was, and would remain, in love with her, the painting is not only an excellent Pre-Raphaelite work but a memento of the personal lives of a talented and exotic company.

Bancroft went on to gather up more of Rossetti's best. *Found* is pure Pre-Raphaelite, a painting drenched in imagery, painstaking in detail, and painful in psychological message. *Mary Magdalene,* a painting whose model identity has been the subject of some puzzlement, is nevertheless the Pre-Raphaelite ideal of a full-lipped, intelligent woman thinking profound thoughts. *La Bella Mano* portrays another woman (the model, Alexa Wilding, is known) whose red-haired beauty also meets the Pre-Raphaelite requirements. Bancroft obtained another version of Alexa Wilding, superciliously combing her hair, in *The Lady Lilith.*

The Wilmington collector went on to Rossetti's contemporaries, collecting *The Council Chamber* and *Hymenaeus* by Sir Edward Burne-Jones. That painter had a different, some might say more innocent and likable, ideal of feminine beauty, which recurs (along with a superb sense of color and stainless draftsmanship) in both paintings. Ford Madox Brown's paintings seem more illustrative, or less symbolic, than the others: his *The Corsair's Return* and *The Dream of Sardanapalus* are based on Byron's works, and his *Romeo and Juliet* is pure Shakespeare.

Bancroft's commitment was all-encompassing. He bought *The Dead Rossetti* by Frederic James Shields, *Mary Magdalene* and *May Margaret* by Frederick Sandys, and *The Highland Lassie* and *The Waterfall* by John Everett Millais. Such works, plus scores of other paintings, drawings, and photographs, added up to a tremendous collection of Pre-Raphaelite art. Samuel Bancroft became so single-minded in his quest that he sought out an elderly woman who had posed in her youth for some of Rossetti's fabulous females, and bought some of the artist's memorabilia from her.

In 1893 Bancroft installed his collection back in Wilmington in his freshly remodeled mansion, Rockford, near the Brandywine. One of the Wilmingtonians who presumably looked at the English paintings with special interest was Howard

· *Dante Gabriel Rossetti*

Mary Magdalene, *1877*

Oil on canvas

Delaware Art Museum,

Samuel and Mary R. Bancroft Memorial, 1935

Pyle. As the 1890s passed, Bancroft made an unsuccessful run for Congress, and then—renewing his pilgrimages to England—consoled himself with new Pre-Raphaelites. He continued collecting nearly until he died, aged seventy-five, in 1915.

It was the luck of Wilmington that Samuel Bancroft's children decided to keep the collection intact; indeed, to continue adding to it. In 1916 the estate bought Rossetti's *Mnemosyne* and a chalk study for *La Bella Mano,* and in 1923 added *Veronica Veronese,* another version of red-haired Alexa Wilding, who is set off perfectly by an equally titian-red violin and a green velvet dress. Meanwhile, the Wilmington Society of the Fine Arts had organized to guard the works of Howard Pyle and help build a new library, where they would be displayed. This expedient gallery opened in 1923, and for some fifteen years would be Wilmington's only art facility. But in 1931 Samuel Bancroft's trustees offered to donate land for a proper art museum and pay for a wing for the museum, which would contain the Bancroft collection. By 1933 the collection was hanging in the library gallery, and soon it was formally donated to the Wilmington Society of the Fine Arts, which was the developing agency of the Delaware Art Center, the first name of the Delaware Art Museum. The new museum opened, as we have seen, in 1938.

Today, the museum's Pre-Raphaelite collection, the best in the United States, is displayed in a rich decorative setting. Red wallpaper designed by William Morris covers the walls. The paintings are the stars, but their era is accented by such objects as William De Morgan pottery, and an important collection of Arts and Crafts English jewelry and metalwork.

As a collector and contributor, Samuel Bancroft has good company in the museum's pantheon. Major associates include the great John Sloan's widow, whose benefactions—as we shall see shortly—have been priceless. In the 1920s, Willard S. Morse donated a large collection of Pyle works and sketchbooks, and a gathering of the artist's published work in books and magazines. The Pyle family also contributed major treasures that included his scrapbooks, reference library, and his ultimate work, *The Mermaid.*

On the foundation of Howard Pyle, the museum began building a broader collection of American art that would include paintings, drawings, sculpture, and decorative crafts. The permanent collection includes art from the middle eighteenth century on, but the chief focus is on American art from 1840, always bearing in mind one great singular exception: the museum's astounding Pre-Raphaelite strength.

The American credentials begin with one of Benjamin West's first portraits, painted about 1757 when the Philadelphian was nineteen. The portrait of a young matron is a fascinating precursor of his then-unknown future in England, a career that would take him to the heights of fame as court painter to King George III, successor to Sir Joshua Reynolds as president of the Royal Academy, and advisor to such struggling young American painters as John S. Copley, Samuel Morse, and

Frederic Edwin Church

South American Landscape, *1873*

Oil on canvas

Delaware Art Museum,

Gift of the Friends of Art, 1964

Charles Willson Peale, all studying in England. From West's slightly naive portrait of *Ann Inglis* the museum visitor can leap nearly half a century ahead to *The Return of Tobias,* a dramatic historical painting that reveals West at his peak.

Charles Willson Peale's son, Raphaelle Peale, although mainly noted for his pioneering still-life and trompe-l'oeil paintings, also produced such splendid portraits as *Absalom Jones* of 1810. The Delaware-born Jones, a Philadelphia Episcopal clergyman, became one of the most important black leaders of the colonial and Federal eras. A Peale contemporary, Bass Otis, worked in both Philadelphia and Wilmington, and his assured portraits of Calvin and Priscilla Smith show why this one-time coach painter became one of America's best portraitists and engravers. Calvin's portrait embodies an additional local connection: it descended in the family of Mr. and Mrs. David Stockwell of Wilmington, who donated it to the museum. Stockwell, as any antiques fancier knows, was one of America's premier dealers for many years.

The collection picks up speed when it passes its official starting line of 1840. Asher B. Durand, that early leader of the Hudson River School, demonstrates his characteristic juxtaposition of towering mountains and peaceful streams in *Classical Landscape.* The painting reflects the new reverence for nature advocated by Durand and his visionary friend, Thomas Cole. It may also be, in part, an interpretation of William Cullen Bryant's poem, "Thanatopsis." The Durand-Cole influence is plain in the next generation of landscapists, of which the museum has a local star, Russell Smith. Smith was a theatrical scene painter in Wilmington and Philadelphia who liked to paint Revolutionary War battlefields; his *Brandywine Battlefield* (1870) is a happy merger of art and local history. It forms a nice contrast to the work of a more famous painter, Frederic Edwin Church, at his brilliant best in *South American Landscape.*

The American collection has more than its share of pleasant surprises, like Philadelphia painter James Hamilton. Forgotten for generations, Hamilton was hailed by his 1850s contemporaries as the ablest marine painter of his time. His seascape, *A Fresh Breeze,* is for 1856 uncharacteristically free, treating light, space, and the elements with a Turner-like spirit. Another Philadelphian, John F. Francis, is represented by *Still Life with Grapes and Peaches* (c. 1845), a skilled work from an important era in American still-life painting.

In a museum that treats illustrators like first-class citizens, it is easy to remember that Winslow Homer began his career as an illustrator for *Harper's Weekly.* His *Milking Time* dates from the very year, 1875, that he ended his newspaper career and went fully into painting. And this early Homer oil shows the same magnificent directness, design, and color sense of any of his later, better-known work.

A lesser-known painter, Thomas W. Dewing, contributes a rare American painting in the French Idealist tradition, *Morning* (1879), in which two sloe-eyed women blast the dawn with long trumpets as gracile greyhounds listen in amazement.

Winslow Homer

Milking Time, *1875*

Oil on canvas

Delaware Art Museum,

Gift of the Friends of Art and other donors, 1967

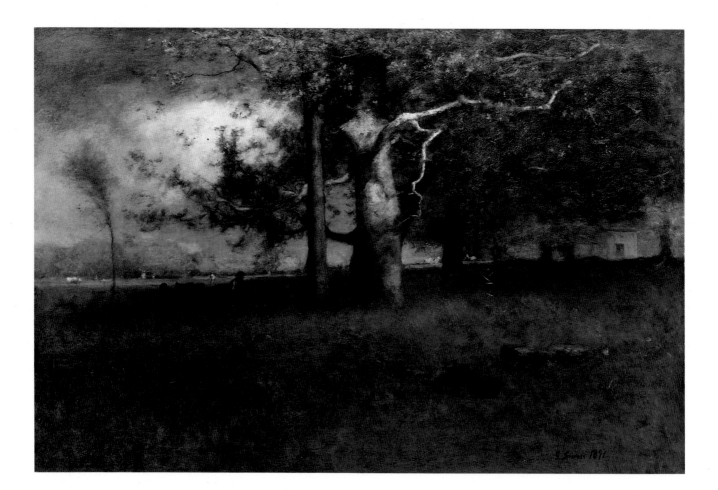

George Inness

Early Autumn, Montclair, *1891*

Oil on canvas

Delaware Art Museum,

Special Purchase Fund, 1965

John Sloan

Memory, *1906*

Etching

Delaware Art Museum,

Gift of Helen Farr Sloan

Fittingly, the museum owns a top example of one of Howard Pyle's favorite landscape artists, George Inness. *Early Autumn, Montclair,* with its gnarled old tree and its russet hues of autumn all luminous and faintly Impressionistic, does in fact suggest haunting similarities to Pyle. Both were Swedenborgians, and presumably accepted that sect's view on nature as a revelation from God: did that mold their outlook?

John Alden Weir and John H. Twachtman, two of the first Americans to embrace Impressionism, are represented with works from the 1890s that deserve to be better known. The matchless Thomas Eakins is represented by the shaggy, brooding head of *Franklin L. Schenck* from 1890; compared with a masterful painting by Thomas Anshutz called *Woman Reading* (c. 1895), and a work by John Sloan called *Violinist, Will Bradner* (1903), the viewer gets one of those flashes of the continuity of art. Anshutz had studied with Eakins, and Sloan studied with Anshutz, all in nearby Philadelphia.

Sloan, in fact, is a towering presence at the Delaware Art Museum. One of the immortals of American art, the Pennsylvania-born Sloan began his career as an illustrator in Philadelphia and New York. In 1908 he was a founder of The Eight, sometimes called the Ashcan School, a disparate group of artists united only in their opposition to academism. Sloan had a gift for human insight and city life that

bordered on sympathetic satire. After a 1960 exhibition at the Delaware Art Museum demonstrated its commitment to American art since the middle nineteenth century, the artist's widow began donating a priceless collection to the museum. She presented Sloan's personal library, complete sets of his etchings and lithographs, and eight of his paintings. In succeeding years she continued adding to this treasury: more than forty paintings by Sloan's contemporaries and students, some 9,000 books, and a gift of hundreds more prints and drawings by Sloan and other young illustrators in the 1890s.

Others of The Eight are well represented in the permanent collection. From the vantage point of time we can study the works of William Glackens, Everett Shinn, Arthur B. Davies, Ernest Lawson, Maurice Prendergast, Robert Henri, and George Luks. In the way of most long-dead artistic uproars, it is difficult to see what all the shouting was about. Was it triggered by the frolicsome Impressionism of Prendergast, as displayed in the museum's *Seashore*? The dramatic palette of Henri's children's portraits, like *Little Girl of the Southwest*? How unlikely it seems! Luks's work may be the most vivid and potentially controversial of the lot; the museum's *Peggy Riordan* is a happy, rich example of his big, thick-pasted, slam-bang style of portrait painting that always seemed to capture some deep bedrock in a sitter's soul.

The museum's early modern artists include Max Weber, Arthur Dove, John Marin, Arshile Gorky, and Marsden Hartley. Gorky's pencil-and-crayon drawing *Untitled*, c. 1943, seems to exemplify perfectly the subconscious inspiration of Abstract Expressionism.

Other twentieth-century works embrace a striking mixture of the best of our own time. Certain titans stand out with their usual prominence. Reginald Marsh's sprawling *Atlantic City Beach* is a hot, squirming, lighthearted blast of color. Edward Hopper's *Summertime* is quintessential Hopper, another of his masterpieces, a summary of Hopper's pitiless unmasking of the bleak deficiencies of city life. It seems a long way from Edward Hopper to such contemporary painters as Al Held, represented by *Rome II*, and to James Valerio's moderately shocking, snake-dominated *Luncheon on the Rocks*. Executive Director Stephen T. Bruni says the museum has been accelerating its contemporary collecting in both painting and sculpture. A newly acquired sculpture of a scrap metal horse, *Riot*, by Deborah Butterfield, is a red and rusty example of a sometimes-controversial genre.

This being the Brandywine Valley, it is fitting that Andrew Wyeth would be a major player in any representative gathering of twentieth-century American art, although the comprehensive Wyeth collection is at the Brandywine River Museum. A strong group of eleven Wyeth works came to the museum in 1965, including *The Corner*, a dry-brush watercolor of one of those battered rural structures that Wyeth has found in the Brandywine region and invested with his enigmatic vision. The best-known Wyeth here is probably *Tenant Farmer*, portraying the desolate and brutal post-deer-hunt reality at a decayed brick farmhouse.

James Valerio

Luncheon on the Rocks, *1989*

Oil on canvas

Delaware Art Museum,

F. V. du Pont Acquisition Fund, 1989

Edward Hopper

Summertime, *1943.*

Oil on canvas

Delaware Art Museum,

Gift of Dora Sexton Brown, 1962

N. C. Wyeth

The Springhouse, *1944*

Tempera on board

Delaware Art Museum,

Special Purchase Fund, 1946

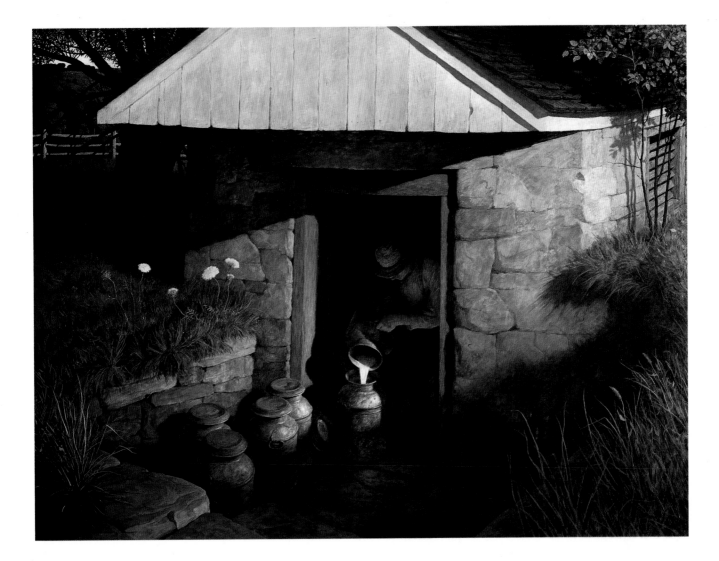

The presentation of Wyeth's work in the twentieth-century American gallery, with his contemporaries, is a kind of warrant by the Delaware Art Museum that it treats giants, even if they are neighbors, in the context of their time. As Stephen Bruni says, people tend to see Wyeth as timeless and miss his place in American art history. That the position of both Wyeth and Pyle emerge with clarity at this museum is proof that a great institution can honor those special people, its native sons, and also present the finest in contemporary work by other nationally known artists.

And in the broader sense, the museum's juxtaposed sheltering of a full range of illustrative art and fine art adds a robust dimension. It creates personality. With thousands of original works of American illustration on hand, there is always a top selection to view. Here are wondrous belles from the sorcerer's pen of Charles Dana Gibson, a 1905 *Collier's* cover (*The Tramp's Thanksgiving*) by the incomparable Maxfield Parrish, and blood-and-guts World War I propaganda (*Victorious Retreat*)

in the brawny style of Frank Schoonover. The artistic skill of such hands seems so obvious that a viewer may wonder at the affected distinction that would seek to put artist and illustrator in different or unequal camps. That aside, it is worth studying these paintings and drawings for the wonderful windows they open on the past. We look in and see the way it was on a steamship deck, in a restaurant, on a street, in a store, in a railway carriage.

At the Drexel Institute, Chadds Ford, and Wilmington, Howard Pyle taught 150 students across 16 years. They included Frank Schoonover, who helped Pyle research the Battle of Germantown, and went on to a noted career specializing in the American West and Canadian wilderness subjects while retaining a studio in Wilmington. In 1905 he created an immensely colorful *Hopalong Cassidy,* now in the museum. Stanley Arthurs, close to Pyle as student and friend, moved into the master's studio after his death and became a noted painter of historical subjects; his murals are in the Delaware State House. Harvey Dunn, who came from South Dakota, settled in Wilmington, covered World War I, and produced heroic studies of the war and of pioneers in the American West. Although Pyle had a number of talented female students who succeeded with children's books and women's magazines, Elizabeth Shippen Green was one of the few who succeeded as an "adult" illustrator. And N. C. Wyeth, who arrived from Massachusetts to study with Pyle, was a blazing talent whose historical interests tracked with his teacher's; he founded his own branch of the Brandywine's artistic heritage. Any generation of the Wyeths is, of course, a special case. Sometimes it seems as if N. C. has been partially eclipsed by his famous son and grandson, an injustice if true; some of his Chadds Ford paintings should have earned him a fine arts berth alongside, at the very least, Grant Wood and Thomas Hart Benton. Proof is in the museum's *The Springhouse,* done in 1944, the year before he died.

It is the final tribute to such great craftsmen that en masse they were so universal and such a part of the broad American view of the Delaware Art Museum. There is probably no "Brandywine School," no body of artists whose work is marked by definable regional or stylistic bonds, nothing even comparable to the brilliant but somewhat cloistral Pre-Raphaelites now coexisting in their special gallery. Yet there is clearly a Brandywine artistic legacy, a two-century sharing of talent, energy, and vision, and it shines in extravagant measure in the Delaware Art Museum.

Coles Phillips

Cover for the Saturday Evening Post, *October 2, 1920*

Watercolor on illustration board

Delaware Art Museum, Acquisition Fund, 1988

COLES PHILLIPS

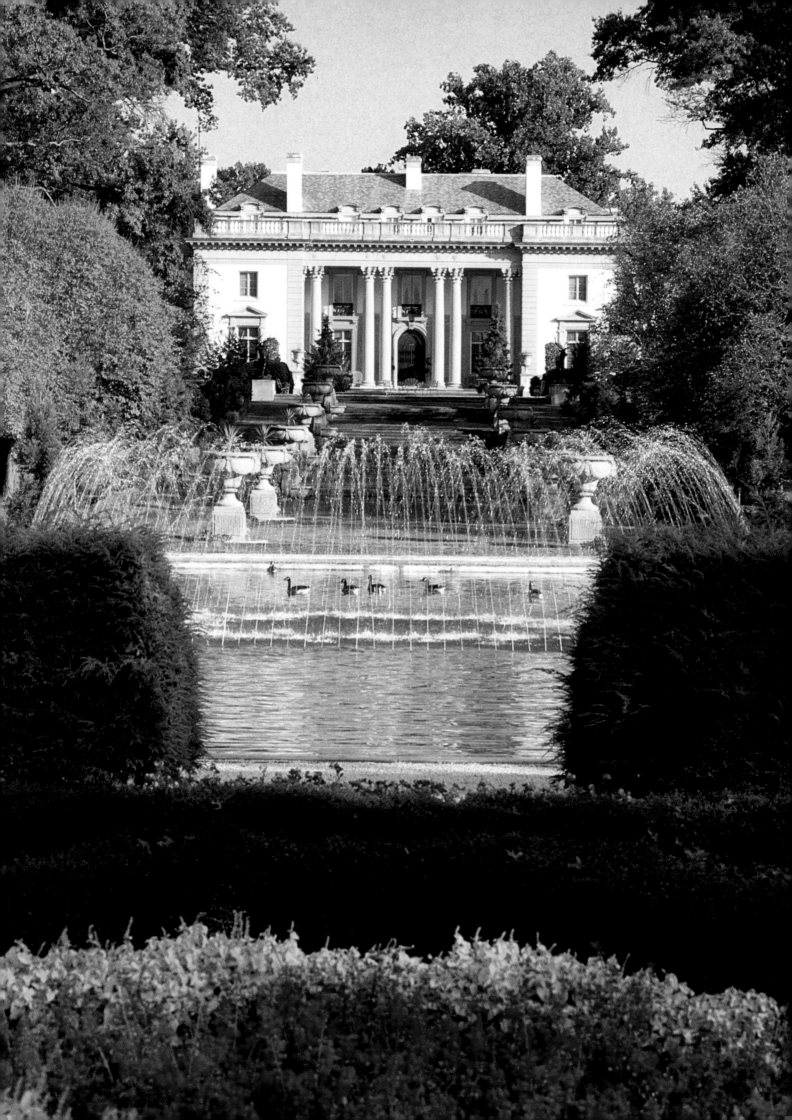

N·E·M·O·U·R·S

Nowhere does the du Pont family's French heritage resonate with more ancien régime grandeur than at Nemours, the 102-room château erected by Alfred I. duPont on the north edge of Wilmington. Yet even here, beyond the phalanxes of blindingly white marble statues and fountains, beneath prodigious planes of pink stucco, something in the viewpoint seems as bedrock American as the mansion's Indiana limestone trim. In truth, the very dream of the house itself began in the mind of a local boy who played in the Delaware woods beside the Brandywine. The 300-acre setting, so formal today, was a tulip poplar forest when young Alfred and his father first took walks there together. The senior du Pont once said that if he could have his wish, it would be to sit under the poplar trees, read books, and eat ice cream for the rest of his life. He died when the boy was thirteen, leaving Alfred with an affection for the site and the beginning of a dream to build his house there.

The great-grandson of founder E. I. du Pont, Alfred I. duPont grew up in the neighborhood at a house called Swamp Hall, and when the time came to report for work in the nearby Hagley powder yard he started, legend says, at the bottom. By 1902, at age thirty-eight, he was Hagley's superintendent, and he would be remembered there as a popular figure who loved music, showered money on Halloween callers, and played Santa Claus at the Christmas parties he staged for employees. Yet times were changing for the Du Pont company, and the days of nineteenth-century paternalism were drawing to their close.

In the second year of the new century the firm's senior partners were on the verge of selling the already-hundred-year-old company, a move opposed by Alfred and two cousins, Pierre and Coleman du Pont. The ambitious young trio bought the company from its widespread family ownership and reorganized under the modern corporate charter that created E. I. du Pont de Nemours. They diversified and

modernized the firm, setting it on a new course for the twentieth century. Coleman served as president until 1915, whereupon a group led by Pierre bought Coleman's stock, and Pierre became president. This led to a long estrangement between Pierre and Alfred, including a lawsuit filed by Alfred for breach of trust. Pierre's lawyers prevailed, and Alfred withdrew forever from all executive roles in the Du Pont company.

Alfred duPont's retirement could hardly have been an oppressive bore, for he certainly had plenty with which to occupy himself. He traveled widely, was an ardent sportsman, and he had his wonderful house. Nemours was still new; it had been completed in less than two years (1909–10) by a local builder, James Smyth and Son, with only a handshake for a contract. DuPont's architectural arrangements, though, were more conventional, and for them he went to the top, to the New York firm of Carrère and Hastings, designers of the old Senate and House office buildings in Washington, D.C. and the Ponce de Leon Hotel in St. Augustine, Florida, and whose New York Public Library would be completed the year after Nemours (1911). The firm's majestic imprint is clear in Nemours, with styling usually described as modified Louis XVI.

The interior, grand as it seems, was nevertheless a lived-in home, and it remains touched by the personalities of the builder and his third wife, Jessie Ball duPont. In the reception hall a portrait of Alfred I. hangs over the fireplace, a 1913 likeness that was criticized by an old Hagley friend as being too stern for verisimilitude. He is in august company. Right beside him, in a less prominent position, is George Washington, painted by James Peale. There was a genuine connection, as Mrs. duPont's family, the Balls of Virginia's Northern Neck, were descended from Washington's mother, née Mary Ball. Jessie Ball's father, a Confederate captain, hangs above a clock that once belonged to Marie Antoinette. Other family members, including an adopted daughter whose parents died in World War I, also look down on the reception hall. A charming painting of a madonna and child was acquired by duPont with the belief that the woman pictured was his great-great-grandmother. The truth then emerged: the painting had been altered to suggest the appropriate period—and implied identity—of his ancestor, and the original was much older than it seemed. Moreover, properly cleaned and restored, it turned out to be a Murillo. "He got a masterpiece instead of an ancestor," the guides say. Guests who strolled past such artifacts, under gilded arches and a coffered ceiling in pastry-like colors, over black and white marble floors with scored plaster walls that resemble stone, surely knew they had arrived.

On some occasions they might have been directed into the morning room, which has something of the feel of an English country house. One green velvet chair was, in fact, present at the 1937 coronation of King George VI. A Sheraton satinwood press bears panels painted by the legendary Angelica Kauffman. Other furniture in the room, however, provides Americanization at a high level. At the desk is a Chippen-

dale chair that originally served in the dining room at Mount Vernon, and another chair, in the Federal style, was used in Philadelphia's Congress Hall when it was the capitol of the new United States.

The drawing room served as a receiving room for the duPonts' dinner parties. Entering the dining room was, and is, a partial journey to prerevolutionary France, under the regal gaze of portraits of Louis XVI and Marie Antoinette. Such emphasis on the doomed royal couple was more than affectation; Pierre Samuel du Pont, Alfred I.'s great-great-grandfather, was close to the crown as one of Louis' economic advisors. The chandelier, suspended over the banquet table like an incandescent wedding cake, is said to have come from Marie Antoinette's childhood home, the Schönbrunn Palace in Vienna. Yet there is an English vein in this room, for much of the trim is high Adamesque. The ceiling, a neoclassical chorus of medallions, friezes,

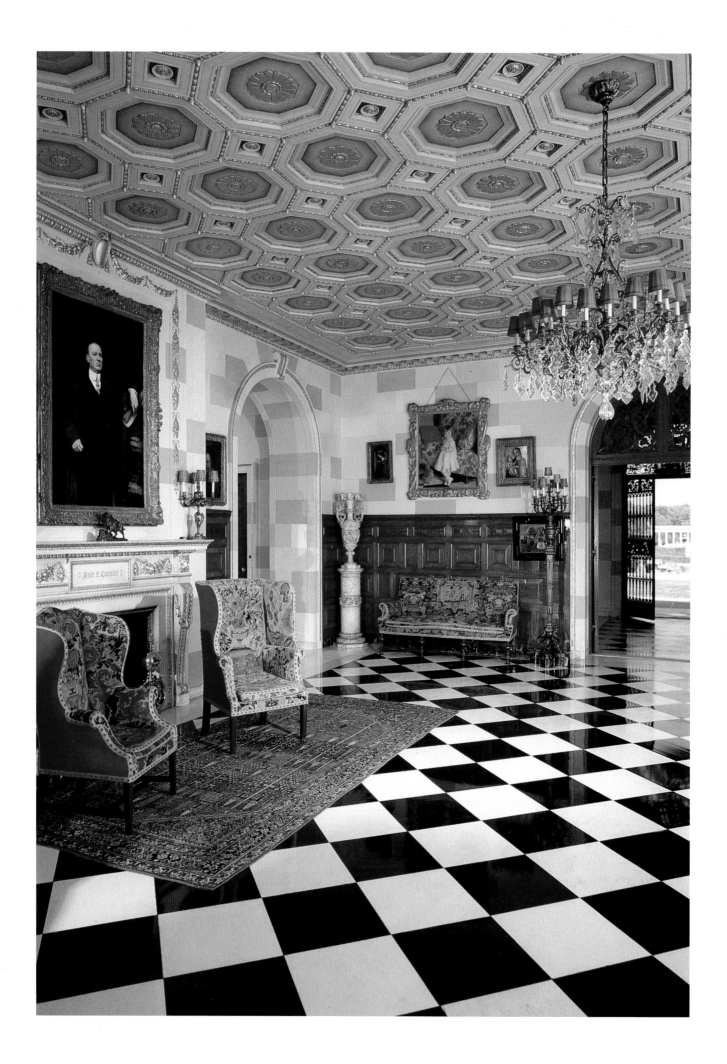

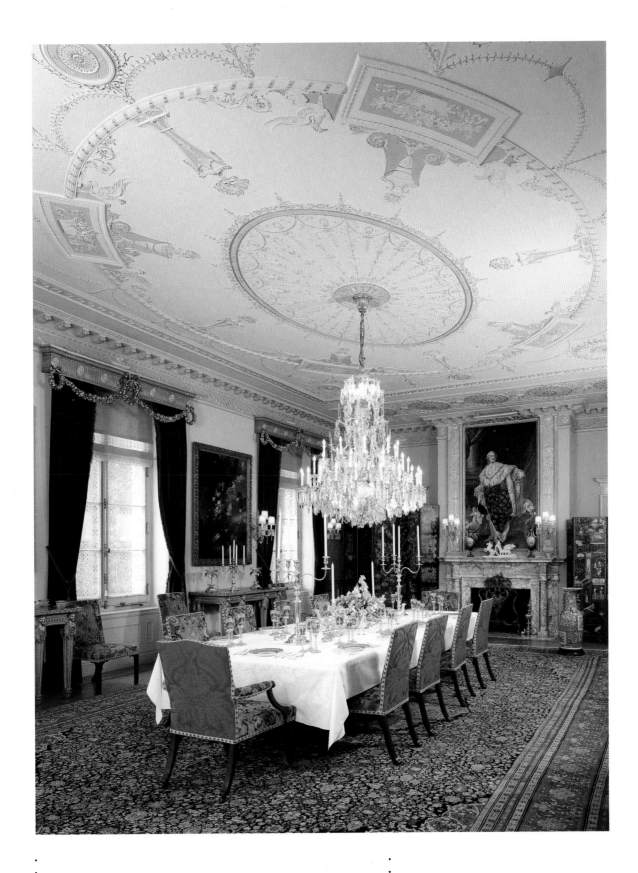

Alfred I. du Pont, by all accounts an excellent host, still greets guests from his entry hall portrait.

Louis XVI still reigns under the dining room's Adamesque ceiling, with its chandelier from Marie Antoinette's childhood home.

Panels of Brussels lace adorn the first-floor windows.

and swags in delicate Wedgwood shapes, is accented by celadon-green and 23-carat gold leaf. As in all the first floor rooms, panels of Brussels lace frost the windows.

Formal entertaining also occurred in the drawing room, where Jessie Ball duPont reigned convivially from 1920 until her death in 1970. Widowed for thirty-five years, she was a woman of vigor, charity, and many interests. A former teacher, she supported myriad educational institutions. Blessed with a keen business head, she pushed for women's advancement in banking. She was even an honorary member of the Florida Sheriff's Association. Her portrait, over the drawing-room mantel, reflects both strength and kindness . . . and her favorite color, pink. It was painted in 1925 by Prince Pierre Troubetzkoy, a popular Russian who lived in Mrs. duPont's native Virginia. His reputation was high in his time, but the drawing room holds the

work of artists of more consistent reputation. Sir Joshua Reynolds painted a portrait of two eighteenth-century English noblewomen, and George Romney contributed a portrait of William Beckford, an eccentric English literary figure of the Georgian and Regency eras.

The art sets the tone for a large, eclectic collection of objects in the drawing room. The most unusual may be a round table whose Sevres porcelain top incorporates a central portrait of King Louis; he is surrounded by a bevy of legendary eighteenth-century court ladies, including Mme de Pompadour, Mme Du Barry, and Marie Antoinette. Dresden jars and gilded furniture mingle eclectically with a signed Tiffany vase and a Pre-Raphaelite statue.

The du Ponts—rich, numerous, and often talented—may seem to present a perplexing family tree to the visitor at Hagley, Winterthur, and Nemours. Some of the confusion may lessen when a visitor studies the portraits at Nemours, a number of which line a hallway outside the drawing room. They begin with Alfred I.'s great-great-grandfather, Pierre Samuel du Pont de Nemours, who advised Louis XVI, and was the first of the family to come to Delaware. Then comes his son, Eleuthère Irénée, who founded the powder factory at Hagley, and who was succeeded by his son Alfred Victor. In the next generation, Eleuthère Irénée II, son of Alfred Victor, was the father of Alfred I., builder of Nemours. The gallery also includes Alfred's mother, Charlotte Henderson; his only son, Alfred Victor II, an architect who helped design the Nemours sunken gardens; Admiral Samuel Francis Du Pont; and various relatives of Jessie Ball duPont.

The last portrait painted of Alfred I. hangs in the Nemours library, a clubby room under a coved and ornamentally molded plaster ceiling. Swedish artist Herman Linding painted it from an earlier portrait in 1936, the year after Alfred's death, and the duPont personality seems veiled. A warmer family touch is a portrait of the fabled Florida tycoon, Ed Ball, brother of Mrs. duPont and financial advisor to Alfred I. The two are in good company: on the carved oak overmantel (from seventeenth-century England) are a pair of sixteenth-century German portraits attributed to Lucas Cranach the Younger, and nearby are two paintings of the same era attributed to Pieter Breughel the Younger, as well as George Romney's *Mrs. Prescott and Her Three Children*.

The portrait parade continues in the writing room, a kind of intimate annex to the library, with fourteen colored-chalk studies by Robert LeFevre of various early du Ponts. A pair of Gilbert Stuart pen-and-crayon sketches of Pierre Samuel du Pont and Thomas Jefferson recall the friendship between the two contemporaries. They had known each other since Jefferson was the ambassador to France, prior to the revolution that uprooted the du Ponts, and they corresponded often in later years. When he built Nemours, Alfred I. resurrected and modernized a bit of Jefferson's Monticello ingenuity: the house has a built-in wind indicator, connected to a dial in the writing room and the upstairs hall.

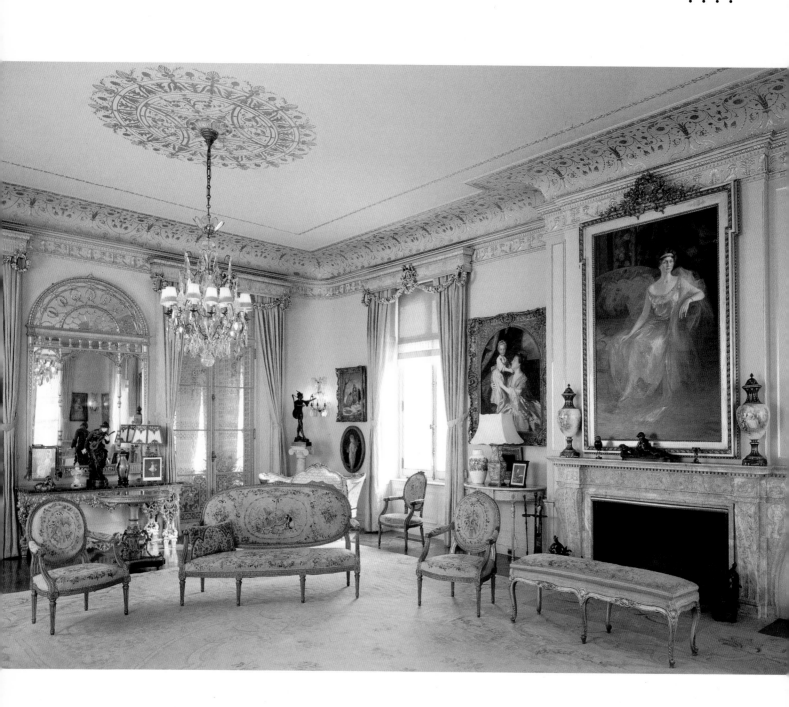

Troubetzkoy's portrait of Jessie Ball du Pont hangs in the drawing room, where Mrs. du Pont liked to receive guests.

Private concerts once resonated in the Nemours music room, where amateur performances doubtless seemed enhanced by a sumptuous decor. Gilded harps surmount the doors, lyres bedizen the sconces and andirons, and other instruments are woven into the upholstery. A white and gold Steinway grand piano dominates the floor, and Alfred duPont's violin and initialed case rest on an eighteenth-century sofa. He was not only an accomplished violinist but a composer as well, once creating a march performed around the world by John Philip Sousa. Nearby, music of another sort trills from the Nemours conservatory, where cages of live birds serenade a selection of plants from the mansion's greenhouse.

Ascending the main staircase to the second floor brings more reminders of Alfred I.'s French heritage. The big eighteenth-century French crystal chandelier may have belonged to the marquis de Lafayette, whose bust (by the great Houdon, dated 1790) looks on from the lower landing. Lafayette, like Jefferson, was a friend of Pierre Samuel du Pont, whose bust (and that of his wife, Marie le Dée) is enshrined grandiloquently on the upper landing. The iron railing was transplanted from an early French château. But the most intriguing article in the stair hall is a seventeenth-century Gobelin tapestry, the kind made with genuine gold threads. In this case the gold threads were pulled out to help finance Napoleon's wars.

On the second floor, suites of bedrooms, bathrooms, and sitting rooms recall the duPonts' life-style, which was polished and formal but relieved by every comfort for relaxation and convenience. The decor mixes French and English in an early twentieth-century statement that strongly suggests the era of World War I. The paneled, gilded bedrooms are several notches less grand than the downstairs rooms. In the Venetian bedroom, the chandelier, sidelights, and mirror are Venetian glass, and the gold, fan-shaped headboard is Venetian-inspired. The green room features satinwood furniture and rose-hued marble. Each bedroom has a working fireplace, although Nemours was centrally heated.

Museum-quality porcelain and art grace the upstairs hallways, many of them reflecting the duPonts' affection for animals. In a group portrait, their favorite dogs still wait for the master's greeting on the wall of the hallway to his private sitting room, a masculine place furnished in dark mahogany. Nearby, the master bedroom suite features a collection of Royal Copenhagen animal figures and furnishings that are predominantly Chinese Chippendale.

Jessie Ball duPont's sitting room, displaying her own memorabilia and pictures of Alfred I., seems as if she just stepped away. Her big white-and-aquamarine bathroom rivets many visitors' attention because of such fittings as a showpiece stall shower, a convolution of plumbing coils that surrounds the bather with hundreds of needle sprays.

Technical ingenuity is evident throughout Nemours, and for today's visitor some of the mansion's most fascinating artifacts are mechanical ones. The kitchen bristles with early twentieth-century iceboxes and refrigerators that could have served a

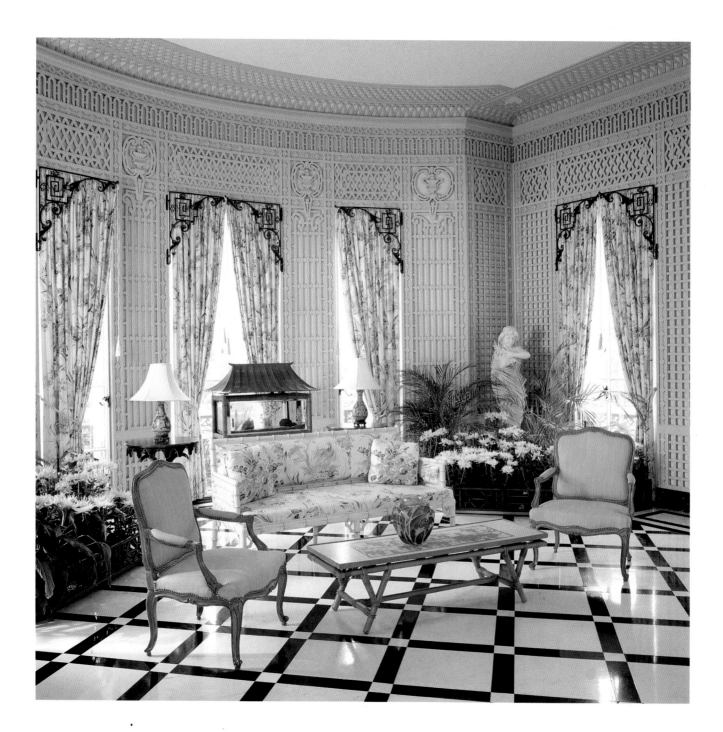

The trilling of caged birds and the

beauty of greenhouse plants enliven

the Nemours conservatory.

A chandelier that Lafayette may have owned

now brightens the way in Nemours' stair hall.

Spring water from the estate was bottled on this basement machinery.

medium-size hotel, their construction quality rivaling that of bank vaults. In the butler's pantry, the service nerve center of the house, a callboard alerted the on-duty factotum by buzzer and light when someone signaled from a distant room. A dumbwaiter sits poised, its tray set, ready to whisk upward. Still more impressive 1910 technology is down in the basement wing. Nemours even had its own bottling plant, where water from the estate's springs was purified, sometimes carbonated, and bottled in containers sterilized on the spot by jets of hot water.

An ice-making room displays the technology of pre-Freon days, when ammonia and cold brine did the job, in this case turning out 30-pound blocks of ice. In the adjacent machine room, where a massive black emergency generator could power the entire house in case of a utility failure, mighty belt-driven compressors, condensors, and circulators drove the ice plant. In the furnace room, two big red and black boilers—original, save for having been converted from coal to oil—still heat the property. One is enough, but Alfred I. believed in engineering redundancy.

Generators and compressors remain in immaculate condition in the machine room.

The lower levels are not all 1910-vintage technology. A cypress-paneled exercise room still holds such challenges as a torturous-looking oak steam cabinet and a vintage, saddle-seated exerciser. The clublike billiards or pool room (one table for each) has comfortably soft cork floors, a seated gallery, adjustable overhead lights, and convenient call buttons to the butler's pantry. There is even a two-lane bowling alley. All this equipment, doubtless the best money could buy in 1910, appears to be in almost new condition, right down to the unused Brunswick score sheets.

Even the duPonts' personal or family artifacts seem larger than life. In the basement trophy hall is the 6 ½-foot working model of a battleship, the U.S.S. *Idaho,* that once plied the waters of Nemours' ponds, powered by as many as sixty-eight flashlight batteries. The ship was built in 1928 by son Alfred Victor, assisted by his wife and a friend. Alfred Victor served on the *Idaho* in World War I. Nearby, a "display room" holds a small museum of objects that perhaps would not fit anywhere else. They include family sketches, an assortment of the mansion's china,

tableware from the duPonts' yachts, and more portraits of Jefferson, Lafayette, and Pierre Samuel du Pont. Here, too, is a plaque presented by Jefferson to du Pont for helping the United States acquire the Louisiana Territory. Of incomparable significance in the du Pont history is another artifact: the first patent that the company founder, Eleuthère Irénée, received for a gunpowder granulator.

Alfred I. maintained his office in the basement, as well, where the objects displayed presumably included those that meant a great deal to him. Here are

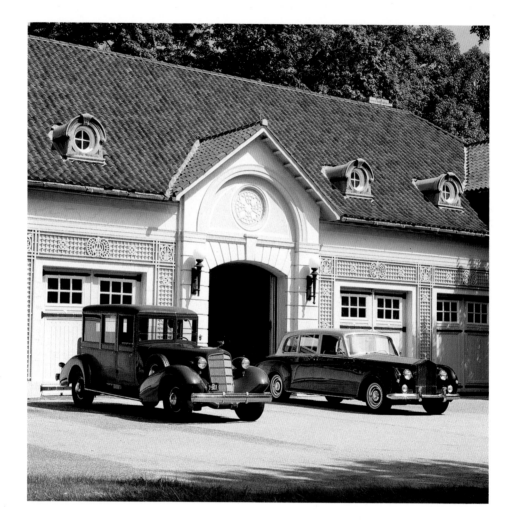

Yesterday's luxury cars still wait for

the du Ponts at the Nemours garage.

Details from Nemours' iron garden gates (above)

and white Carrara marble sculpture in the

Sunken Garden (below)

trophies won by his sloop, *Sue,* between 1913 and 1915, and a horn-handled cup presented to him by employees of the Brandywine Powder Mills. He was by heritage a gunpowder man, and his interest is warranted by an office collection of artillery shells and even a small saluting cannon. Here, too, he kept a tangible reminder of his childhood home, a carved chair from Swamp Hall.

Today's visitors to Nemours receive careful tours in small groups of six or seven, led by guides whose polished style reflects a sense of personal welcome. The sociable experience begins on the south portico, overlooking a splashing fountain where each guest receives a flower and a chatty, intelligent introduction. After touring 36 of the 102 rooms, visitors take van or walking tours of the grounds. A popular feature is the duPont garage, where five vintage cars, including two Rolls-Royces and Alfred's well-used Buick coupe, remain at the ready. The Alfred I. du Pont Institute of the Nemours Foundation, a multispecialty children's hospital, founded by Alfred I., is on the estate grounds today, but with 300 acres, there was plenty of room. Most of the original grounds and gardens are intact and often spectacular, adorned by such features as two marble sphinxes once presented by Louis XIV to his financial controller general, Jean Baptiste Colbert. One pair of the mansion's garden gates came from Wimbledon Manor, one of Henry VIII's favorite retreats; another set of gates was made for a palace of Catherine the Great of Russia. Busts of the French statesmen Turgot and Talleyrand, friends of Pierre Samuel du Pont, ornament the Southern Gardens, which they share with a boxwood parterre and 8,500 square feet of perennials and annuals. Here, too, are four of the original tulip poplars that inspired duPont to build here.

The main vista from the mansion's portico, facing northwest, extends across grassy terraces to a one-acre reflecting pool with a 157-jet fountain. Across the pool lies a maze, slightly tilted so the pattern is visible at the distant mansion, leading the eye to an imposing colonnade surmounted by statuary. Beyond, but on the same panoramic line, is the mansion's sunken garden, designed by Alfred Victor du Pont and Gabriel Massena with original sculpture of marble and bronze, completed in 1932.

The landscape grows less formal now, more "picturesque," softened by an irregular pond and adjacent rock garden, planted with bulbs and dwarf conifers. In a striking all-American touch, two deck cannon from the frigate *Constitution*—"Old Ironsides" herself—are mounted by the lane. But the great vista has one more classical element to unfold: the Temple of Love, a round, columned, serene pavilion sheltering a life-size statue of Diana by Jean Antoine Houdon, cast in 1780. The Temple of Love with its major sculpture is the concluding point of the stately visual axis begun at the mansion, and a handy symbol as well. It seems to say that when Alfred I. duPont transplanted the glories of Bourbon France to Wilmington and Nemours, he did so with a smiling acknowledgment of the most compelling of human frailties.

The Nemours water tower: practicality under a Gothic roof

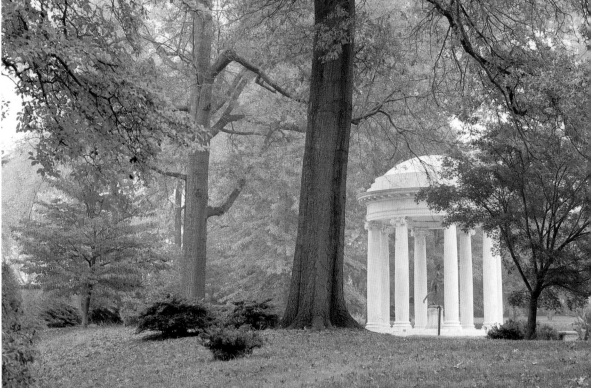

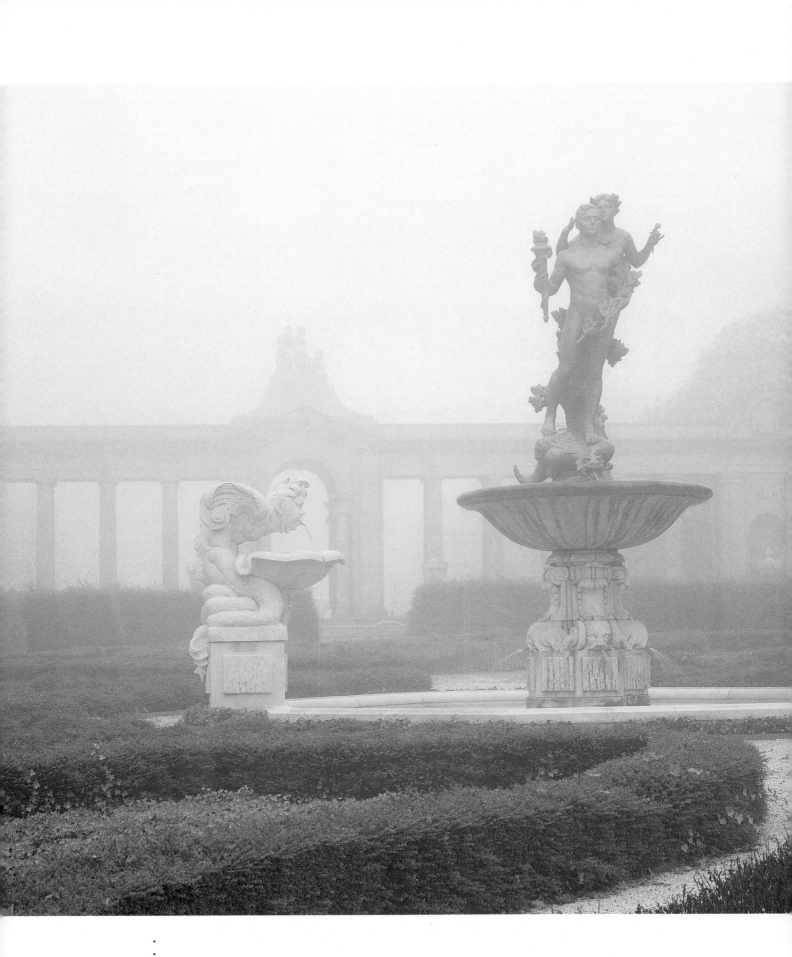

Left. *The statue of Diana in the Temple of Love was cast by Jean Antoine Houdon in 1780.*

Above opposite. *Detail of garden statuary around the Reflecting Pool*

Above. *Fountain sculpture called "Achievement" in the Nemours Maze Garden*

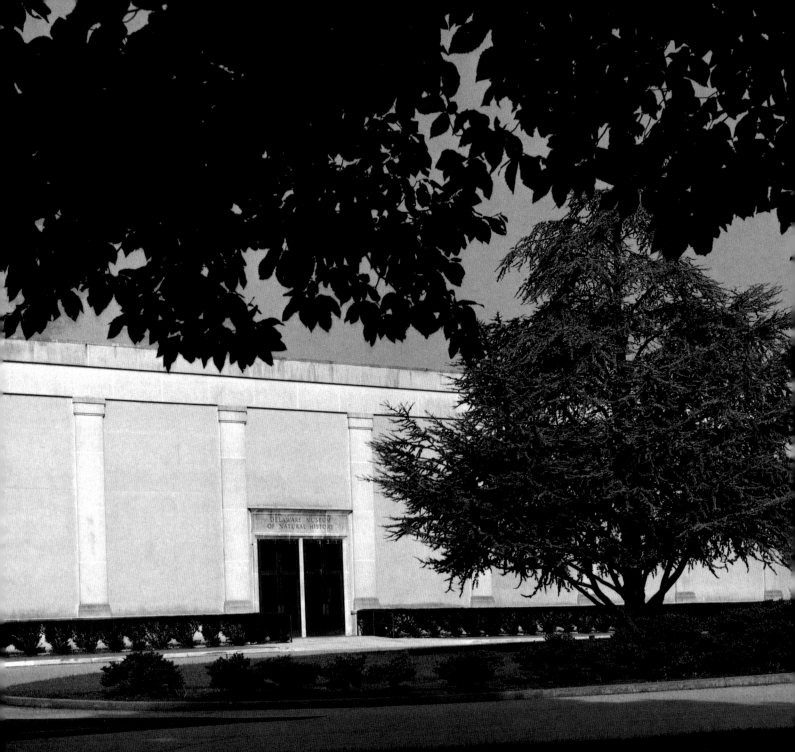

Opened in 1972, the Delaware Museum

of Natural History is the youngest of the

Brandywine's museums.

T·H·E D·E·L·A·W·A·R·E

M·U·S·E·U·M O·F

N·A·T·U·R·A·L H·I·S·T·O·R·Y

The "outgrown shell by life's unresting sea," as Oliver Wendell Holmes put it so charmingly in "The Chambered Nautilus," has found repose—guaranteed safe, high and dry—just five miles north of Wilmington along the Kennett Pike. There behind the enigmatic pilastered rectangular façade of the Delaware Museum of Natural History is gathered one of the world's largest collections of shells, a sight that might have stupefied even Dr. Holmes, or Alexander Pope, or any other poet who ever waxed lyrical on the beauty and strangeness of mollusks. But poets tend to find significance to suit themselves, and science seeks its own objective truths. At the Delaware Museum of Natural History, the repository of many astonishing once-living things, the mission is serious science. It must be added quickly that fun and beauty keep springing forth, as irrepressible as the squeals of children seeing an elephant bird egg for the first time.

The question soon arises: How does a state as small as Delaware rate a natural-history center of such quality? And the answer, to no one's enormous surprise, involves a du Pont. The founding father, John Eleuthère du Pont, although born in 1938, was only the great-great-grandson of Eleuthère Irénée. The past is sometimes closer than we think.

It would be difficult to find collections of greater dissimilarity than the decorating arts treasury of Henry Francis du Pont, and the shells, birds, and eggs of John E. du Pont. But those first cousins once-removed built great institutions around their respective collections. Henry's is at nearby Winterthur, of course, and John's at the Delaware Museum of Natural History. The museum is the youngest by far of all the Brandywine Nine, dating only to 1972, when John du Pont opened the doors to the public for the first time. "As this museum takes its place with other fine institutions of natural history throughout the land, we are confident it will contribute to our storehouse of knowledge of this immensely important discipline," he said.

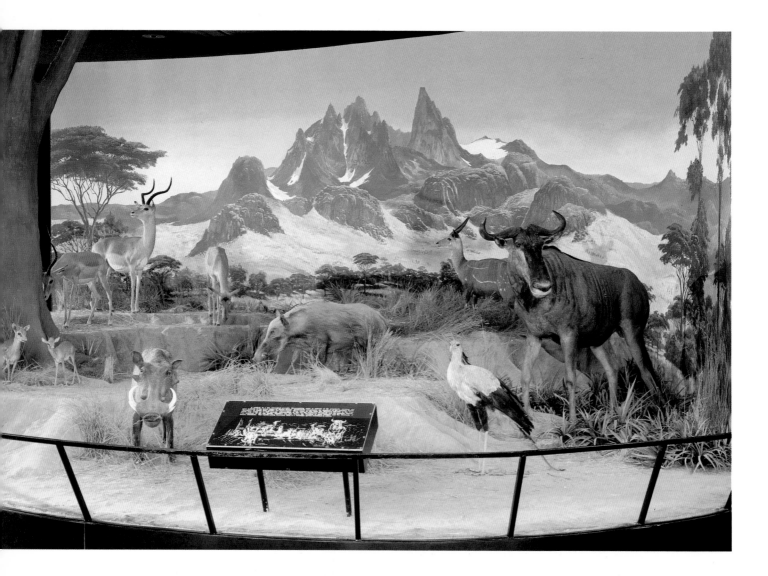

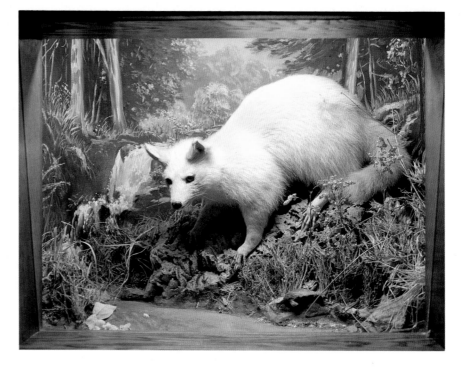

The diorama of an African waterhole is one of the largest and most popular exhibits.

As a teenager in the 1950s, John du Pont made extensive collections on which to base studies of birds and shells. He went far afield, to the Philippines, Samoa, the Fiji Islands, Australia's Great Barrier Reef, and other Pacific sites. In 1957 he incorporated the Delaware Museum of Natural History as a nonprofit foundation whose emphasis would be on mollusks, birds, and mammals. Long before the new building was completed, du Pont annexed other first-rate collections and began planning interpretive exhibits and dioramas. When the museum opened, he served as its first director, hiring curators, launching research and publications programs, and expanding the collections. He stepped down as director after ten years but remained on the board of trustees.

The museum may be described figuratively and literally as existing on two levels, public and research. On the main or gallery floor of the 70,000-square-foot building a clockwise perambulation leads through connecting exhibition areas, with galleries devoted to mammals, shells, and birds. Visitors are greeted by a mounted polar bear, an eagle, and an African elephant, which should establish that the museum's compass is a global one, yet at another mammal display—introducing the South American jaguar—a guest was overheard to observe that he "hadn't realized jaguars were native to Delaware."

Authentic Delaware fauna get star treatment, however, in exhibits tracing the entire animal pageant from upland woods to wetlands and ocean. These three-dimensional dioramas, each measuring about 5 by 10 feet, display in realistic habitat such mounted animals as the white-tailed deer, skunk, cottontail rabbit, tufted titmouse, and pileated woodpecker. Beside a Delaware stream, an otter seizes a fish while a startled blue jay takes wing. But the creatures and the geography expand quickly. These bright bay windows on the natural world open even to skunks and all their relations. There are collared peccaries, lions, leopards, and ocelots. The non-Delaware jaguar lies indolently on a tree branch, its front paws eerily suggestive of human hands. One of the largest exhibits is an open diorama of African animals at a water hole. Presented around a pothole of precious water in a dry streambed is an assortment of such antelope as dik-dik, gnu, bushbuck, and impala. Warthogs and birds complete the ensemble.

Beyond geographical groupings, other displays enter the realm of science at once more specific and more complex. For most nonscientific visitors, these demonstrations become surprisingly painless and even fascinating routes to knowledge. One makes sense of animal pigmentation, including such minutiae as albinism in muskrats and raccoons (rare). We learn that black squirrels may constitute true polymorphism, and that ermines, which are white in the winter for reasons of camouflage in the snow, are brown in summer.

A display of white animals, like this raccoon, helps explain animal albinism.

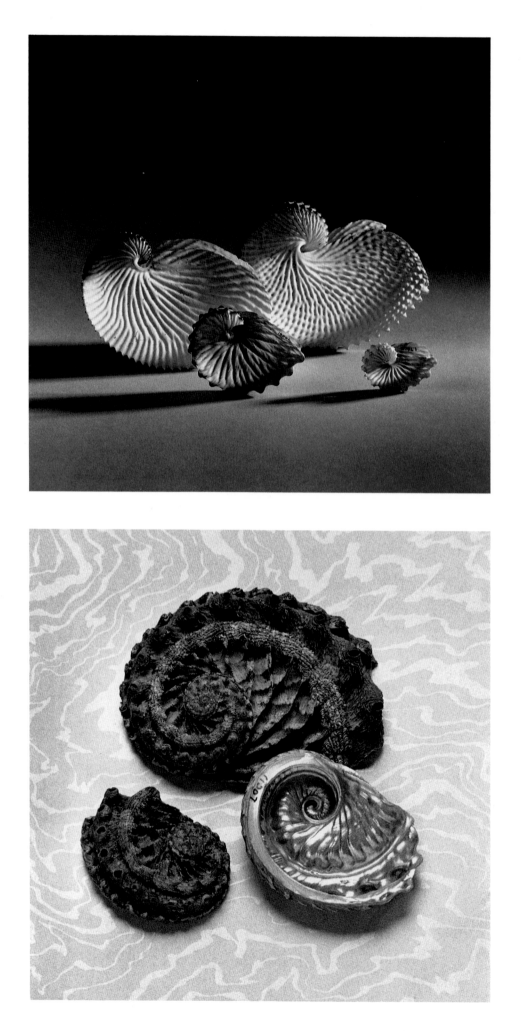

Paper nautilus shells, egg cases of the genus Argonauta

Entering the Hall of Shells, a visitor is smitten by the magnitude and beauty of the collections in more than a dozen themed displays. Odd facts swim up from these cases of ethereally beautiful shells. How many of us knew already that mollusks live in the deepest part of the oceans, in deserts, and trees of the forest? That there are some 70,000 living species? One is the *Spondylus* or thorny oyster, spectacularly beautiful in its hues of orange, peach, and white, bristling grotesquely with sharp prongs like frozen arms. As comely, perhaps, are the cone shells (family *Conidae*), but they may carry a fatal sting. But for sheer class, the aristocrats of shells may be the invariably elegant volutes, with their creamy smooth inside lips. There is even a display of some altogether bad guys of shelldom, invaders like the *Corbicula* clam, and the giant African snail, a voracious eater whose mass migrations across highways can give new meaning to the warning, "Slippery Pavement." Balancing this bizarre image, another display treats the helpful medicines that have been extracted from shells. And another examines the many table delicacies provided by mollusks, with appropriate menus and wine.

From the very dawn of mankind we have been fascinated by shells, treasuring them as beautiful and strange art objects, and working them into jewelry. Cameos are cut from helmet shells or *Cassis* and from pink conch or *Strombus*. The museum's exhibition of the arts and shell craft explores this genre with some striking examples. They include beautifully carved oysters and chambered nautiluses, worked by political prisoners on New Caledonia. Somebody carved an exquisite punch ladle, and a liquer cup. And there are shell cups and saucers from Thailand and Mexico, modern American dolls and decoupage, and shell miniatures and floral arrangements.

At one point, visitors cross over a full-size coral reef, looking down through a clear plastic bridge into shell-studded depths at giant clams and corals. Alas, there is no real water. Only in one small aquarium do we find water and life. Bright tropical fish in shades of deep blues, purples, and yellows glide like living jewels, their mouths and eyes gaping wide in looks of marvelous innocence.

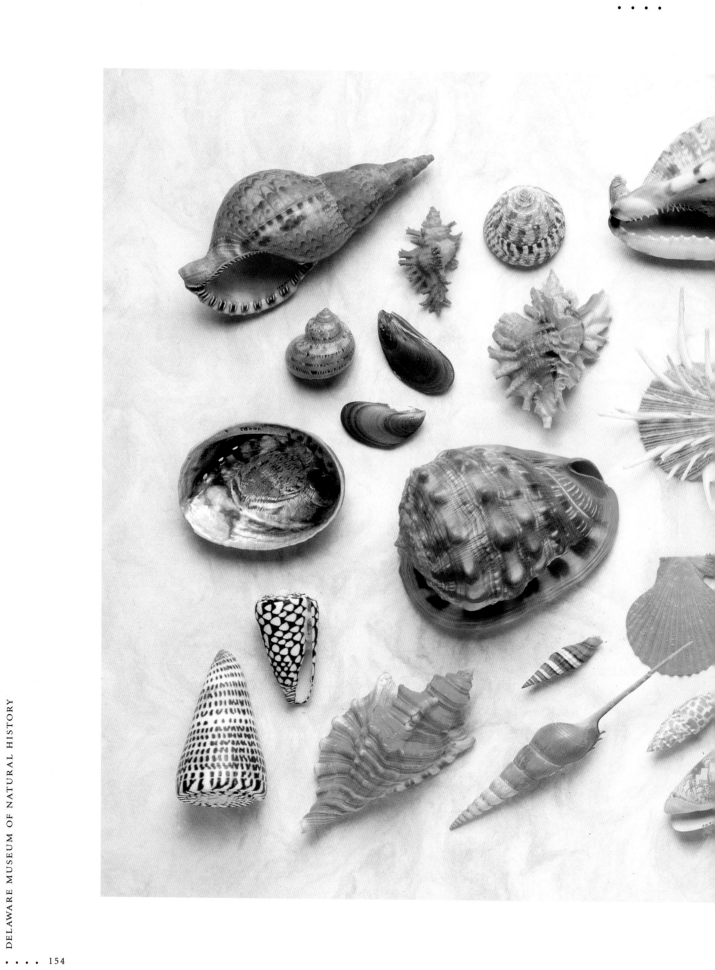

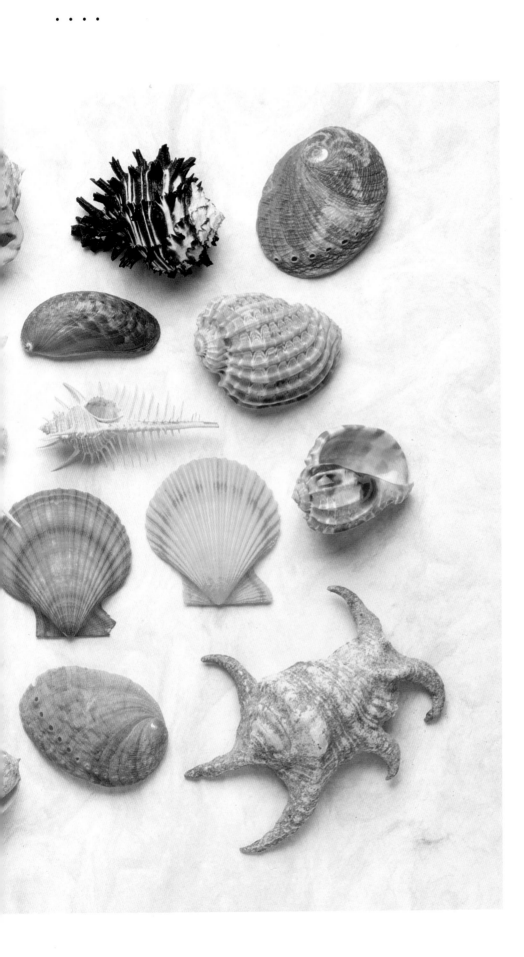

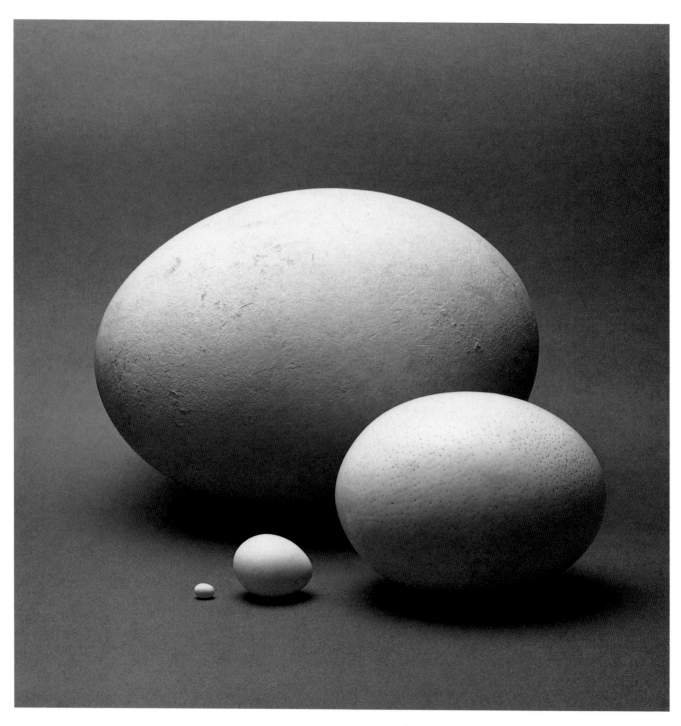

From mighty to minute, the world's birds

come in unequal packages.

The public ground floor includes the Discovery Room,

where active participation is de rigueur. Adults as well as

children may handle actual specimens.

Ornithological exhibits are basically different from those of mammals and shells, because they must include the sequence of eggs and birds. In one striking side-by-side display, the eggs of a king penguin, bald eagle, domestic pigeon, and eastern phoebe are bracketed, in descending order, between those of an ostrich and a black-chinned hummingbird. The magnitude of the ostrich's egg vis-à-vis the hummingbird's (almost 3,000 times by weight, we are told) suggests a planetary juxtaposition of monstrous Jupiter and little Pluto. Yet even the ostrich egg pales into insignificance beside the nearby petrified egg of the extinct elephant bird. Some egg displays are so beautiful that here, as in some art museums, upholstered benches are provided for guests to sit and admire.

From the curious, grotesque, and beautiful, the emphasis shifts to the rare, vanishing, and extinct in an exhibit of mounted birds that is touched with a degree of ecological melancholy. Here are the great victims of man's unchecked hunting for food: the Eskimo curlew, the heath hen, and the long-lamented passenger pigeon, which looked for all the world like a mourning dove on steroids. Happily, there are displays of survivors as well, such as the great horned owl, common throughout Delaware. The owl's terrifying glare—it seems to come into the world looking outraged—is amply merited by the facts about its ferocious life-style. Cruising silently on a 5-foot wingspan, the great bird dines on almost any small creature alive, up to and including skunks. Its cry includes hoots, whistles, shrieks, screams, and hisses. But it has a tender domestic side, with a mating routine that includes energetic dancing, head wagging, and caressing. Any such fact related to birds seems fair game, so to speak, for the museum. One exhibit displays many of the various practical and ornamental uses to which humans have put feathers. Another exposes the nesting habits of swifts, and another gathers in the gaudy birds of the Philippines.

The African hawk eagle

The Huia bird

Birds of the Philippines are among the gaudier specimens in the ornithological displays.

The owl parrot roams at night, like an owl; it even resembles one.

The passenger pigeon

It is the singular nature of this Museum, however, that the bulk of its collections are away from public view, in vast storage areas, workrooms, and laboratories on the upper floors. These birds, eggs, and shells are fragile and must be guarded in endless ranks of shallow-drawered steel cabinets, away from light, dust, insects, and changes in temperature and humidity. Consider the bird collection, totaling more than 75,000 specimens. Most of them are preserved, in ornithological parlance, as "skins." This plainspoken description does not prepare an unsuspecting layman for the surreal impact when a wide, shallow drawer glides open with its cargo of birds, aligned in perfect rows, each lying on its back. The feathered skins are in the natural bird shape of their original owners, plumped out with cotton, which is visible only at the eye sockets. This gives the birds a white-eyed, staring, pathetic quality, a stillness somehow blunt and absolute. There are 62,000 of these little figures; well, some are not so little, and when a giant white albatross is rolled out on its tray, the effect is startling enough to evoke, in even the least impressionable visitor, poetic memories of Coleridge's "Rhyme of the Ancient Mariner."

Thousands of bird skeletons, and whole birds preserved in alcohol, raise the silent feathered population to more than 75,000. These, and more than 100,000 bird eggs, have come from all over the world. Originally, John du Pont's collection emphasized eastern Pennsylvania; later, it branched out to cover the entire United States, and then embraced birds of the Philippines. Today, a scholar at the museum will find birds from Borneo, Egypt, Kenya, Mexico, and South America, among other far-flung locations. Yet, appropriately, the home region of the three-state Delmarva peninsula is the best represented. Moreover, the museum actively supports bird studies in Delmarva, and works with amateur birders in gathering and maintaining such information as breeding trends. The museum has long been involved in scientific publication and has produced reports on bird subjects in the Philippines, New Mexico, Mexico, and the South Pacific. It has computerized the Delaware ornithological record for a forthcoming book, *Birds of Delaware*.

The museum's malacology, or shell, department is one of the hemisphere's largest, with a collection of more than 2 million specimens and almost 17,000 square feet in its storage area, work rooms, and laboratory. Yet that may be only the beginning, for there is storage capacity for 15 million shells. Shells are stored rather like the birds, carefully ranked on shallow trays in metal cabinets. Yet a shell is different; it never owned a personality remotely like that of a bird, which, despite the finality of death, clings in fragile ghostlike suggestion about the still feathers of the ornithology trays. When alive, the mollusk—a fleshy, unsegmented creature whose mantle secretes its house—hardly elicits the same human empathy as a bird. We may admire its diversity, ranging from a tiny sea snail to a 50-foot squid, and we may wonder at the complexities of the gastropod, bivalve, and cephalopod. Many of us enjoy eating oysters, clams, scallops, and mussels, but it is a different kind of affectionate interest from that we feel toward birds. The shell alone is a different matter. It can be beautiful, and it almost always seems mysterious, a Circean thing from dark,

drenched grottoes fringed with swaying weeds and coral fans. Its loveliness lies somewhere between that of a once-living thing and the work of a master jeweler, a collaboration of Neptune and Fabergé. Some shells are spectacularly beautiful. Visitors to the Hall of Shells in the exhibition galleries may be assured they are seeing excellent specimens, a representative sampling of the vast collection upstairs.

What, then, is the point of the enormous and growing number of shells—and birds—in the museum's collection, more than can ever be exhibited to the public? The answer is that scientific research always needs a large body of primary data, and large collections provide it. The museum's scientists and visiting scholars preserve, identify, study, compare, and analyze. This research is of the kind scientists call "systematics," or taxonomy. It is the study of the identity and biodiversity of species by categorizing living organisms vis-à-vis their resemblances and relationships. Even the ground rules of systematic classification rapidly get confusing to most of us; all those vexing distinctions between phylum, class, order, family, genus, and species. A tray of shells that look alike to the casual observer tell intriguing tales of comparative morphology to the taxonomist.

The museum, thus, is an asset for professional scientists, as well as an attraction for the public. Somewhere in between lies a busy schedule of programs and special events, including workshops, films, changing exhibits, special weekends, and children's weeks. Some programs are one-time events, but some are popular perennials like the Bird Identification Workshop, a ten-hour course held in late winter. Aimed at beginning-to-intermediate "birders," it emphasizes the overall bird population of the Mid-Atlantic region. There are also special workshops on Delaware birds. Fish, ants, spiders, bones, seeds, owls, eggs, creatures of the deep: virtually anything in the realm of living natural science may be the subject of workshops, with lectures, field trips, and opportunities to meet the living subjects at close range. Such activities span various age groups, but there is a rich summer program for children only. Of obvious special interest to Wilmington-area youngsters, the program occasionally branches from natural history into other aspects of science, such as magnetism and electricity, and the sketching of natural objects. Taking the helm in 1991, new director Glen P. Ives promised to take the museum even farther along the path as a resource for children.

Approached by the layman one at a time, the museum's disparate parts may seem unrelated at first acquaintance. But that is a superficial and misleading view, and one that a visitor soon discards here with each new insight into the natural world. For the subject matter is, at bottom, all of a piece, recalling some words from *Silas Marner* by George Eliot: "In natural science, I have understood, there is nothing petty to the mind that has a large vision of relations, and to which every single object suggests a vast sum of conditions."

The great American explorer and naturalist John Muir put it another way: "When we try to pick out anything by itself, we find it hitched to everything else in the universe."

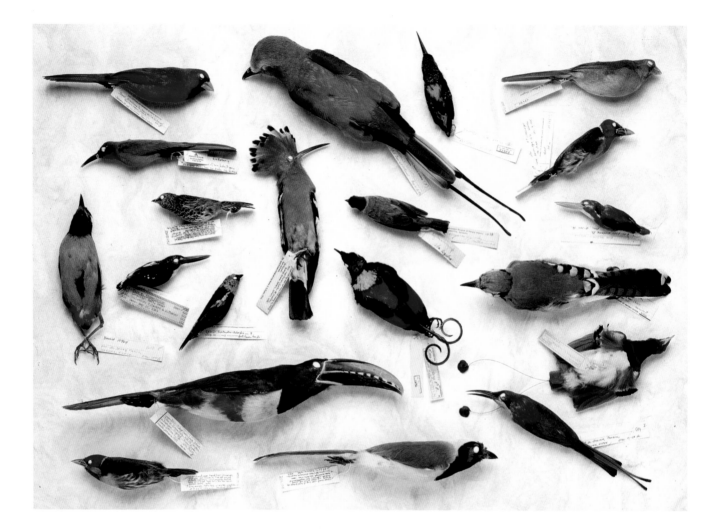

What the public does not see: a few of the museum's

thousands of birds preserved for scientific study

The museum's collection of rare early

scientific books is a resource for scholars.

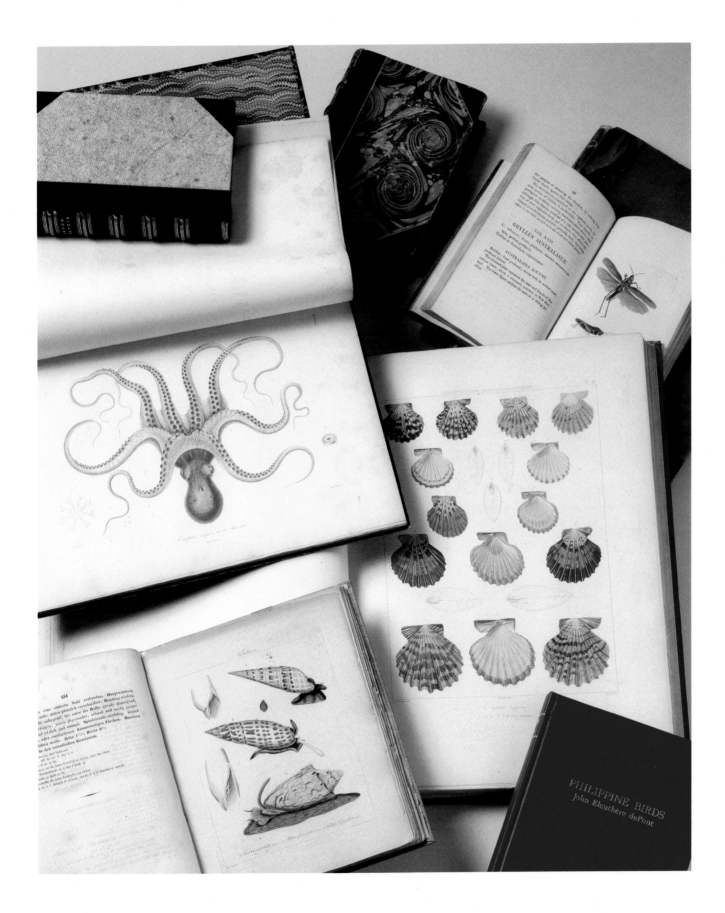

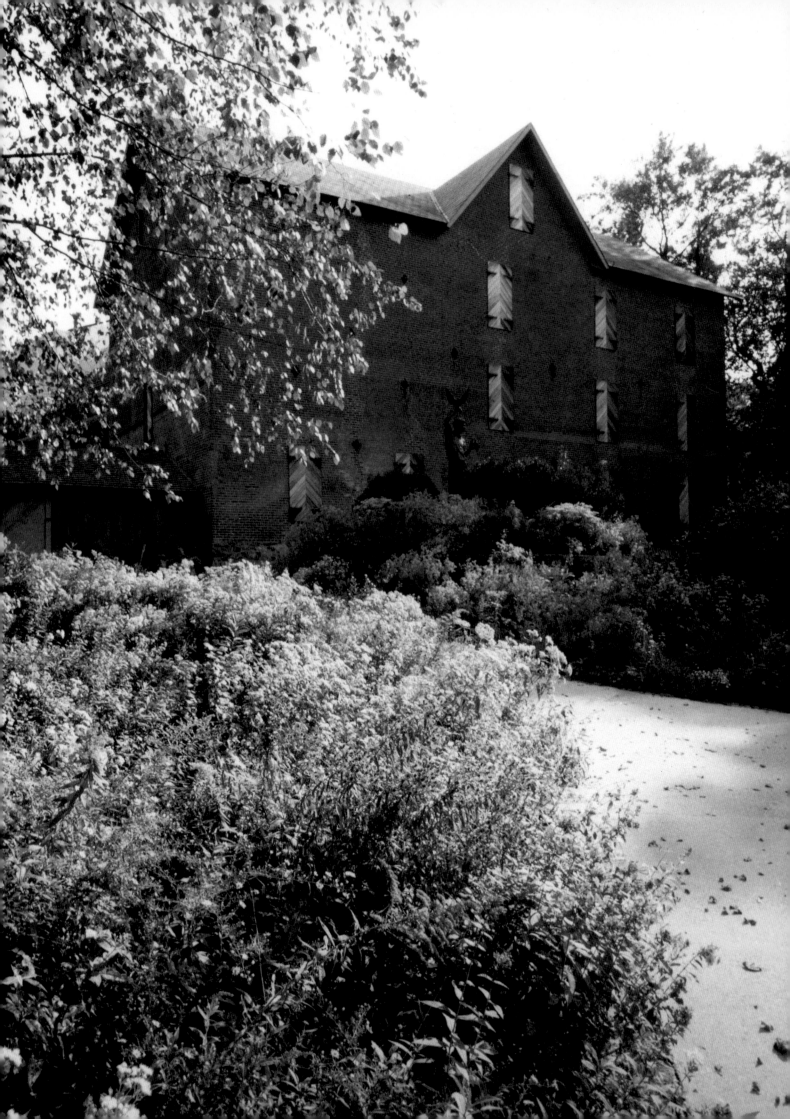

T·H·E
B·R·A·N·D·Y·W·I·N·E R·I·V·E·R
M·U·S·E·U·M

I t is probable that only in the Brandywine Valley has an environmental crisis spurred the creation of an important art museum. Oh, the museum arose—to put a fine point on it—only after the initial environmental crisis was dealt with, but not very long after, and with linkage of the most direct kind. The protagonists in this masterful double play were the same people. Environment and art alike would be permanently shielded and fostered by their organization, which they called the Brandywine Conservancy.

In 1967 the region around Chadds Ford, Pennsylvania, was a quiet rural enclave, still essentially unaffected by its proximity to both Philadelphia and Wilmington. It was pure good luck, here at the heart of the Mid-Atlantic region, that the place had changed very little since the day in 1777 when General Howe's British army defeated General Washington's Colonials at the Battle of the Brandywine, a couple of miles east. But the impending twentieth-century auction of two key parcels of real estate at Chadds Ford rang alarm bells for those who wanted the Brandywine to remain unspoiled.

One site was a 40-acre meadow, the other an 1864 gristmill on 9 acres. They fairly glowed with commercial potential. Their industrialization (an oil tank farm was one possibility) would have altered the character of Chadds Ford and the Brandywine Valley forever. So the Brandywine Conservancy, a nonprofit organization, was formed to buy the imperiled properties behind the leadership of George A. "Frolic" Weymouth, a prominent Brandywine citizen. Soon it saw the need for a broader, ongoing conservation program. Viewed in totality, the Brandywine Valley faced many threats to its natural and cultural heritage. The new group began forging a partnership of local government, property owners, and its own professional staff. From the Conservancy's fledgling Environmental Management Center, the group plunged into the complexities of conservation easements, assistance to governments,

and historic preservation. Two old Brandywine bugaboos—flooding and water pollution—received close and persistent attention.

Four years later, in 1971, the same people opened the Brandywine River Museum in the old mill, which had ground its last flour in 1941. The Conservancy began the museum with modest ambitions: it would open only in summer, staff would be part-time and volunteer, and the one annual exhibition would be devoted entirely to the art history of the region, recognizing artists who were part of the Brandywine tradition. The museum would conserve the region's cultural environment in the same way the Conservancy was dealing with the natural environment. The art exhibited was expected to be almost entirely borrowed.

None could foretell the astounding developments within twenty years, though there were straws in the wind. Even before the mill alterations were complete, the Delaware Art Museum donated a set of Howard Pyle's murals. And Mr. and Mrs. Andrew Wyeth contributed paintings by nine important Brandywine artists, including the museum's first N. C. Wyeth. Thus, before the Brandywine Museum opened its doors, it owned works by two of the region's finest artists of all time.

The concept of a summer museum run by limited staff proved impractical and lasted about a year. Luckily, the Conservancy had gone all-out on its conversion of the mill, and was ready with a physical plant of superb potential. Baltimore architect James R. Grieves removed the roof, gutted the interior, laid steel trusses across the mighty 3-foot-thick walls, and replaced three floors by suspending them on steel rods hanging from the truss system. Then, ingeniously, he concealed the rods by halving and routing the mill's massive original posts and gluing them back together with the rods inside. Then pine floors were laid. Walls were a rough, appealing plaster. The mill's character was safely restored.

A new contemporary addition at the rear was also part of the 1971 project. More than a decade later, in 1984, the same architect created another addition, bringing the museum's total space to 60,000 square feet. Yet so cleverly do the curved, glassy walls of the modern annexes recede from the rugged, angular mill and blend with the riverside that the museum doesn't seem as large as it is. Another reason is that much of the museum's maintenance and mechanical apparatus is in a separate building, the equivalent of two blocks away.

Visitors approach the museum through surrounding borders of native Brandywine plants. These local flowers, shrubs, and trees look casual and unstudied, as if to suggest the flora growing naturally beside an uncommonly picturesque country lane. As the seasons change, trillium gives way to iris and then asters. The plants seem to link the Conservancy's environmental and museum personas. Through this comfortable perimeter the pathway leads across a courtyard paved with stone known as "Belgian block," laid in graceful curved patterns. On one side is a row of sheds of archaic Quaker shape, and here and there an example of millstone. The river, perhaps 100 feet wide at this point, flows slowly by in one of its calmer, deeper

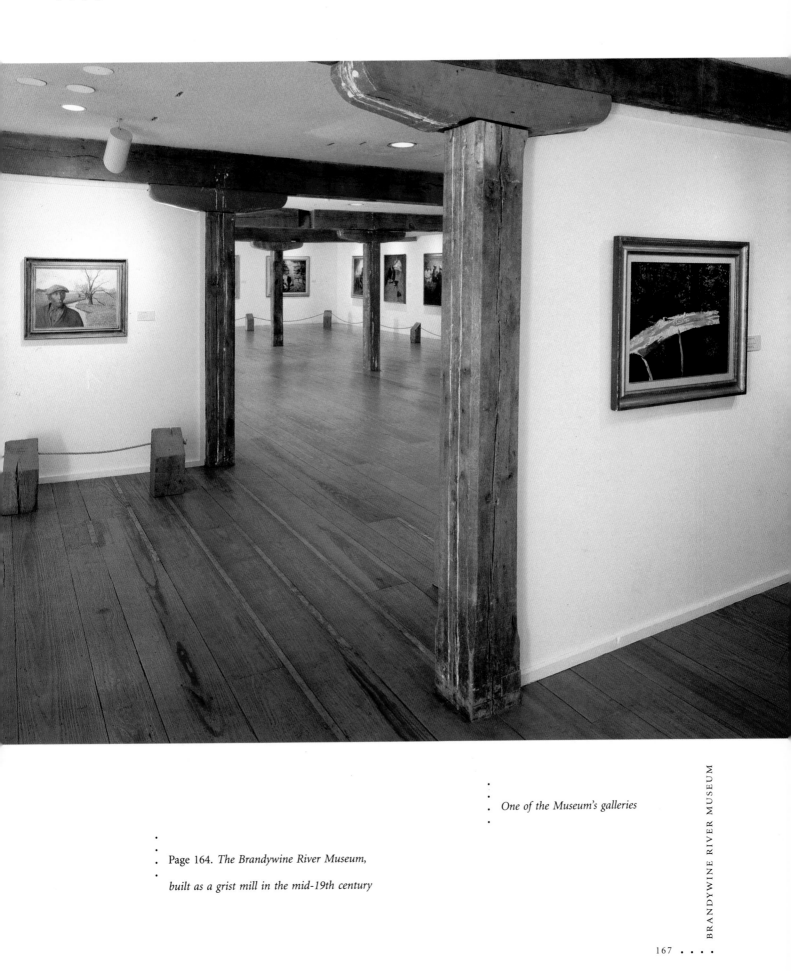

One of the Museum's galleries

Page 164. *The Brandywine River Museum,*
built as a grist mill in the mid-19th century

Museum courtyard, paved with Belgian block

stretches. The river and a long-abandoned railroad bridge provide a panorama for diners in the museum's glass-walled restaurant.

"The idea," says James H. Duff, the director, "is to be a small museum, or to appear like a small museum. We will always have the 1864 gristmill at the center, so that as a visitor approaches there is the sense of the area's history. There is the lobby with its old bricks and rough white plaster, and then a contemporary glass façade looking out across the river. Visitors get a sense of the environment in which so many of the Brandywine artists, particularly nineteenth-century artists, worked. Then they enter the first-floor gallery of landscapes, and see paintings which immediately reflect—in a philosophical sense, at least—what they just saw."

Along with the plan to run a part-time museum with borrowed works, the institution's entire artistic outlook metamorphosed quickly in the early years but never strayed far from the Brandywine theme. In 1980 the board of trustees issued a definitive statement of purpose. The museum would deal with American art and art history, focusing primarily on objects related to the Brandywine region, on American still-life painting, and on American illustration.

That direction is instantly clear in the first-floor gallery, which beckons straight to the region's milieu and history. The visitor encounters William Trost Richards's *Valley of the Brandywine,* a hay-mowing scene painted about 1886. A few paces ahead is another Richards Brandywine scene, this of the tree-fringed river. A Philadelphian trained in Europe, Richards was noted for seascapes as well as landscapes. His mastery of the Brandywine's gentle aura was clearly complete. The span extends to the late twentieth century and the vast contributions of the Wyeths but thoughtfully includes a variety of works, among them *August,* a mellow meadow painted by "Frolic" Weymouth in 1974. The Brandywine Conservancy's founding father—and prominent sporting coachman—turns out to be a skilled artist as well.

It is a long way back to Bass Otis's small 1819 work of a house by the water, thought to be the first American lithograph. Thomas Doughty's *Gilpin's Mill on the Brandywine* records a setting of far-off 1830. Asher B. Durand chronicled beautiful trees in *Landscape, Wood Scene,* in 1854. Edward Moran, better known for his marine subjects, painted a masterful, rock-strewn *On the Brandywine* in 1862. Later in the nineteenth century, Jasper Cropsey painted *Autumn on the Brandywine,* and Thomas Anshutz created *Chester County Plowman* with more than a suggestion of Winslow Homer. It is intriguing to see how notable Victorians, some of whom were leaders in the Hudson River School of romantic landscape painting, were clearly inspired by the Brandywine. Another pleasure is making the discovery of lesser-known artists like James Brade Sword, whose *Along the Brandywine* of 1881 proves again that minor masterpieces can crop up unexpectedly. And a radiant seascape by Alexander Stuart called *Sailing* (1880) might even trigger thoughts of an underappreciated masterpiece.

William Trost Richards

The Valley of the Brandywine, Chester County

(September), *1886–87.*

Oil on canvas

Collection Brandywine River Museum,

Purchased through a grant from the

Pew Memorial Trust.

Jasper Cropsey

Autumn on the Brandywine River. *1887*

Oil on canvas

Collection Brandywine River Museum

The permanent still life collection is rich in American trompe-l'oeil paintings. Exemplar of that popular, often amusing genre of the 1880s and 90s is George Cope, a West Chester artist whose works here include the notable *Indian Relics* and *A Day's Bag*. (Cope, it should be added, did not live by trompe alone; his landscape *The Atkins Furnace, Pottsville, Pa.* of 1890 is a lesson in industrial history. Here is the real look of the past, with fires and smokestacks and locomotives blazing and belching hellishly in the night.) More gallery charmers are Victor Debreuil's *Barrels of Money* and Alexander Pope's dogs in a crate, *Do Not Feed*. Other trompe-l'oeil experts include William Harnett, John F. Peto, and DeScott Evans, who hit the mark in 1888 with his realistic almonds in *Free Sample—Try One*. Carducius Plantaganet Ream's *Peaches* (1880) are nearly three-dimensional. Taken together, the still-life works form a strong and entertaining specialty.

The Brandywine region's extraordinary relationship with illustrators emerges in the museum's collection of nearly five hundred artists' works for publications. The art of illustration "has been treated as a kind of pejorative notion by critics and art historians in most decades of the twentieth century," says Jim Duff. "One of the great joys here has been finding marvelous drawings by such artists as Reginald Marsh and George Bellows, not commonly thought of as illustrators, who did fine drawing for American publications. There is some remarkable pen-and-ink work in American illustration. It's a study by itself."

Felix Octavius Carr Darley, the Philadelphia-born king of American illustrators in the generation before Howard Pyle, sets the quality level straightaway. The museum often hangs his earlier works, such as an 1859 drawing, rich in period dress detail, for James Fenimore Cooper's *The Pioneers,* a later ink-and-wash drawing

George Cope

Indian Relics, c. 1891.

Oil on canvas

Collection Brandywine River Museum,

Museum Volunteers' Purchase Fund, 1977

from 1887 of a couple for a Dickens work, and a watercolor farmyard scene of 1865 warranting his broader artistry. Darley's talent with pen and ink strongly influenced Pyle, and his presence nearby made him—by only the slightest geographic stretch— a figure in the Brandywine heritage. As for Pyle himself, his towering presence down the road at the Delaware Art Museum extends its long shadow northward to Chadds Ford. The Brandywine River Museum, cheerfully acknowledging that the preeminent Pyle collection is in Wilmington, displays enough of his drawings and paintings to reveal the height of his talent, the complexity of his techniques, and his importance to American illustration. Here is some of Pyle's earliest and most pivotal work, including the frontispiece for *The Wonder Clock,* an ink drawing of 1887. The

Howard Pyle

Frontispiece for "The Wonder Clock," *c. 1888*

Ink on paper

Collection Brandywine River Museum,

Museum Volunteers' Purchase Fund

F. O. C. Darley

Farmyard Scene, *c. 1865*

Watercolor and pencil on paper

Collection Brandywine River Museum

.
.
.
Maxfield Parrish
.
The Knave of Hearts

(*Title page for Louise Saunders's* The Knave of Hearts.

New York: Charles Scribner's Sons, 1925), 1922

Oil on composition board

Collection Brandywine River Museum

Frederic Remington

They Were a Hard Looking Set

(Illustration for "After Geronimo,"

Outing, *1887), 1887*

Ink on paper

Collection Brandywine River Museum

Remington.

selection usually includes several monochromatic oils, which—though purely commercial illustrations—shine with artistic integrity. Pyle's full crackling energy, bravura style, and vast human empathy all radiate from such full-color oils as *They Stood Staring at the Violent Sky* of 1905. The *Harper's New Monthly* short story for which he painted the work is long forgotten, but the painting lives, this moment in a graveyard riveting us with its imperishable suspense and fragile, confused humanity. Yet the permanent collection's key Pyle work is *The Nation Makers,* a major action scene of the Battle of the Brandywine, painted on the very site, in 1903, where Pyle held summer classes at Chadds Ford. The great illustrator and his students actually lived and worked on the Brandywine battlefield in structures familiar to Washington and Lafayette.

Signed to many illustrations in the museum's permanent collection are such star names as Charles Dana Gibson, whose famous pen style pulses from across the room, and Frederick S. Church, recalled by his Uncle Remus drawings. Maxfield Parrish contributes a parody of a limp-wristed artist. Included are top magazine illustrators remembered fondly by many readers of the old *Saturday Evening Post:* Norman Rockwell (a charcoal study of Yankee Doodle) and Mead Schaeffer (*Arabs on a Brick Wall,* a vivid, colorful, bravura work from 1927).

Cartoons are displayed from Thomas Nast (satirizing Bismarck) to Rockwell Kent (ridiculing politicians) to Al Hirschfeld (portraying Boris Karloff and Peter Ustinov). The great John Sloan left us his viewpoints on Prohibition in a 1912 drawing. Many are surprised to learn that Reginald Marsh made hilarious period drawings, in his unmistakable style, for a 1942 edition of *Moll Flanders.* But many of the artists are unknown to modern viewers, and they come as totally fresh breezes. Consider Rufus Zogbaum, who captures our interest with his gouache and watercolor shipwreck scene of 1891, *A Drama of the Sea.* Such illustrations invariably contain fascinating historic and social detail, such as the way Alice B. Stephens's *A Woman in Business* records a busy moment at a dry-goods counter in 1897. Another successful female artist, Jessie Wilcox Smith, is remembered by her charming 1900 mixed-media work of *Goldilocks and the Three Bowls.*

Surprisingly, despite the disappearance of the stories for which many illustrations were made, we are pulled into the suspense of a dramatic moment, as in a 1908 monochromatic oil by Gayle P. Hoskins, *The Papers Slipped Unheeded from Dickman's Grasp.* On the edge of a gossipy circle in a swank private club, a stunned Dickman has just read something devastating, freezing the mysterious instant that still grips our attention and curiosity. Background social commentary is another Circean fascination of such pictures. In a gouache and watercolor by William Thomas Smedley, *The Rich and the Poor,* a rich woman dismounts from a glistening carriage pulled by silver-mounted horses, attended by driver and footman. Around them a nimbus of onlookers, pinched faces stoic and bitter, jolts us with fin-de-siècle social consciousness.

····

Frank E. Schoonover

The Canadian Trapper

(Illustration for Jack London's White Fang,

Part III, "The Gods of the Wild,"

Outing, *July 1906), 1906*

Oil on canvas

Collection Brandywine River Museum,

Gift of Mr. and Mrs. Andrew Wyeth

Rose O'Neill

Gas, *1905*

Ink on paper

Collection Brandywine River Museum

The museum even takes an occasional foray into fashion illustration. Rico Lebrun's ink and watercolor *Travellers on a Coach* pictures an elegant 1920s group atop a sporting drag. The picture has a special meaning in the Brandywine, for one of the popular features of the Winterthur Point to Point race is a parade of such vehicles, garnished by such people.

Themes of patriotism and Americana were strong among the great illustrators. William H. D. Koerner's *Through Mud to Glory* (1914) recalls the misery of a Civil War march. William J. Aylward's *Perry Transferring the Flag* (1913) captures high melodrama on the Great Lakes a century before. Harvey Dunn, one of Pyle's best students, demonstrates his brawny style in such museum favorites as *Ox Driver* (1909).

The continuity between Howard Pyle and three generations of Wyeths traces one of the most singular legacies in the history of art, a body of talent that is universal in scope, yet rooted solidly in the Brandywine Valley, and a part of its artistic tradition. To begin understanding the Wyeth connection with the Brandywine, it is helpful to imagine young Newell Convers Wyeth arriving in Wilmington to begin studies with Pyle. Wyeth, a farm boy of Needham, Massachusetts, had grown up "doing every conceivable chore that there was to do about the place." That upbringing honed his 6-foot 2-inch frame to an understanding of the body's work under physical stress. Years later, he would say that when he painted a figure on horseback, a man plowing, or a woman buffeted by the wind, he could sense the muscle strain, the feel of the hickory handle, "or the protective bend of head and squint of eye that each pose involves."

Encouraged by his mother but against the wishes of his father, young Wyeth studied art in Boston before, at twenty, he was accepted by Howard Pyle in 1902. He blossomed under the tutelage of Pyle, who beyond cavil was one of the great art teachers of all time and, moreover, was at the summit of his craft and career. Wyeth perceived Pyle as a combination of Beethoven, Washington, Goethe, and Keats. The Wilmington/Chadds Ford master led his students on a sternly disciplined path to technical competence, but the hard journey was always tempered by his trust—which he advanced insistently—that imagination was the supreme element in artistic success.

"He told his students that they must be artists first, and then illustrators," wrote Jim Duff in the catalogue for a 1987 Wyeth family exhibition, *An American Vision*, "but aside from the composition, drawing, and painting techniques he taught, he constantly emphasized drama and emotional content, which he believed had to arise from the artist's personal concern for a subject."

A few months after he arrived at Wilmington, Wyeth sold his first *Saturday Evening Post* cover, a horseman on a bucking bronco. The picture was a harbinger of exciting things to come. Wyeth was fascinated with the American West, and the just-vanished frontier. In 1904, armed with a fresh Western story illustration assignment,

N. C. Wyeth

In the Crystal Depths

(Illustration for "The Indian in His Solitude,"

Outing, *June 1907), 1906*

Oil on canvas

Collection Brandywine River Museum

N. C. Wyeth

Old Pew

(Illustration for Robert Louis Stevenson's Treasure Island.

New York: Charles Scribner's Sons, 1911), 1911

Oil on canvas

Collection Brandywine River Museum

N.C. headed for Colorado, Arizona, and New Mexico, where he punched cattle, photographed cowboys and Indians, and sketched. Two years later he returned to Colorado, and before returning to the East he gathered a collection of Western artifacts and clothing for future years of studio reference. N.C.'s Western paintings would always have the look—almost the scent—of dusty, sweaty reality. His preeminence in the field lasted for years, even after his boyish enthusiasm had cooled.

But the East was too much in his blood. By 1906 N.C. moved to Chadds Ford, permanently enchanted with the artistic qualities of its landscape. He felt the "real story" of nature there as never before, he said, adding: "And this is a country full of 'restraints.' Everything lies in its subtleties, everything is so gentle and simple, so unaffected." It would be hard to improve on that verbal description of the Brandywine region. It would be still harder to improve on Wyeth's pictorial evocation of those same words in the Impressionistic *Chadds Ford Landscape,* which he painted in 1909, now in the museum's permanent collection. Its golden, late-summer meadows, the roofs of its modest town, and the hazy hills seem the very essence of the Brandywine.

Increasingly, N.C. liked to paint Indians of the Eastern tribes. *In the Crystal Depths,* done when he was twenty-six, is an amazing picture; a brave, drifting in his canoe around a dark cliff, pensively gazes down into the water, enjoying the spectacle. It is a human, appealing subject and an almost reckless composition in which the Indian and his craft nearly disappear in the cliff's shadow, while bright sunlight spills off-center to the right. Adroitly, Wyeth saves the structural harmony with masses of foam, curling pale and sinuous into the dark foreground of the stream's surface.

Yet it was not for Indians, or cowboys, that N.C. Wyeth's public impact reached its dazzling peak, but . . . pirates. And related sea adventures. This occasionally causes some confusion vis-à-vis the work of his pirate-disposed mentor, Pyle, but any contest over who painted the best pirates would have to be judged a draw. Wyeth's pirates swashbuckled forth in new Scribner's editions of *Treasure Island* and *Kidnapped* just before World War I. The museum owns four originals painted for *Kidnapped* in 1913. Others remain in the private collection of the Wyeth family, whose loans to the museum mean that the pictures are often on display there. Two popular masterpieces from *Treasure Island* are *Ben Gunn* and *Old Pew.* A beam of light catches Gunn's shaggy countenance peering from the forest, his hair and beard almost one with the rugged bark of the great trees. It is a classic of simplicity, yet a profound characterization. And Old Pew? Here he comes down the road, hideously slashing with his cane, ranting through rotted teeth, and behind him the moonlit Admiral Benbow Inn stands ghostlike under meager stars. Surely, after this, there could never be another version of blind Pew.

Unlike Pyle, throughout much of his career N.C. was highly sensitive to the commonly perceived distinctions between illustration and fine art and chafed to commit himself to "a real mark." As time permitted, he returned to landscapes and

still lifes as if to refresh himself, and in the process painted some of his finest work; look at the museum's *Dusty Bottle* or *Dying Winter*. Amid what he called the "succulent meadows" and "big sad trees" of Chadds Ford he found perennial inspiration, and some of his scenes of the 1930s and 1940s reflect that era's rural zeitgeist with an authority comparable to that of his great contemporaries, Thomas Hart Benton and Grant Wood. N.C. had a vast store of work yet to do when he died, at age sixty-three, in a grade-crossing accident at Chadds Ford.

Andrew Wyeth

Siri, *1970*

Tempera on panel

Collection Brandywine River Museum

Talent as a genetic cargo is normally too fragile to guarantee, but the Wyeth family must be an exception. Of the five extraordinarily gifted children of N.C. and his wife (née Carolyn Bockius of Wilmington) three were painters, one was a musician, and another an inventor. The youngest, Andrew, was born July 12, 1917, the hundredth anniversary of the birthday of Henry David Thoreau, one of N.C.'s heroes.

"His devotion to Thoreau and nature was to affect his approach to Andrew's development," James Duff has said. "Father and son had in common some of the most important elements that shaped their art: a love for details of the rural landscape, a sense of romance, a strongly felt heritage, admiration for certain other artists and writers, innate artistic ability, and deep concern with technique." (Of the painters N. C. Wyeth admired and studied, he named Pyle, Constable, Millet, Dürer, Homer, and the Italian Impressionist Segantini.)

Yet there would be enormous differences. N. C. Wyeth's meaning surged across his paintings like a battle flag, unmistakable and unambiguous. He had his subtleties, but they tended to derive from composition and subject selection, as well as technique. An Andrew Wyeth work, on the other hand, inevitably is a study in recondite psychological complexity. It is usually mysterious, provocative, and occasionally disturbing. That may puzzle those viewers who see the detailed realism and bucolic subjects and want to think that here is a pleasant, safe painter of some vanishing archaic America.

Andrew Wyeth's intensely personal view of his subjects is all the more challenging to the beholder because, perhaps at least half the time, those subjects are taken from within a few miles of the family home along the Brandywine near Chadds Ford. (The other subjects derive from his other favored place, his summer home in Maine.) Thus he is painting in exactly the same geographic milieu in which dozens of preceding painters, including his own father, found their inspiration but saw things entirely differently. Andrew Wyeth's inner vision of the Brandywine landscape can seem as hard and unsentimental as a pitted plowshare. Look at his *Evening at Kuerners*, a stucco-sided farmhouse set under winter-dead trees in funereally dark hills. The house glows palely under a nacreous sky. Light spills from the windows of one room, but there is no welcome, no hint of a beacon lamp lighting the way for some home-bound loved one. Instead, perhaps, someone in that room is listening to the news. Or just sitting, staring at mildew-stained inner walls. Or maybe someone is dying there. Or . . . That is the kind of thinking that an Andrew Wyeth picture can generate.

His sole artistic education came from N.C., who worked with him enthusiastically from early childhood. It was traditional art study in that his father insisted on years of practice with charcoal-and-pen drawing, but once it was time to paint, Andrew largely went his own way. He once said that his father rarely talked about technique, but "he helped me simplify things." Curiously, Andrew never was comfortable with oils, and strongly preferred watercolors until he began working with egg tempera.

His brother-in-law, Peter Hurd, who had married N.C.'s eldest child, Henriette, introduced him to the medium in the late 1930s. (Both Hurds and Wyeth's other son-in-law, John McCoy, are represented in the museum's collection.)

Andrew in oil might be just as distinctive as Andrew in tempera, but we may never know. Tempera is ideally compatible with his minutely detailed technique, producing exquisite results that live somewhere beyond the normal margins of realism. In the museum's *Siri* the girl's blond tendrils seem three-dimensionally perfect. Wyeth captured the young Scandinavian sitting as straight and clear-eyed as for a high school portrait, against the cream-painted molding of an antique fireplace and door, a masterful blending of human and architectural elements. *Siri* is not exactly typical Wyeth, however; it is bright and hopeful and almost ebullient. The same girl in *Indian Summer*, viewed from behind, stands nude on a rock overlooking a somber forest, darkly ocher and umber. This is—somehow comfortingly—more like the real thing, the pure Wyeth. What is the meaning of this juxtapositioning of young girl and gloomy forest, a blend that Poe might have loved?

Andrew Wyeth

Bare Back, *1980*

Drybrush watercolor on paper

Collection Brandywine River Museum

.

.
.
. *Andrew Wyeth*
.

Roasted Chestnuts, *1956*

Tempera on panel

Collection Brandywine River Museum

.
.
. *James Wyeth*
.

Portrait of a Pig, *1970*

Oil on canvas

Collection Brandywine River Museum,

Gift of Mrs. Andrew Wyeth

The paintings of this artist defy typecasting. Sometimes one simple exaggeration makes all the difference, as in the grotesquely tall, whip-slender roadside figure in *Roasted Chestnuts,* waiting for customers that somehow we suspect will never come. In one of his watercolors, *Big Top,* a farm wagon and three placid cattle seem as light and harmless as a nineteenth-century English landscape painter might have rendered them, yet above this harmless grouping is the dark congestion of an alien sky,

swirling at the horizon. Instead of a pretty farm scene the picture becomes almost spectral. In such ways does Andrew Wyeth palm the ace.

Not since the Peales has America produced a family of such artistic heft as the Wyeths. James (Jamie) Wyeth, son of Andrew and grandson of N.C., began his career at the top, bursting on the national art scene with a series of portraits in which faces of magical realism seem to float in sable backgrounds. His choice of subjects was as striking as his lush use of oils: a callow, leather jacketed youth in *Draft Age;* his father, Andrew, with features glowing from the dark as if lit by lantern light. Jamie Wyeth has immortalized an unshaven local character known as Shorty quite as effectively as some of his other subjects: Andy Warhol, Rudolf Nureyev, and John F. Kennedy.

Striking as his human portraits may be, Jamie Wyeth has carved out an additional specialty with animals. His *Portrait of Pig,* huge, hairy, pink-teated, is one of the most popular in the museum's permanent collection. Pigs, chickens, cows, goats, ducks: Jamie Wyeth's animals are an engaging lot, not sentimentalized but more sympathetic than Andrew's creatures, whose expressions tend to seem somehow alien and secretive.

Raised on the family farm by the Brandywine, and steeped in all the appropriate traditions, Jamie began his art training at age twelve under his painter aunt, Carolyn—an accomplished artist in her own right who is represented in the Museum's collection—and from fourteen with his father. Unlike Andrew, he stuck with oil and watercolor. Sometimes his paintings seem to suggest Andrew's work (consider *Wolfbane,* a still life of his wife's hat on a chair); others, like *And Then Into the Deep Gorge,* echo faintly the dramatic instinct of N.C. Like his father and grandfather, he has been a student and admirer of the legendary Pyle, and he adds Thomas Eakins to his list of painterly role models. Yet Jamie Wyeth is clearly his own artist, a major talent enlivened by humor, tempered by pathos, and spurred by an urge to experiment. Like his dynastic predecessors, he achieved success so young and with such apparent endurance that he made it seem deceptively easy. At the museum, a visitor—exercising the unparalleled opportunity to study Wyeth works in depth and quantity—can make a balanced judgment of the talent, vision, and energy they represent.

The Wyeth family's early interest in the museum became a tradition of support that continues to the present day. The Andrew Wyeth gallery, which usually has at least forty works by its namesake on display, is a highly visible consequence. Although the Wyeths have also contributed many works by other artists, many with a Brandywine viewpoint, it should be said that many of the works in the permanent collection, or on frequent loan, were provided by others among the museum's large body of supporters. Together, these fertile relationships harmonize with the institution's purpose of regional preservation of cultural and natural history. The result is a museum uniquely local, yet enriched throughout with renowned artists. Some far larger museums should be so fortunate.

James Wyeth

Study for Nureyev, Half Figure with Coat, *1977*

Pencil and wash on paper

Collection Brandywine River Museum,

The Margaret I. Handy Memorial Fund, 1980

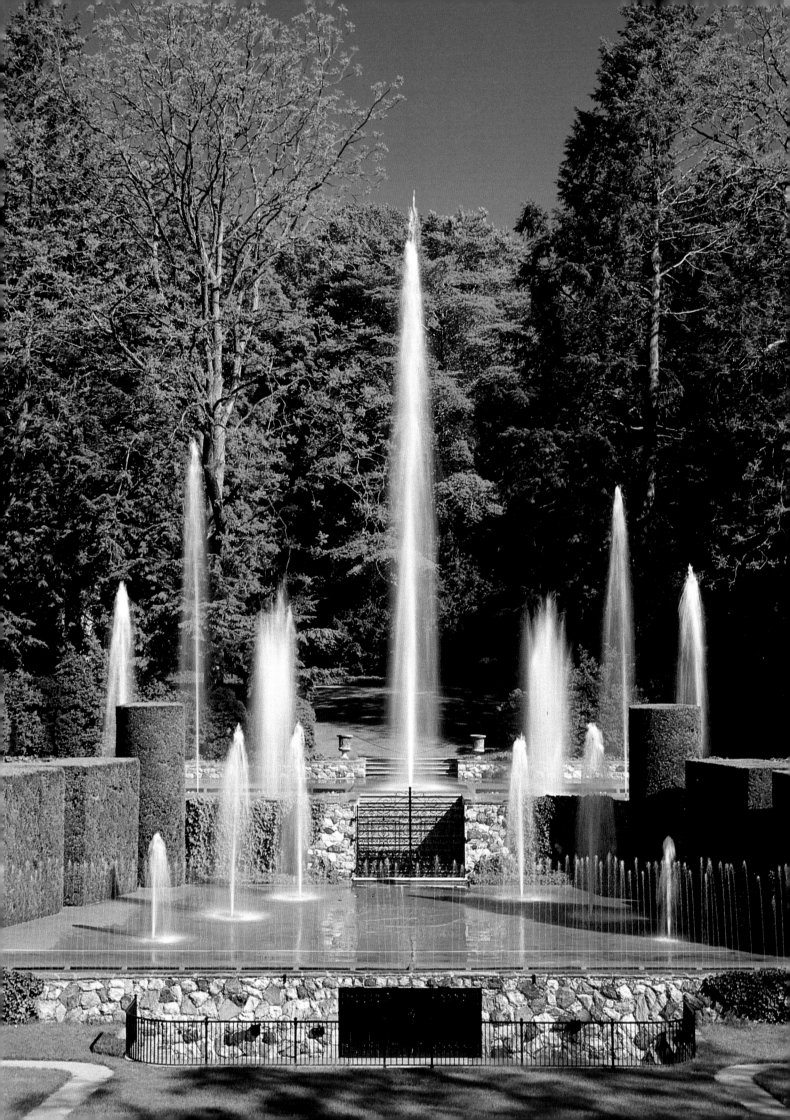

L·O·N·G·W·O·O·D

G·A·R·D·E·N·S

"As a child I was always delighted to behold flowing water," Pierre Samuel du Pont recalled, and he always seemed to be in the right place at the right time to see it. As a six-year-old in 1876, Pierre found the fountains at the Centennial Exposition "captivating beyond description with jets of all kinds spurting like mad and without cease." At nineteen, he visited the Paris Exposition of 1889, where illuminated fountains spangled the Champ-de-Mars by the new Eiffel Tower. The clincher was applied in 1893, when he saw the World's Columbian Exposition in Chicago. "The germ of the creation of the Longwood fountains was found in the great fountain in the Court of Honor at the Chicago Exposition," he said.

Fate was kind to Pierre du Pont, for it enabled him to more than match the nineteenth-century waterworks that stirred his youthful inspiration. On a 1,050-acre estate near Kennett Square, Pennsylvania, he spent much of his lifetime creating and enjoying (and inviting the world to come and share) his own stupendous fountains. Still going strong almost forty years after his death, they flare, fizz, and thunder in the midst of acres of the exquisite color and greenery of gardening on a cosmic scale. Together, they create an ensemble of beauty and delight that is surely one of the most original spectacles on earth.

Du Pont's great caprice would have taxed anyone's lifetime quota of creative energies, and it seems even more remarkable when we learn of his parallel business career. Chemist, industrialist, master of finance, he began—like many bearing the same name—working with Du Pont gunpowder in the company founded by great-grandfather Eleuthère Irénée du Pont. In 1902, at thirty-two, he joined cousins Alfred and Coleman and bought controlling interest in the company. Pierre became treasurer and then vice president, and then in 1915 he became president in a corporate struggle that resulted in a long estrangement from Alfred, the master of

Page 192. *Fountains of the outdoor theater, first installed in 1915, sometimes drenched the performers.*

Pierre Samuel du Pont, c. 1912

Nemours. Under Pierre's presidency, the Du Pont Company underwent a vast expansion in chemical manufacturing and flexed its muscles in other directions. Soon the company owned so much stock in General Motors that Pierre became president of the automaking behemoth in 1920 to safeguard du Pont family interests. He served for three years, returning to E. I. du Pont de Nemours full-time in 1923 as board chairman. Clearly, in his time, he was Du Pont's leader, the first among equals in a family of tycoons. Paradoxically, perhaps, he was a relatively simple and shy man who shunned the limelight and did not surround himself with ostentatious luxury. But he liked people, and liked to entertain. That was where Longwood came in.

The place must have been predestined for horticultural greatness. In 1700, for 44 pounds sterling, William Penn himself sold 402 acres here to a fellow Quaker named George Peirce. The buyer's son, Joshua, erected in 1730 the first section of the brick farmhouse that stands today. By the late 1700s, another generation of Peirces (Joshua's twin grandsons Joshua and Samuel) had begun planting a 15-acre grove of ornamental trees, surely one of the first arboretums in the New World. But the Peirces, while pioneers, were not alone. Quakers saw the natural world as a path to understanding God, and they encouraged the study of horticulture. Stimulated by this powerful blessing, and abetted by the fertility and natural beauty of the region, southeastern Pennsylvania became America's first horticultural capital.

Early in the nineteenth century the Peirces continued planting both native and exotic trees, including some of the earliest ginkos ever brought from China to North America. The brothers ranged over the Mid-Atlantic region on horseback, collecting specimens that they then planted in tightly packed rows. By the middle of the nineteenth century Joshua's son, George Washington Peirce, was squire of the property; he took the responsibility as seriously as his forebears had but added such recreational facilities as croquet courts, lakefront rustic summer houses, and rowboats. Peirce's Park became a well-known pleasure ground in Chester and Brandywine countries.

After George died in 1880 the property deteriorated, though it remained in the Peirce family until 1905, when it changed hands several times in quick succession. A sawmill was moved in, preparatory to cutting down the great trees so carefully cultivated for a hundred years. Enter Pierre du Pont at this hairbreadth moment, buying the entire historic arboretum and the old Peirce farmhouse. He seemed the soul of diffidence about the deal, which he described as something he would have diagnosed formerly as an attack of insanity. "As I have always considered the purchase of real estate a sign of mental derangement and have so proclaimed, I fear that my friends may be looking for permission to inquire into my condition. However, I believe the purchase worth the risk, for my farm is a very pretty place, and I expect to have a good deal of enjoyment in restoring its former condition and making it a place where I can entertain my friends."

The savior of Peirce's Park began quickly. In 1907 he laid out the first flower garden, just south of the house, a 600-foot-long "old-fashioned plan of straight walks and box borders at the edge of flower beds." Relying on home gardening books, du Pont did all his own designing; he had been sorely disappointed in the work of a New York landscaper hired for an earlier Wilmington project. His idea for this first effort was to provide appealing, colorful vistas from the house. In the middle of the garden, he constructed a round pool twenty feet in diameter with a single spouting jet, the first fountain at Longwood.

Pierre was so pleased with his big new flower garden that he threw a party for four hundred relatives and friends. Dining sumptuously, the guests were serenaded by a military band and dazzled by fireworks. The event was so successful that it set a pattern that endured until 1940, with time out for World War I and the Great Depression. The time was always around the second week in June, when the garden—consisting mostly of perennials in du Pont's day—was at its peak. According to Colvin L. Randall, a spokesman for today's Longwood Gardens, du Pont's search for new ways to amuse and delight his guests spurred him to ever grander effects, "the concept of gardens as theater, with live performances, fountains, fireworks. His house was very simple; he didn't go in for a theatrical display in his home, but he did in the gardens. He particularly liked the gardens of France and Italy. He wasn't especially fond of English gardens."

The Flower Garden Walk, with its circular

single-jet fountain, billows with flowers three

seasons of the year.

Fireworks, colored fountains, and

stirring music: Longwood at its festive best

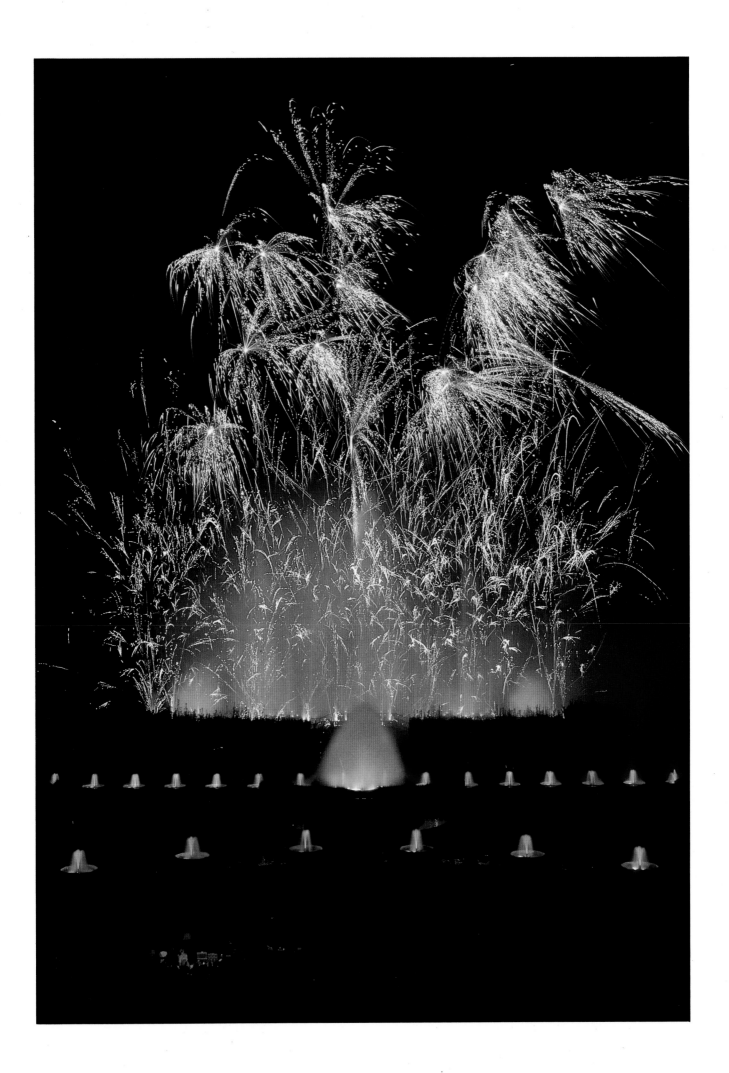

Touring Italy in 1913, du Pont scouted a score of villas and came back loaded with ideas. One was to build an outdoor theater, which he designed on the site of the old Peirce barn. It opened spectacularly at the 1914 garden party with a program of dance, concluding—in the words of a newspaper scribe—with a "frolic by the harlequins, who, much to the surprise of the guests, danced among them . . ." Braced by his good notices, Pierre immediately began planning the 1915 renewal. He added fountains to the stage, so that his dancers would be enhanced—and sometimes drenched—by spurting waters.

By 1926, Pierre was radically upgrading the open-air theater. He burrowed under the stage to make dressing rooms, sculpted the level ground into a proper amphitheater for better audience visibility, and installed a big new 750-nozzle fountain system that included a water curtain in front of the stage. In a refinement that dazzled even the most jaded of the flapper set, the fountains were illuminated by more than 600 colored lights. At the same time, several hundred yards away, the impressario added an entirely new fountain called the Italian Water Garden. Similar to a water display the du Ponts had observed near Florence, the new facility featured 600 jets playing from blue-tile pools and pedestal basins.

Du Pont's fountaineering now reached for its sparkling apogee. In 1928, on a large, low-lying area south of his new conservatory, he added an immense rectangular basin, two stately canals, and two circular pools, all ornamented with carved Italian limestone. The ensemble was bordered with Norway maples pruned into boxy shapes. This he called, with typical lack of pretension, the Main Fountain Garden. To hurl water as high as 130 feet skyward from hundreds of illuminated fountains, eighteen mighty pumps recirculated up to 10,000 gallons of water per minute. And these fountains did not merely splash on and off; a huge console of switches and levers enabled a controlling helmsman to create an infinity of effects. Each jet could be bathed individually or in combinations of red, green, blue, white, and yellow light. It was the master of Longwood Gardens' goal to rival the great fountain he had seen at the 1893 Chicago Exposition, and to take inspiration from such European masterpieces as the Villa d'Este at Tivoli, and he clearly succeeded. (In the 1980s, long after du Pont's death, the fountains were computerized and choreographed to accompany concerts of recorded music, geysering and changing color on microsecond cue in more than 17 million possible syntheses.)

From the beginning, du Pont built his great caprice one section at a time, rather than according to a grand design. One thing tended to lead naturally to another, as when construction of the Main Fountain Garden uncovered so much stone that it suggested construction of two nearby entities, the Hillside Garden and the Chimes Tower and Waterfall. But the overall garden plan was partitioned, rather than integrated. Du Pont compared Longwood Gardens to a department store, specifically to Wanamaker's, the Philadelphia pioneer of the genre. By most tallies, Longwood Gardens has twenty-two departments spread across its total 1,050 acres.

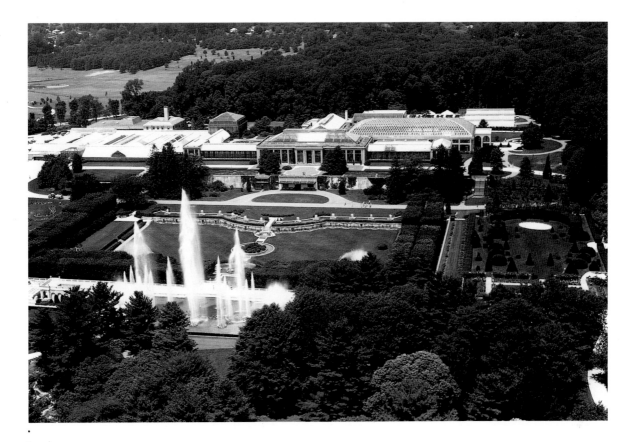

The Conservatory and fountains of Longwood offer a vast panorama.

The fountains of Longwood Gardens: Pierre S. du Pont's answer to his childhood inspiration

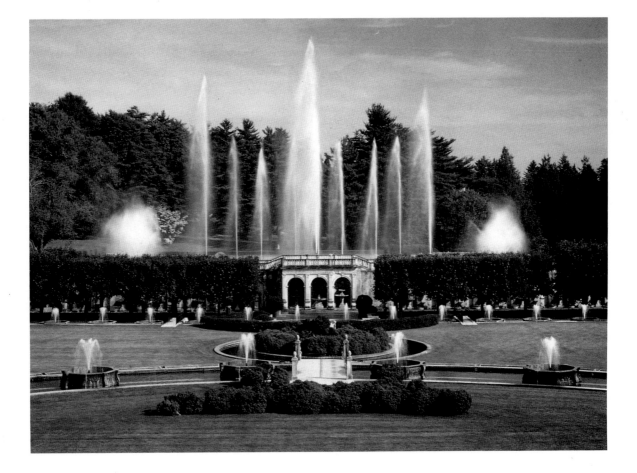

Excavations for the Main Fountain Garden

uncovered enough stone to build the waterfall.

The Hillside Garden is a rapidly changing

delight from March through October

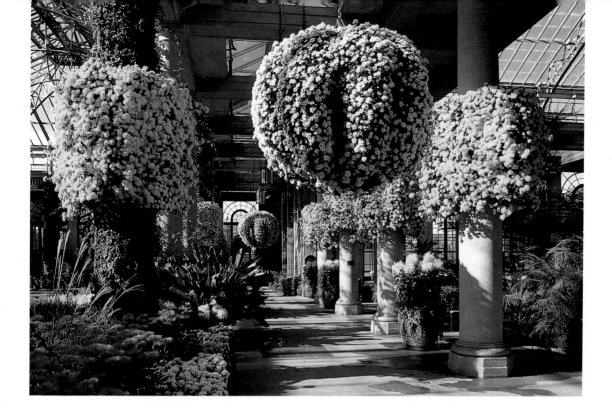

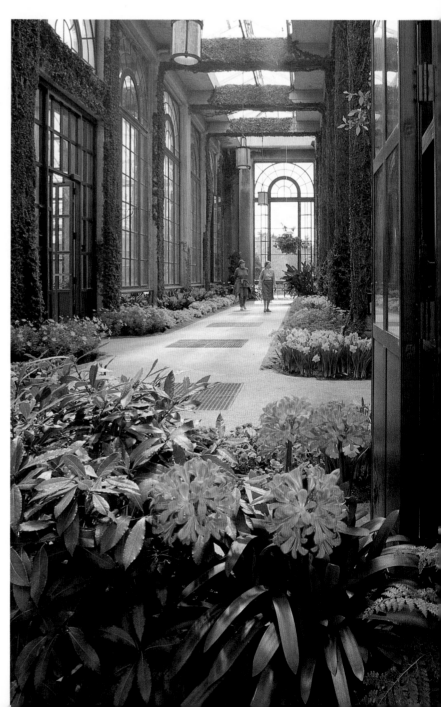

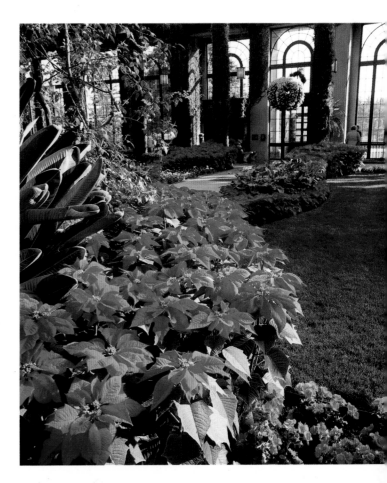

····

The Main Conservatory building

was completed in 1921.

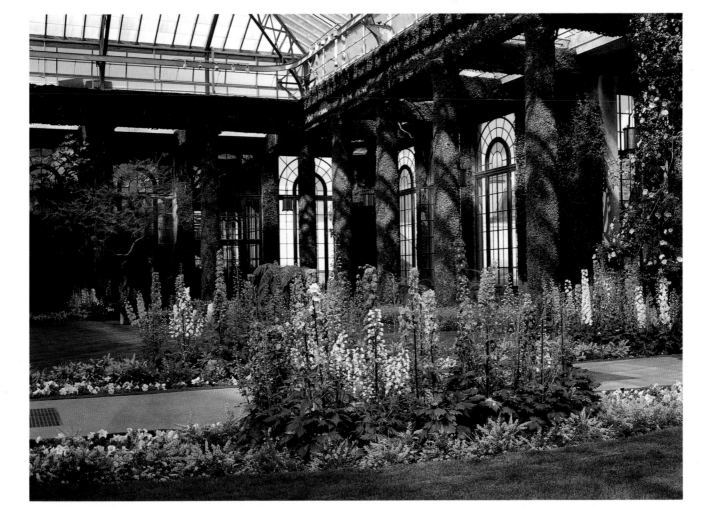

Du Pont connected two wings on the Peirce House in 1914 to create a "winter garden" with cleverly engineered disappearing windows. He liked the result so well that—never slow to amplify a good thing—he began building the gigantic three-and-one-half-acre complex that visitors see today. After several false starts the Main Conservatory building was finished in 1921. He called it the Orangerie, and filled it with citrus trees; these days the cavernous space is devoted mostly to blazing displays of flowers in beds separated by expanses of lush grass. So cleverly did du Pont downplay the greenhouse aspect that, apart from the glassed roof, a visitor might almost think himself in a Mediterranean palace. Classical columns, many covered with creeping fig, soar upward to Greek architraves, while the outer walls are mostly Palladian windows framed in bronze arches and mullions. Purple bougainvillea flashes high overhead.

A kind of endless spring lives in the vast Conservatory, which is open every day of the year. A visitor arriving in the depths of January will find a kaleidoscopic wonderland of color and fragrance in twenty different garden areas. Yet the calendar is observed, and springtime in the Orangerie features 45,000 bulbs blazing away from January to April amid golden tunnels of acacia blossoms. There is always some change with the seasons: yellow primroses give way to pastel delphiniums and foxgloves to sunny fuchsias, raspberry-hued crape-myrtles to blue and orange birds-of-paradise. In the fall, the chrysanthemum festival is a popular feature, with more than 15,000 specially cultivated plants.

The Orangerie connects with a comparable area called the Exhibition Hall, forming a T-shape space about 100 by 180 feet. The hall features a sunken marble floor that is usually flooded with a pool of water to reflect ethereal images of the Australian tree ferns that live there. Sometimes the water is drained for flower shows, concerts, dances, or banquets, but du Pont provided other space as well for his gatherings. At the north end of the Exhibition Hall are the Music Room and the Ballroom, whose decor is formal and traditional with parquet floors and crystal chandeliers. Visitors who have gained some sense of the reach and grasp of Pierre du Pont are not terribly surprised to learn that he installed a great pipe organ in the Ballroom. Its 3,650 pipes proved too meager for the task. In 1929, he bought a new Aeolian, a 55-ton instrument whose 10,010 pipes and assorted machinery are installed in nine concealed chambers. It is probably the world's largest residence organ. The instrument is about the size of the organ in the Mormon Tabernacle, but considering the smaller space around it at Longwood Gardens, the Aeolian's puissance is such that it is often called the world's loudest organ.

Something of du Pont's expansionist vision must have remained at Longwood Gardens when Pierre died in 1954, bequeathing an endowed institution "for the sole use of the public." Much of the Conservatory has been rebuilt or enhanced since then. In 1973 the big East Conservatory replaced an azalea house dating from 1928. Even larger than the Main Conservatory, the newer building features a graceful

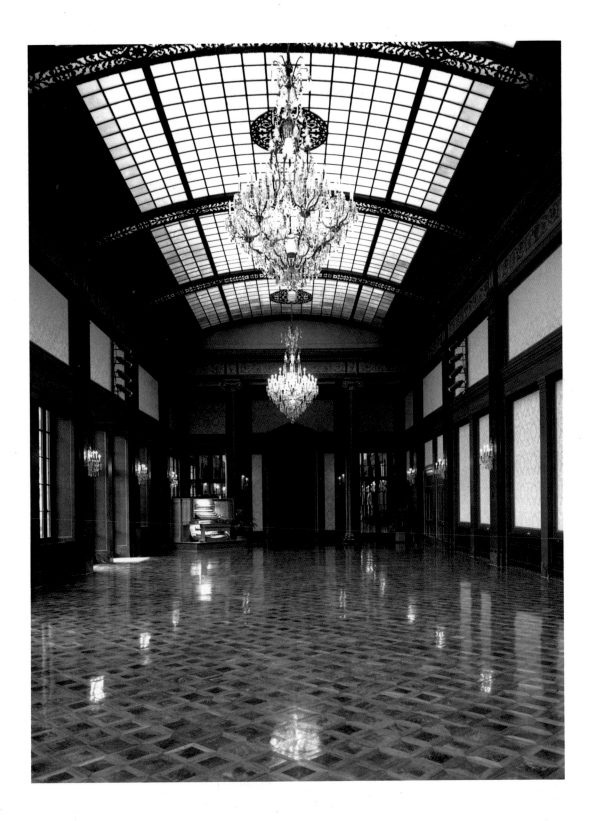

The Ballroom, to the rear of the Conservatory, was finished formally

with crystal chandeliers, a pink glass ceiling, and walnut parquet floors.

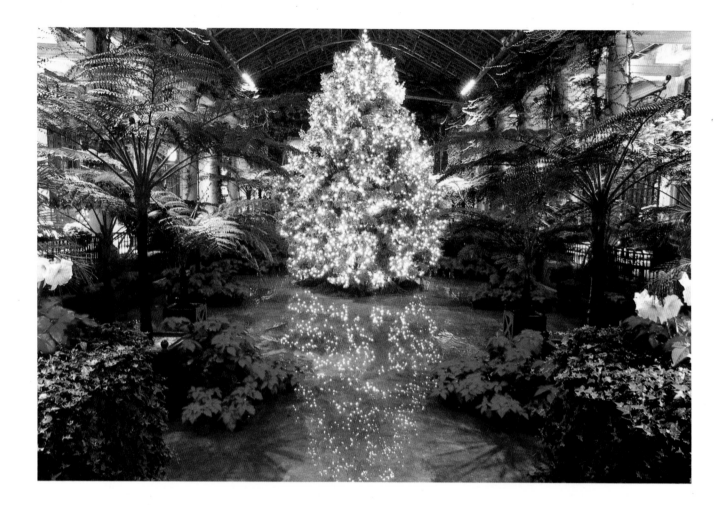

The Exhibition Hall's sunken marble floor

is usually flooded to create a reflecting pool.

The huge East Conservatory of 1973

replaced an earlier Azalea House.

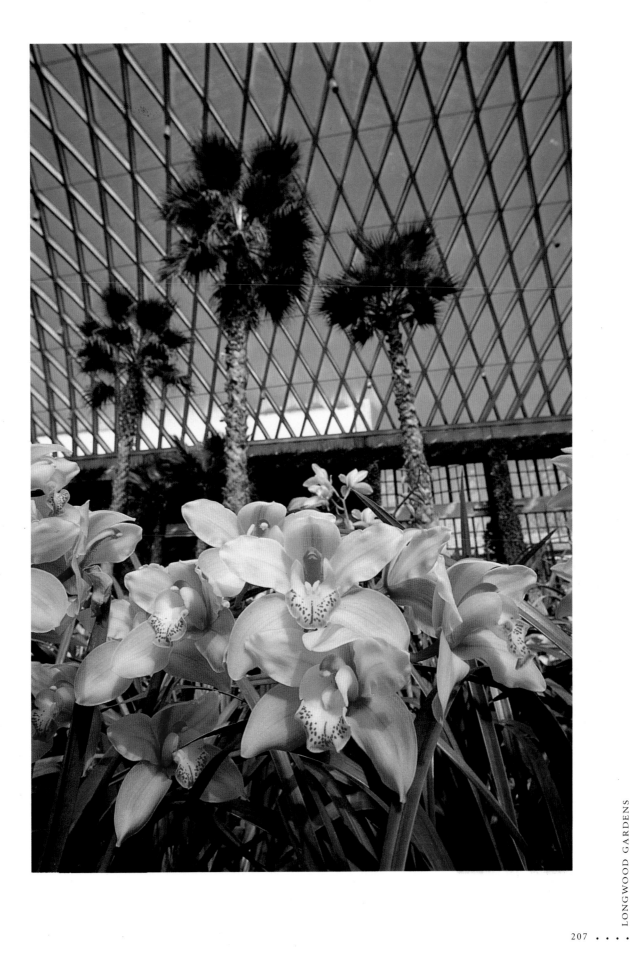

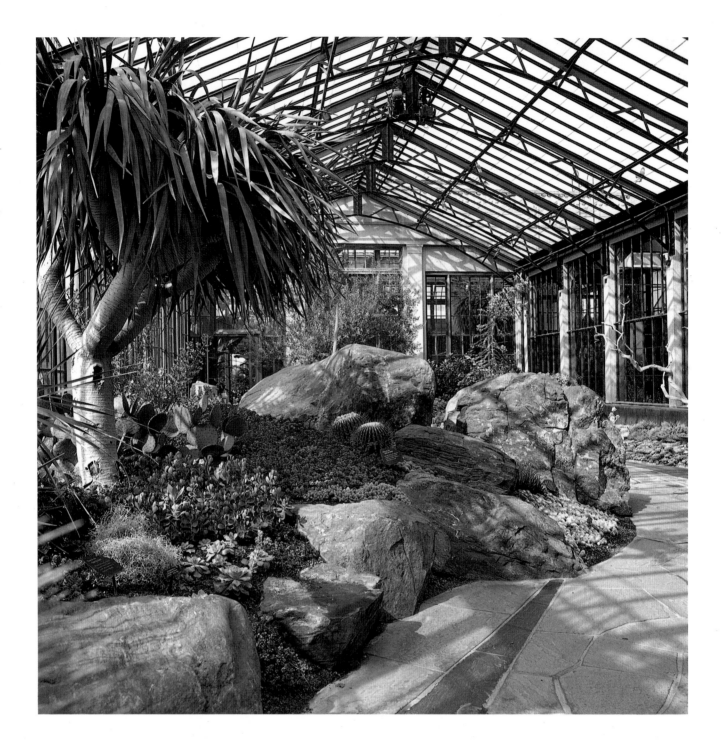

The Silver Garden, with its plants from dry landscapes,

has an other-worldly, science-fiction look.

domed roof of curved acrylic panels. Under it an ever-changing composition leads from acacias and cymbidium orchids to ornamental peppers, all enlivened by a central watercourse and erupting fountain. In the bonsai collection, plants include blue atlas cedar, pomegranate, Hinoki false cypress, Scots pine, and chrysanthemum bonsai. Next door, an exhibition of espaliered fruit recalls Pierre's great fondness for nectarines and grapes, and his once-prodigious greenhouse production of them.

Unfolding, as Pierre said, like departments, are other indoor specialties. The Children's Garden beckons, beside topiary rabbits and live goldfish through low flowered arches, and a miniature maze marked "Kids Only." The Garden Path leads through a lush, informal gathering of subtropical plants. There is a Palm House, a passage for ferns, a place for insect-catching plants, a realm for roses and hibiscus, and the Tropical Terrace, where a dark stream courses under 20-foot-long aerial roots of the princess vine. As if that weren't startling enough, the middle of the room is dominated by a 500-pound fern. The Silver Garden, a place of haunting beauty, is home to the silvery gray plants that have learned to reflect light and store water in dry landscapes. They seem as crafted and illusory as a science-fiction painting, their exotic paleness enhanced by delicate pink and orange blossoms from pearl echeveria, and ruby-hued flowers of the *Mammillaria infernillensis,* looking for all the world like a fuzzy artichoke. Mr. du Pont's banana department displays twenty different types and perhaps nostalgically recalls a presidential visit. When Calvin Coolidge toured the greenhouse, it's said he was his legendary tight-lipped self, uttering no sound as he passed some of the most spectacular plants and blossoms on our planet. But once, just once, his lips were inspired to move, and the word they spoke was, "Bananas."

Most visitors are more demonstrative, and they positively rave in the orchid room. Longwood Gardens counts 2,000 different types from all over the world in its collection, and as many as 350 will be on display at any time. Next door, a gallery of cloud forest plants continues the exotic theme with its pitcher plants, bromeliads, and nepenthes. Visitors' pleasured exclamations often reach a crescendo at the waterlily display. The one conservatory attraction that is outdoors (though partially protected by greenhouse walls) is at its best from mid-July to early October. Here are pools covered with day- and night-blooming tropical waterlilies and lotuses. The star attractions—on stage in the center pool—are giant waterplatters, first successfully hybridized at Longwood Gardens. These astounding flat dishes, pea green with raised ruby rims and up to 6 feet in diameter, are too beautiful to be called grotesque, yet there is something monstrous about them, as alien to the Brandywine as an outcropping of moon rocks. The biggest of these heroic pads can support a small human; a guest looks around uneasily lest there be bullfrogs of a matching size.

In a total contrast with such theatricality, the Idea Garden brings visitors back to earth. Just west of the Main Fountain Garden, this relatively new feature occupies the 5-acre site of a former vegetable garden. Now it is useful in another way, displaying

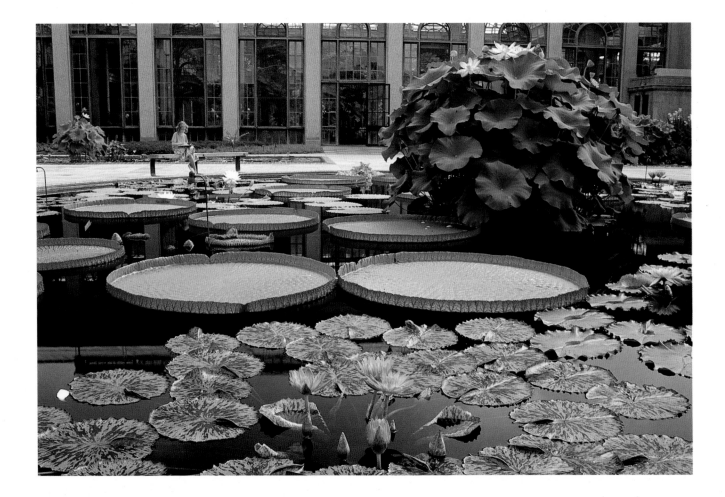

Longwood's giant waterplatters, up to seven

feet in diameter, can support a small human.

From the Idea Garden,

a visitor can take something home: ideas.

various plant groups that do well in the Mid-Atlantic region, and concepts for growing and enjoying them by home gardeners. But across all the outdoor "departments" a visitor will find spectacular challenges to his green thumb, and sources of dreams for an infinity of quarter-acre suburban lots.

Most North Americans can grow wisteria, for example. Longwood's Wisteria Garden demonstrates how to do it on a mammoth scale: trained on arbors, tiered into stake-supported tree shapes, enhanced by assorted ground covers. Peonies? They please most home gardeners, but in the Peony Garden at Longwood the reaction may be unrestrained passion, here among the hybrid tree peonies, astilbes, and Siberian irises. And roses? What home gardener would not melt at the sight of this circle lined with arches of pink climbing roses, all blooming at their giddy best in June?

The Hillside Garden, beside the Chimes Tower and Waterfall, demonstrates the covering of a rocky slope with bulbs, ground covers, perennials, dwarf conifers, and flowering shrubs. The Heaths and Heathers area demonstrate that Scotland has no exclusive rights to these low-growing ground covers. There is even an Oak and Conifer Knoll, where giant sequoias mingle with dawn redwoods, California incense cedars, and assorted oaks and flowering deciduous trees. To add some color in March, the knoll erupts with 95,000 pale purple crocuses and more thousands of yellow winter aconites.

A Topiary Garden, a Meadow, and a Forest Walk all exude their own character and appeal, ranging from showy to serene. Yet, on any given day, the greatest outdoor variety may be the flowers of Flower Garden Walk, du Pont's original—and traditional—effort, dating from 1907. The familiar faces of begonias, mums, hybrid cannas, marigolds, periwinkles, tulips, and zinnias are eminently reassuring, like old friends from home among a huge international throng. After all, Longwood Gardens now embosoms 6,500 different types of outdoor plants, and in the conservatories, another 4,500. It should be added that caring for this huge population is a staff of about 300, including 65 professional gardeners.

Pierre did not lavish great wealth on his house, which remains as low-key as the gardens are spectacular. Although he enlarged it twice, the house only reached twenty-seven rooms, a virtual cottage compared to the mansions of some of his cousins. It retains the sturdy but rather severe architectural proportions of the Pennsylvania farmhouse genre, a look that Pierre must have liked, for it remained his primary home. His additions were more practical than cosmetic. Inside, visitors find enough personal reminders of Pierre and Alice du Pont to get a faint sense of their lives (first cousins, they had no children). A tour covers twelve rooms, including the big paneled library, kitchen, dining room, parlor, Pierre's original conservatory, and his modest study. Most of the display rooms date from the eighteenth-century days of the house and are furnished appropriately in unpretentious antiques. The Peirce-du Pont House is not grand but friendly and is a key ingredient in understanding the

The Idea Garden offers a lavish display of ornamental grasses.

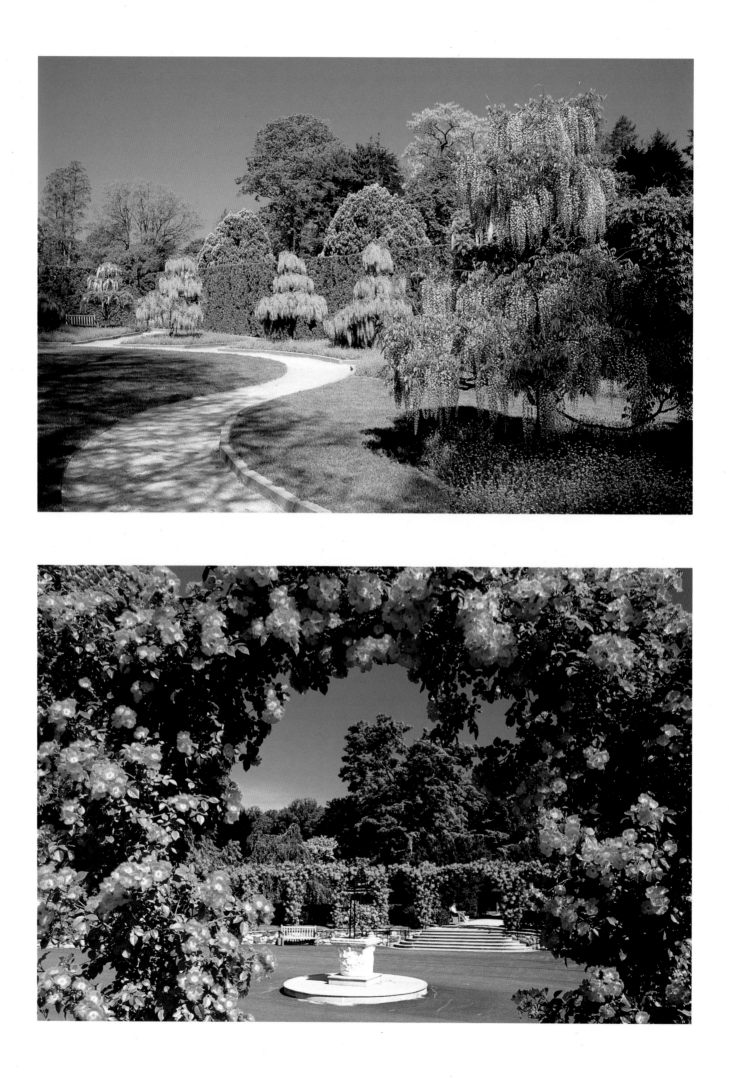

The Wisteria Garden is at its violet-hued best in May.

Lavish arches of pink climbing roses welcome June at Longwood.

The Peony Garden features golden-chain trees, hybrid tree peonies, and Siberian irises.

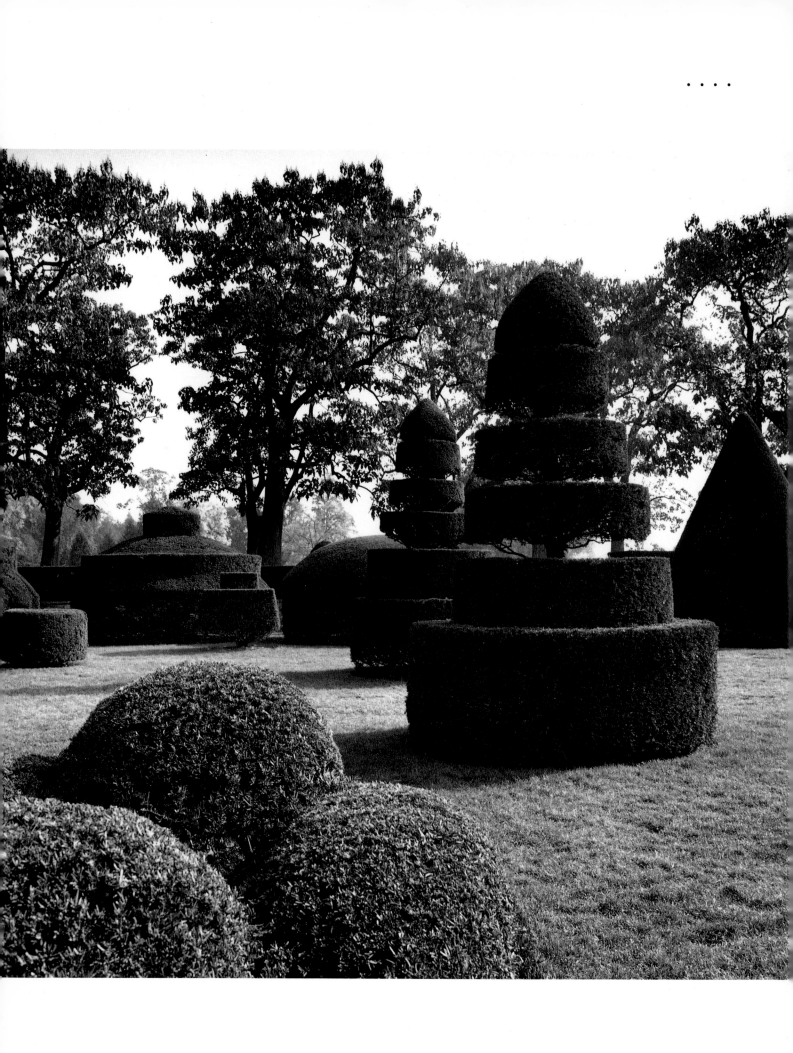

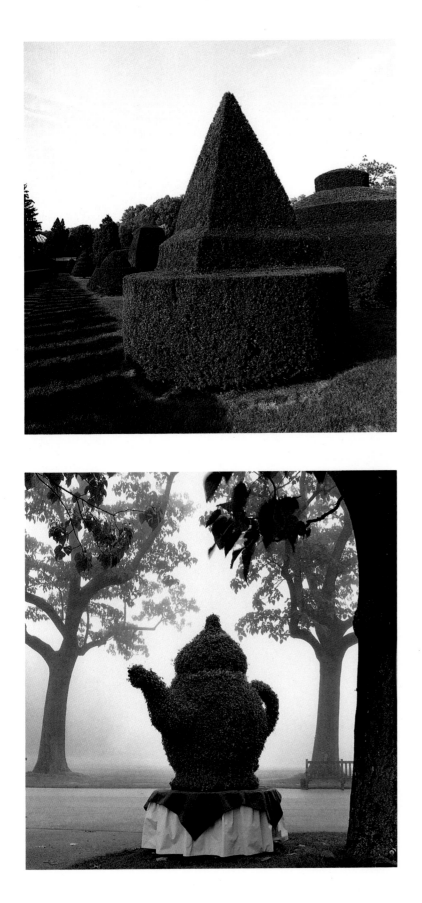

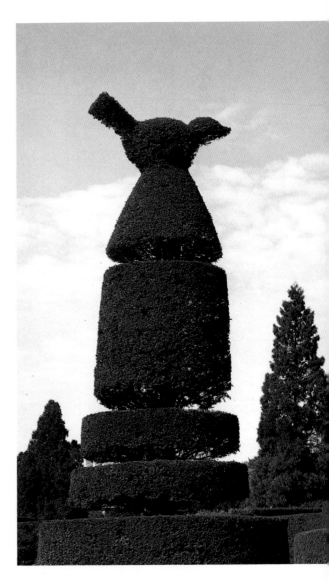

Longwood's Topiary Garden

borders the Main Fountain Garden.

.

. The Flower Garden Walk is where Pierre du Pont began his mighty effort in 1907.

. Du Pont's home (the Peirce–du Pont House) remained comfortable but low-key.

history of Longwood Gardens. Here at the heart of things, the original setting is largely unchanged, and we can sense the attraction that ensorcelled Pierre du Pont. Even some of the old trees planted in the two Peirce centuries remain, like aged but honored relatives, these sturdy Canada hemlocks, cucumber trees, gingkos, and copper beeches, still holding precious life inside. They were the inspiration for great things, and it is good and somehow comforting that we can still stroll beneath them in the fullness of their age as we pay our respects, rejoicing in the beauty and wonder of trees, flowers, and fountains.

I·N·D·E·X

P·H·O·T·O·G·R·A·P·H C·R·E·D·I·T·S

Original photography was provided by Steven Mays. Additional photographs were provided by the following institutions from their archives (numbers refer to pages): *Historical Society of Delaware*: 14, 16, 23–25; *Hagley Museum*: 47 (top), 51 (top left), 51 (bottom), 54, 58–59, 60–61; *Rockwood Museum*: 64, 73; *Winterthur Museum*: 80, 84 (bottom), 92, 98, 99; *Delaware Art Museum*: 106, 107, 109, 111, 113, 115, 117, 119–121, 123–125, 127; *Delaware Museum of Natural History*: 157; *Brandywine River Museum*: 170–177, 179, 180, 182, 183 [© Macmillan Publishing Company], 185 [© Andrew Wyeth], 187 [© Andrew Wyeth], 188 [© Andrew Wyeth], 189 [© James Wyeth], 191 [© James Wyeth]; *Longwood Gardens*: 192 [Photo: Larry Albee], 194 [Photo: Courtesy Hagley Museum], 197 [Photo: Larry Albee], 199, 200 [Photo: Larry Albee], 201, 202 (top and bottom) [Photo: Larry Albee], 203 (top and bottom) [Photo: Larry Albee], 205, 206 [Photo: Larry Albee], 207 [Photo: Larry Albee], 210 [Photo: Larry Albee], 214 (top and bottom) [Photo: Larry Albee], 215 [Photo: Larry Albee], 218 [Photo: Larry Albee]